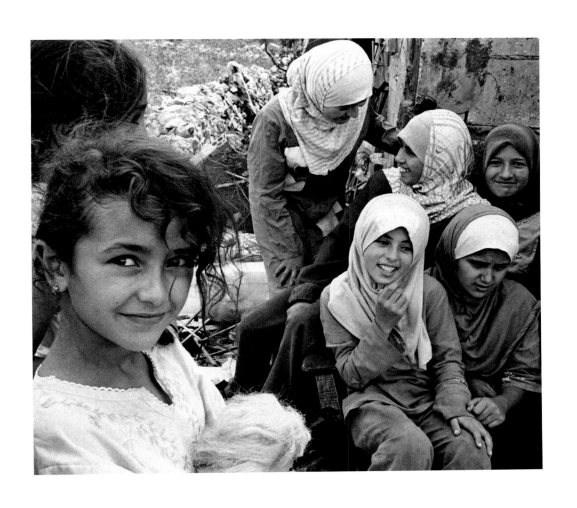

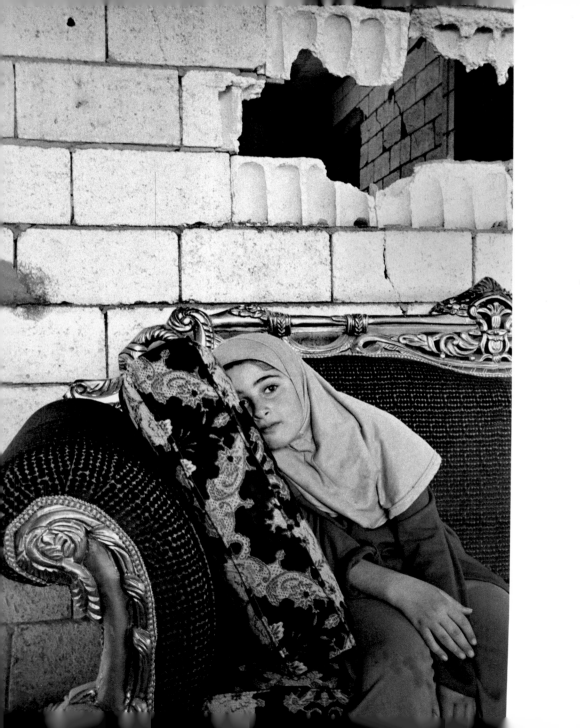

Ordinary Lives

RANIA MATAR

Essay by Anthony Shadid

THE QUANTUCK LANE PRESS
New York

Ordinary Lives
Rania Matar

Manufacturing by Mondadori, Verona, Italy

Library of Congress Cataloging-in-Publication Data
Matar, Rania.
 Ordinary lives / Rania Matar ; introduction by Anthony Shadid. — 1st ed.
 p. cm.
 ISBN 978-1-59372-037-7
 1. Women—Lebanon. 2. Children—Lebanon. I. Title.
 HQ1728.A62M38 2009
 306.874'3095692—dc22 2009016753

The Quantuck Lane Press, New York
www.quantucklanepress.com

Distributed by W. W. Norton & Company
500 Fifth Avenue, New York, NY 10110
www.wwnorton.com

W. W. Norton & Company Ltd., Castle House,
75/76 Wells Street, London, W1T 3QT

1 2 3 4 5 6 7 8 9 0

For my Father, Raja

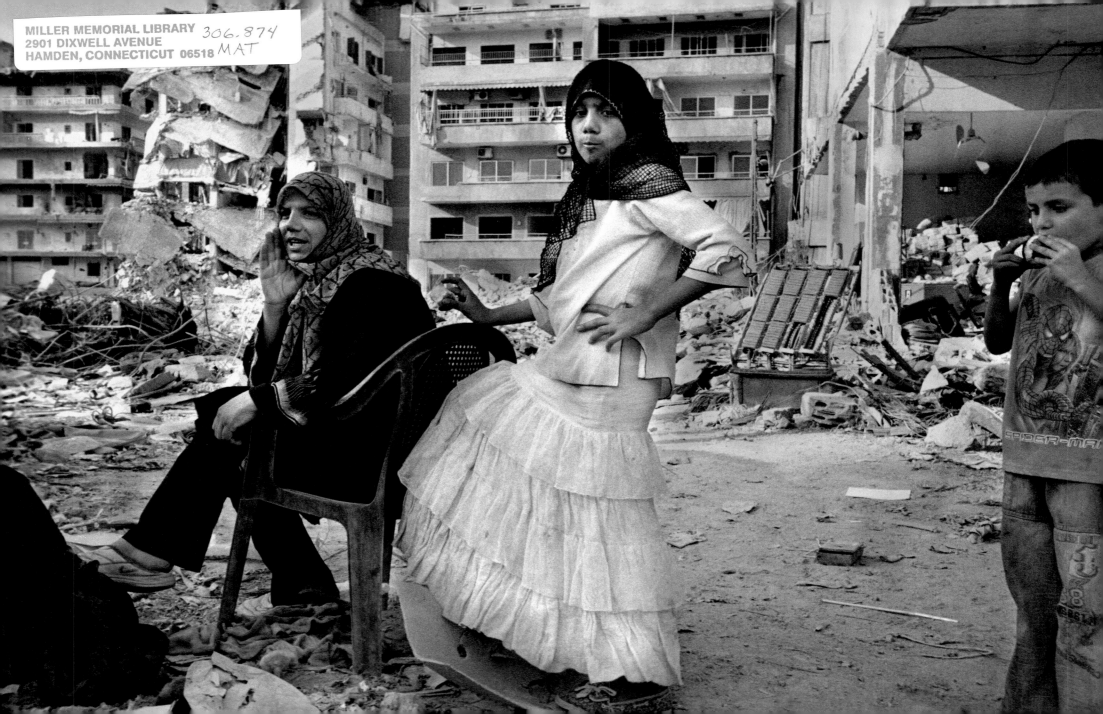

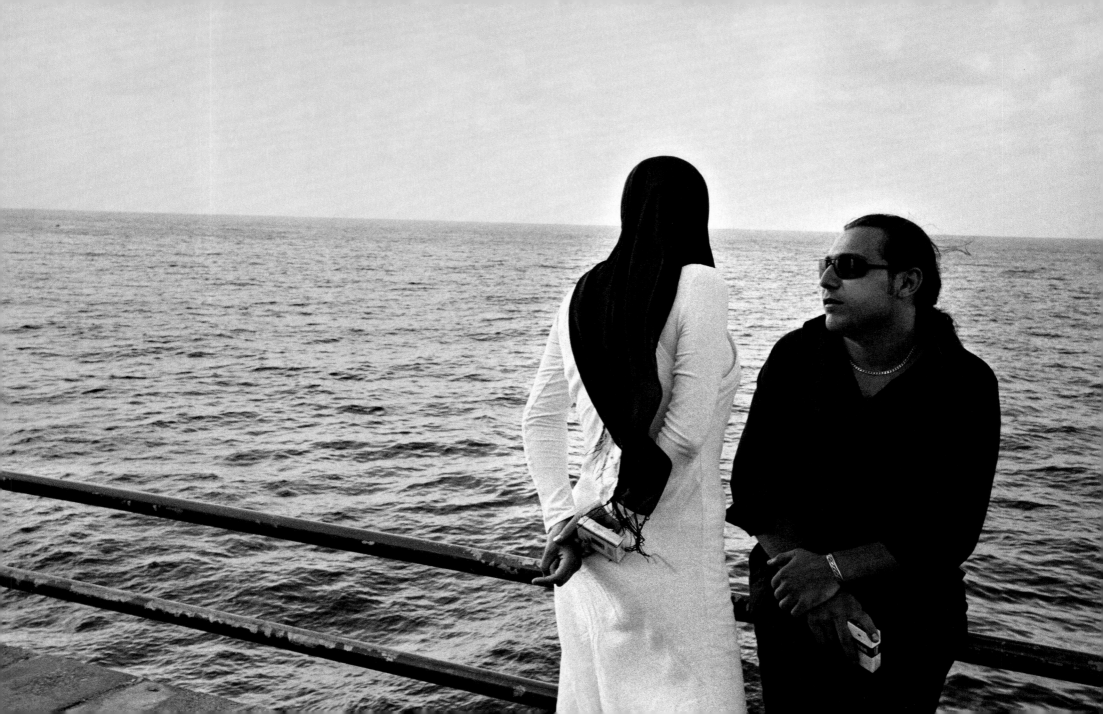

Contents

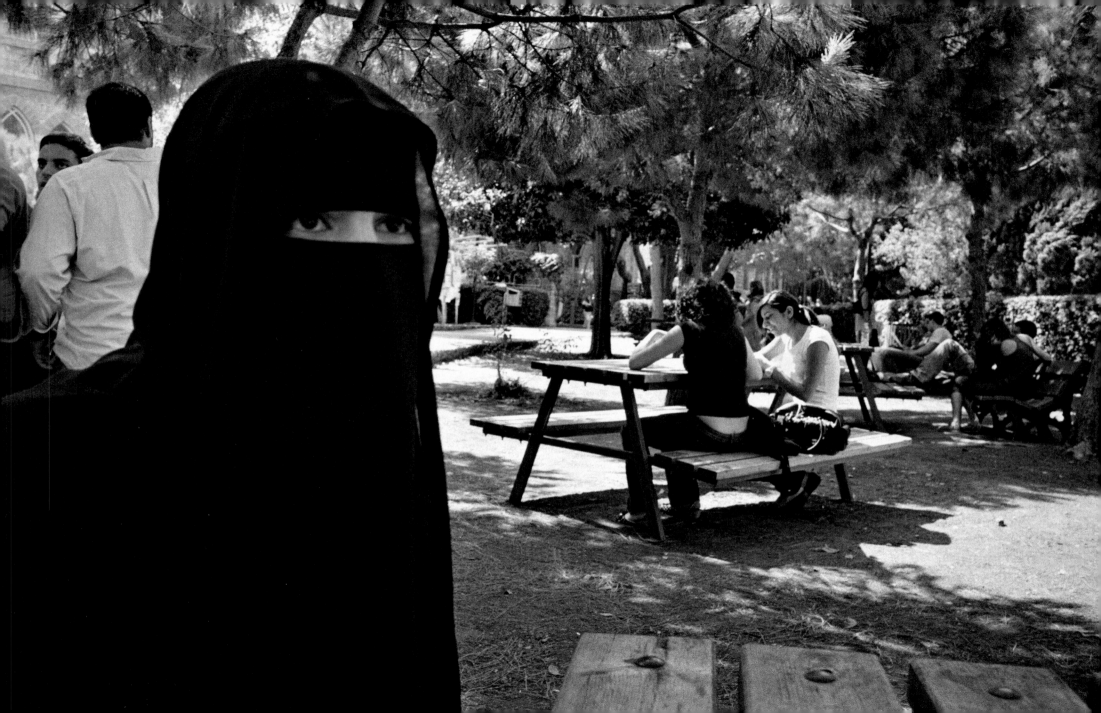

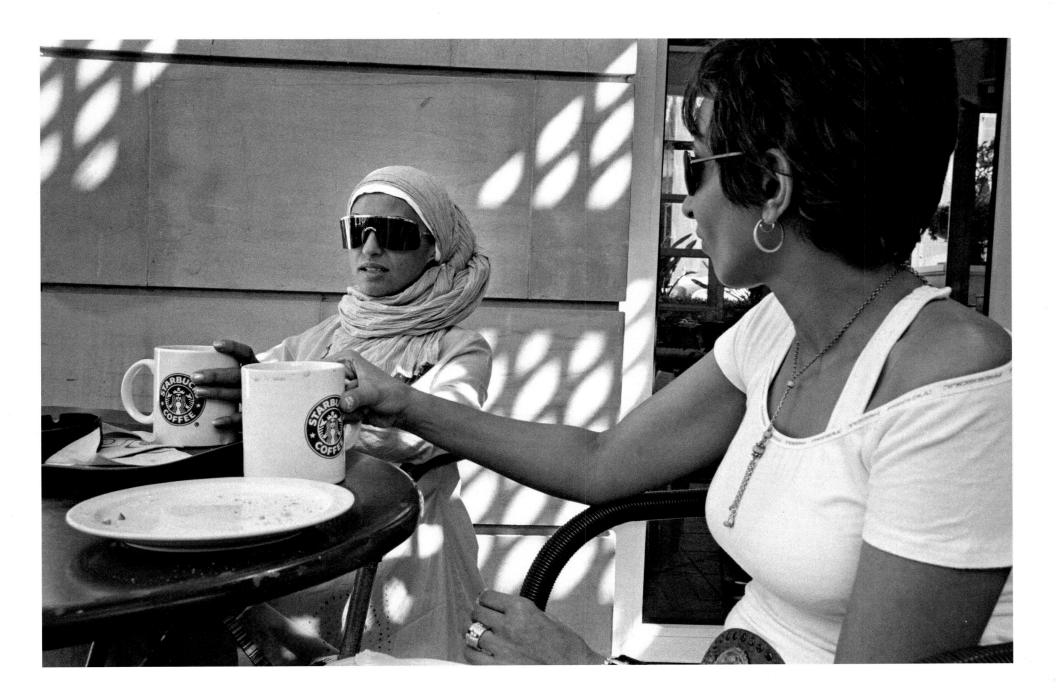

Arguments

consider the infinite fragility of an infant's skull
how the bones lie soft and open
only time knitting them shut

consider a delicate porcelain bowl
how it crushes under a single blow—
in one moment whole years disappear

consider: beneath the din of explosions
no voice can be heard
no cry

consider your own sky on fire
your name erased
your children's lives "a price worth paying"

consider the faces you do not see
the eyes you refuse to meet
"collateral damage"

how in these words
the world
cracks open

<div align="right">Lisa Suhair Majaj</div>

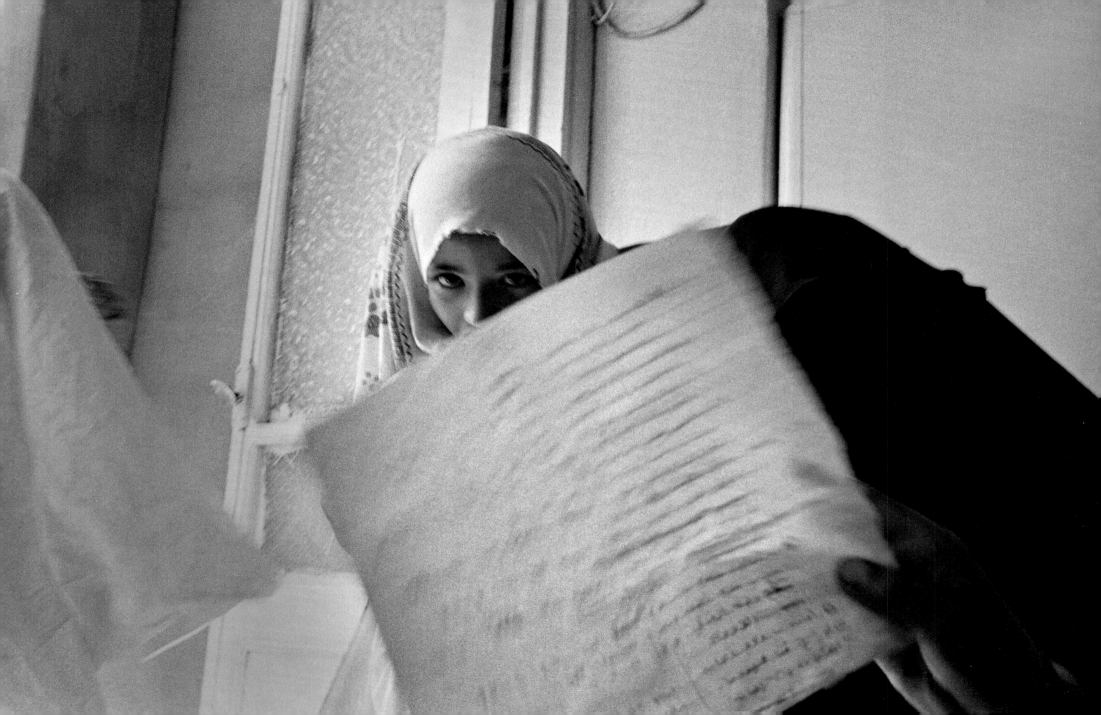

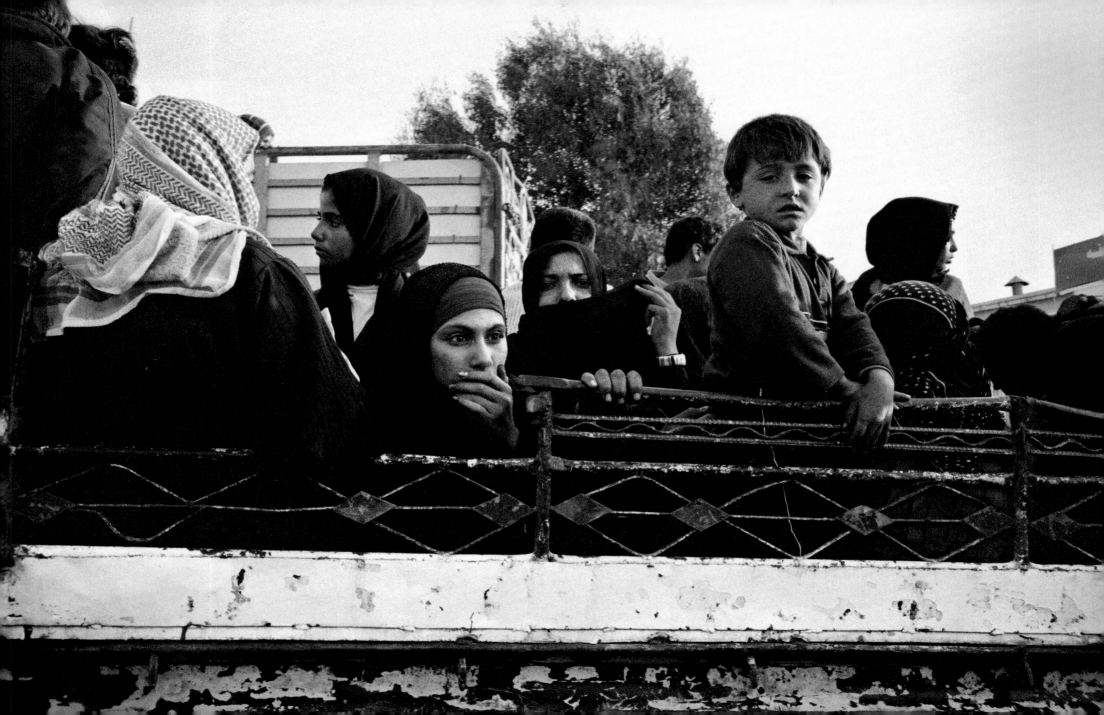

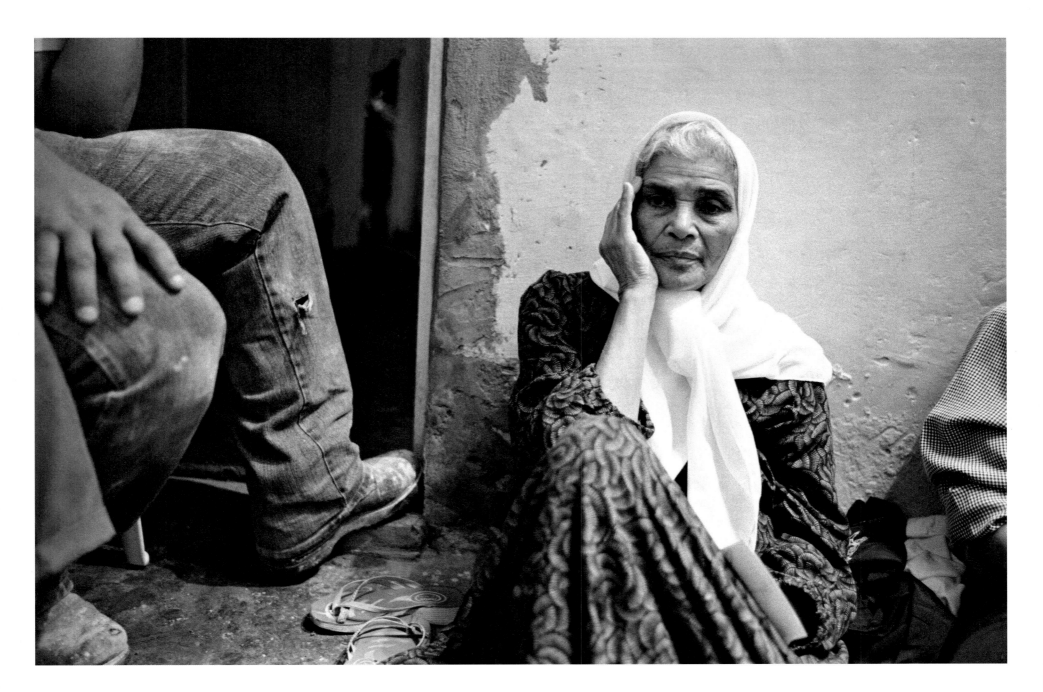

Preface
Rania Matar

The focus of my photography is on the Middle East, women and children especially. Lebanon in particular is interesting because of its key location as a gate to the Middle East, between the West and the Arab world. I grew up and lived in both Lebanon and the U.S. I am a Lebanese insider who speaks the language, knows the country, and understands its people, but I am also an outsider who can see Lebanon and its complexities through Western eyes, who can still be intrigued by the dichotomies that are shocking to the Westerner, but unnoticed by the locals.

The images in this book are from three interrelated bodies of work: *The Aftermath of War*, a photographic essay of life in Lebanon after the numerous wars the country has gone through; *The Veil: Modesty, Fashion, Devotion or Statement*, studying the relatively recent spread of the veil and its meanings among Muslim women in Lebanon; and *The Forgotten People*, portraying life in the decaying Palestinian refugee camps of Lebanon.

These images are not meant to represent all facets of Lebanon as a country, or to be political in any way, but they focus on the universality of being human no matter what the circumstances are, of being a mother, a father, a child, or a young woman no matter what background or religion one belongs to. Girls have friends, bond, and giggle behind their black veils; mothers nurse and nurture their children in refugee camps; toddlers bring a smile to their mothers' faces regardless of surrounding circumstances.

Looking through the rocket hole (page 15)—symbol of war and destruction—one is peeking into a well-preserved building, standing still in the midst of chaos. The people I photograph are doing just that. They are still standing.

Throughout my work in Lebanon, I was welcomed into people's homes and lives, and I was humbled by people's resilience and hospitality. Religion and political affiliations did not matter. In these photos I concentrated on people who did not lose their humanity and dignity despite what they have been and are still going through. I tried to portray them as the beautiful individuals they are, instead of as part of any religious or political group. I concentrated on the spirit with which they continue with the mundane tasks of daily life regardless of their circumstances: their lives that are ordinary in an environment and political climate that are often anything but ordinary.

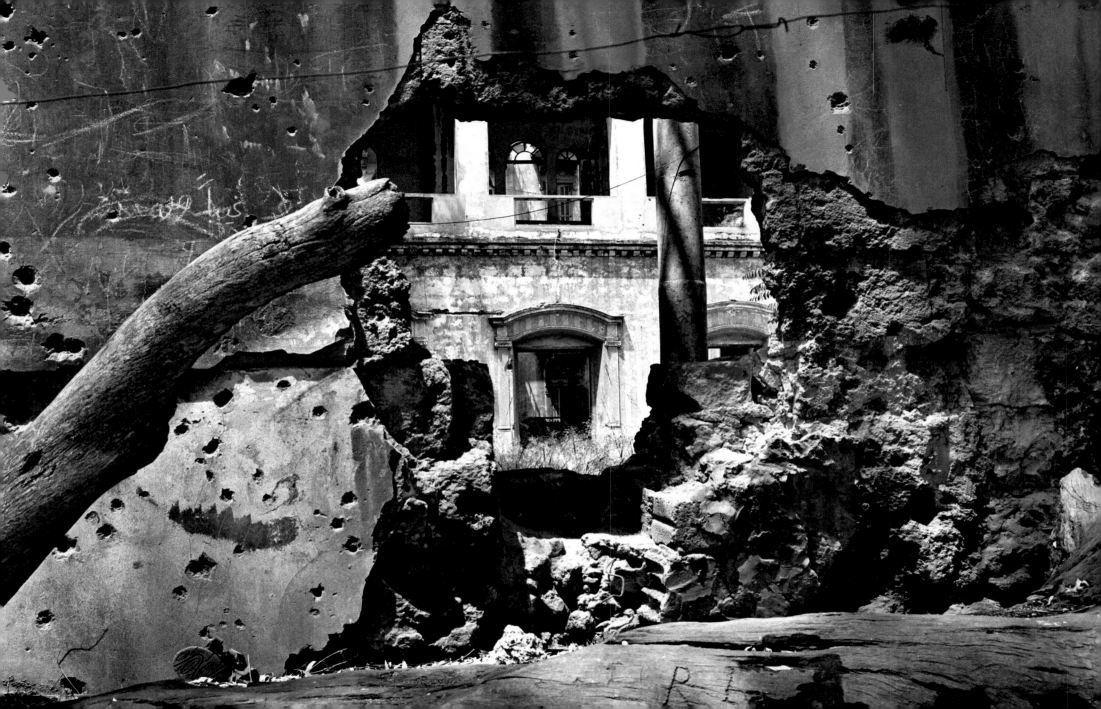

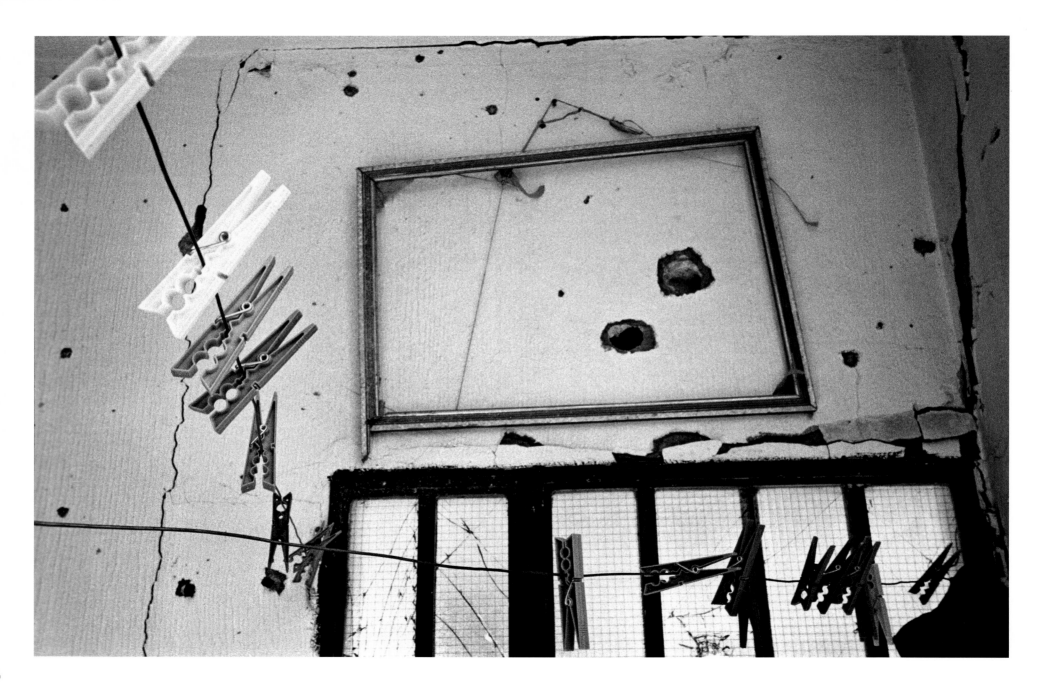

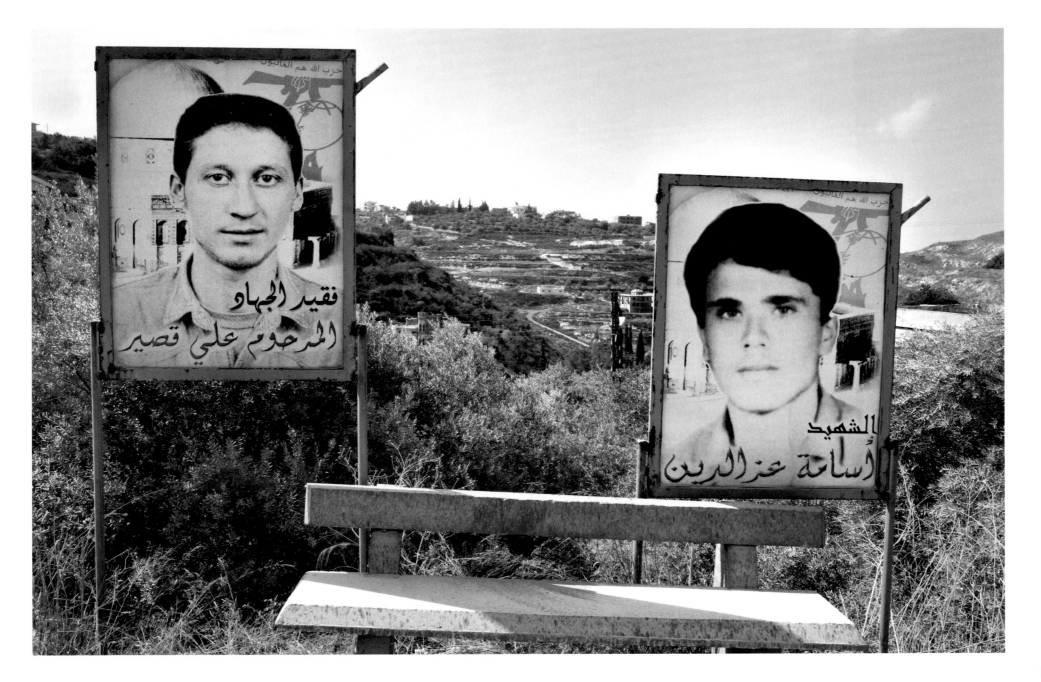

17

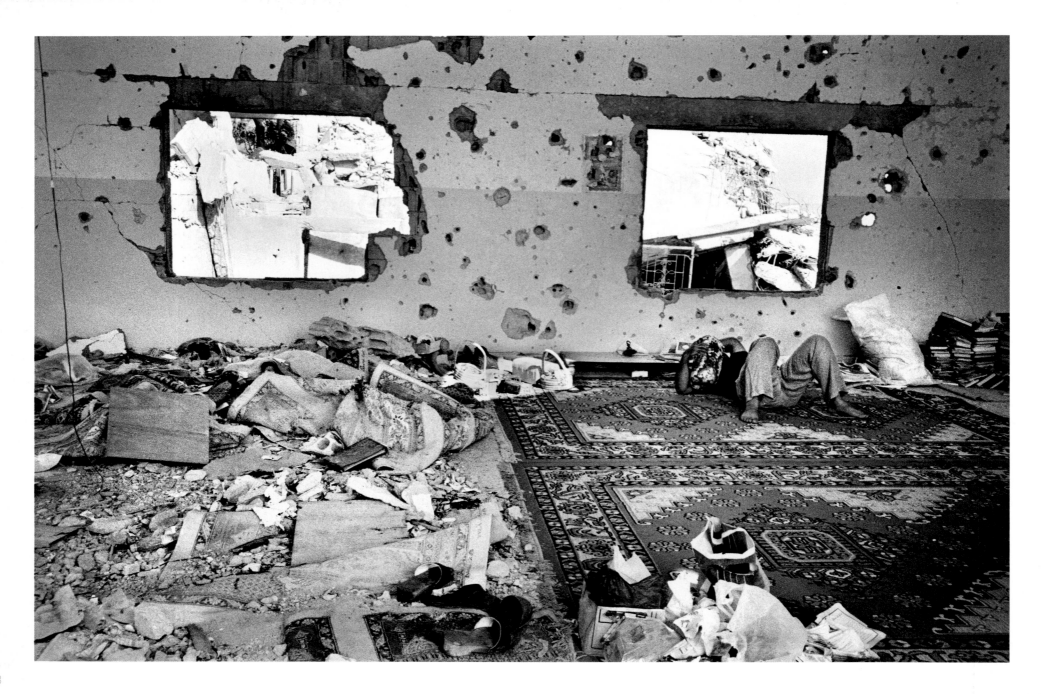

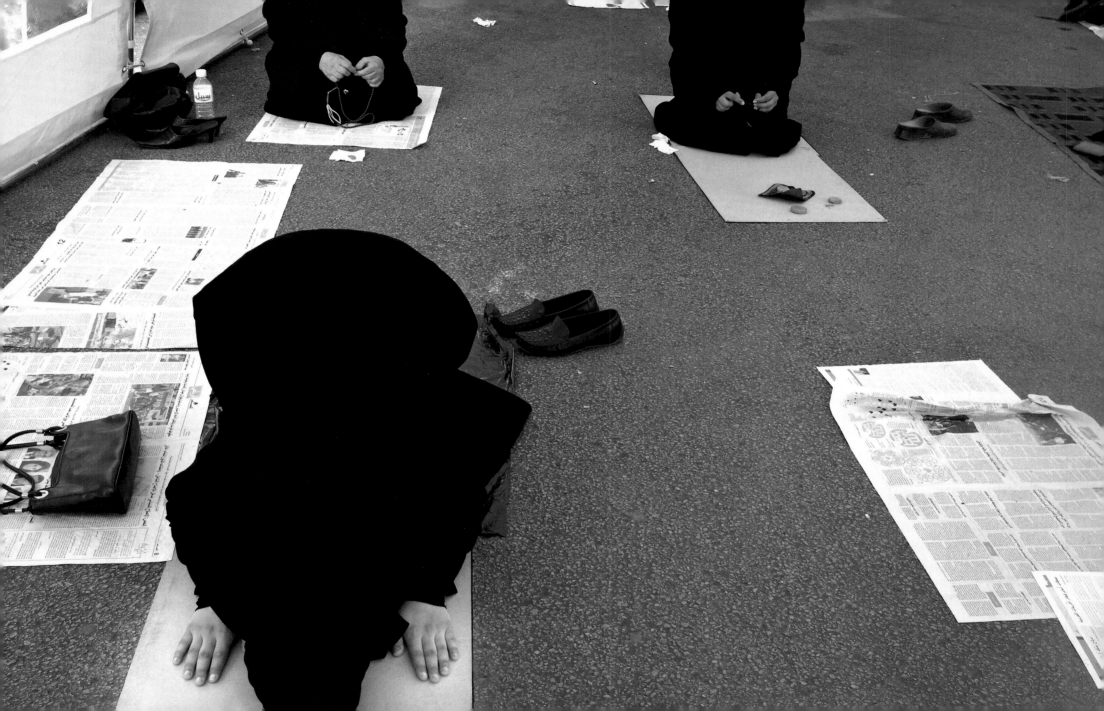

Aftermath of War

A girl is learning to juggle, deeply concentrating on the three balls in the air, a man in the background is jumping rope so close to the edge of the building that he looks like he is about to take flight, a soccer ball casually lays on the ground while a Lebanese flag hangs on a laundry wire blowing in the air. It could be a scene at any summer camp. I was so taken by the flurry of activity going on, the teenagers playing, the beauty of the hills in the background that I did not immediately notice the schizophrenic aspect of the whole situation: life going on within a the skeleton of a building, a building where all the walls have been blown up.

These images are from the aftermath of the Lebanese civil war that lasted from 1975 to 1990, the war between Hezbollah and Israel in the summer of 2006, and the war between the Lebanese army and suspected terrorists who infiltrated Nahr El Bared refugee camp in Tripoli in the north of the country in 2007. They are images of aftermath and rebirth. Those wars had different objectives, involved different players, and occurred at different times, but ultimately the effects on innocent people and the aftermath were similar—destruction, loss, and human suffering.

When the media covers wars, the dead are shown as corpses, identified by numbers, and referred to as collateral damage. For people living far from real conflicts, war is abstracted. They see images of destruction: places they do not relate to, and hear the number of dead: people they do not know. Through my images I hope to honor some of the people who have to deal with war's devastating realities intruding in their daily lives. War is only half the story; the other half, the aftermath, is often ignored and forgotten. It could be any war, any time. Once it ends, it fades from public attention. The people who lived and suffered through it, who lost homes, family members, and friends are now forgotten. They have to deal with the reality of their loss and the difficult task of rebuilding their shattered lives, while the world's attention moves on to the next crisis.

What struck and humbled me most was how quickly people, seasoned by the experience of war, resumed their lives, how they picked up the pieces and moved on to preserve their dignity, their children, and their spirit, with a humanity that shines through destruction and rises above the rubble.

—R.M.

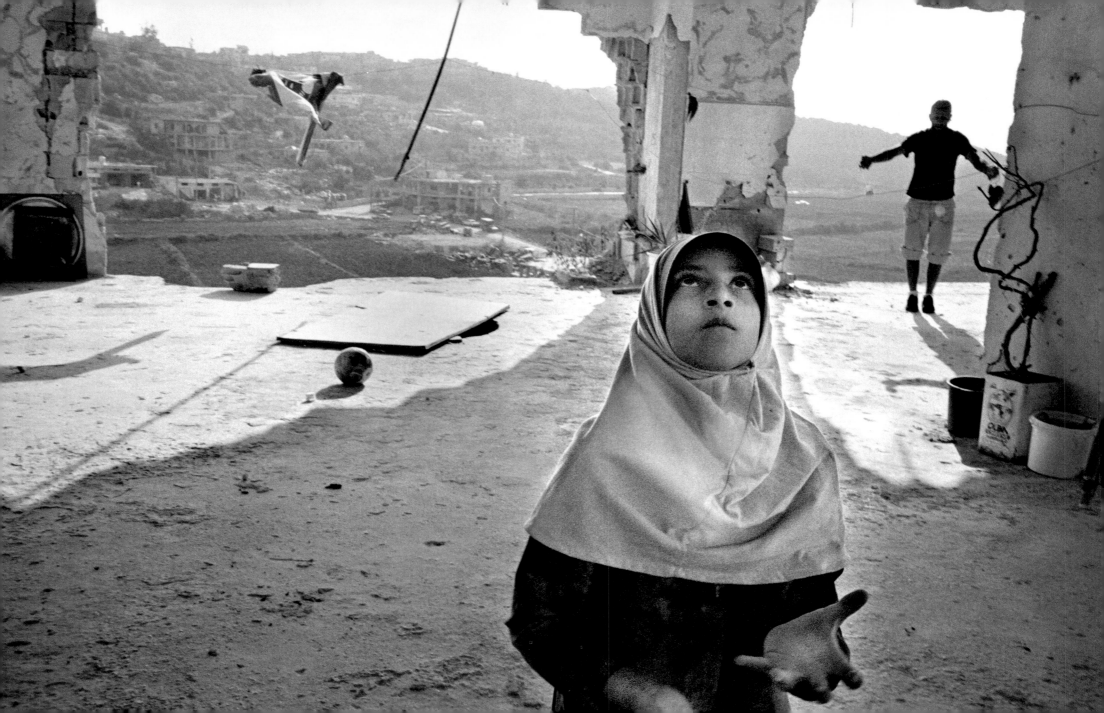

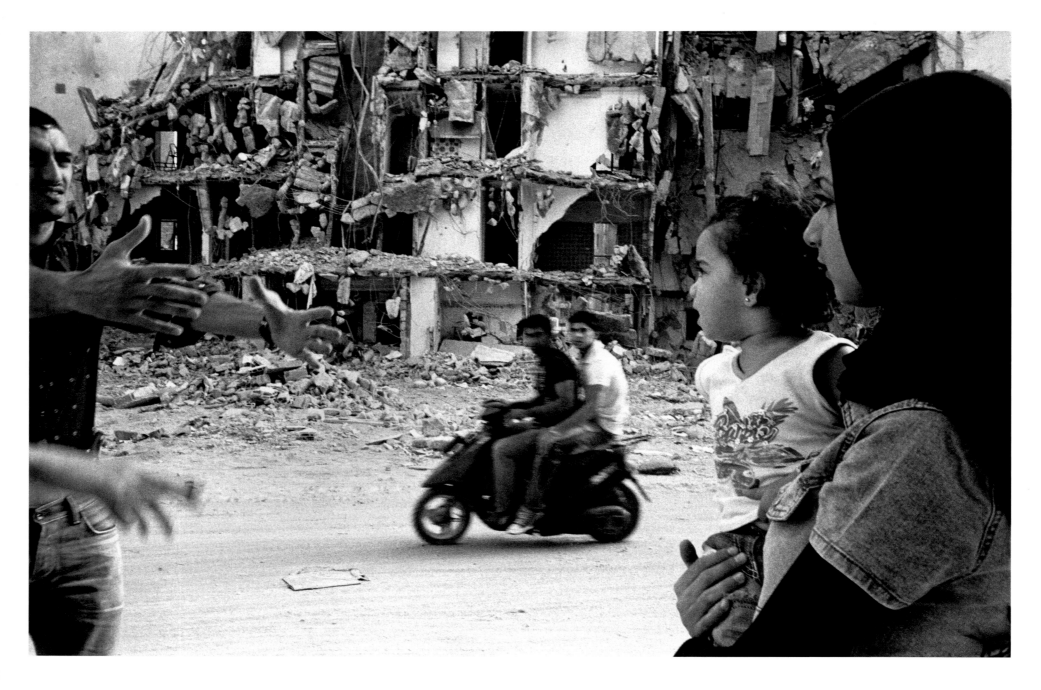

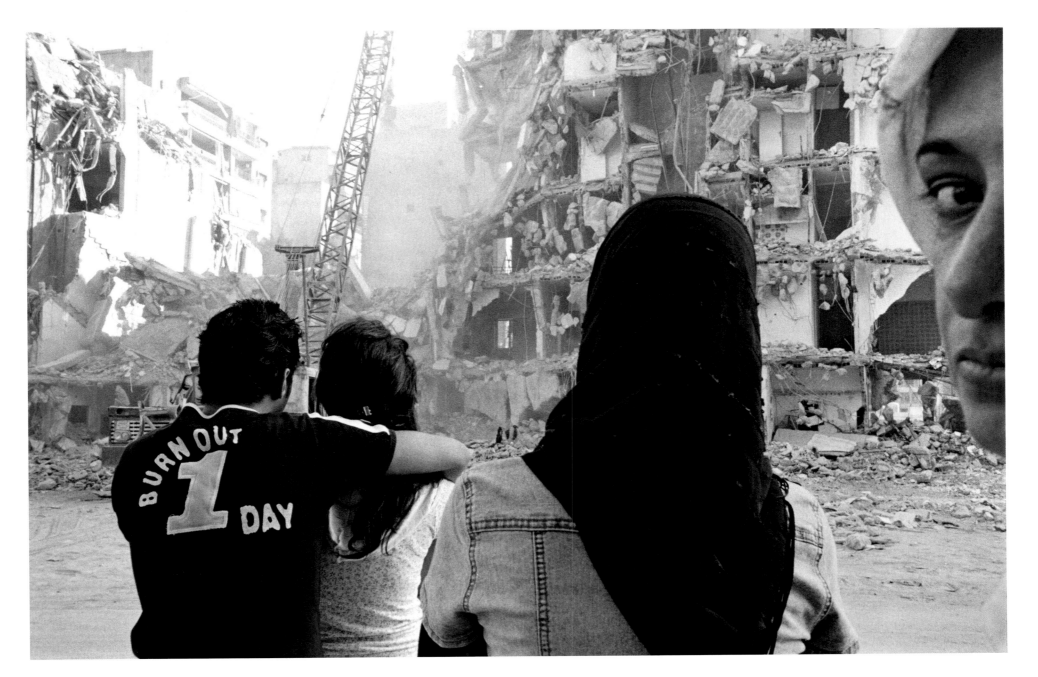

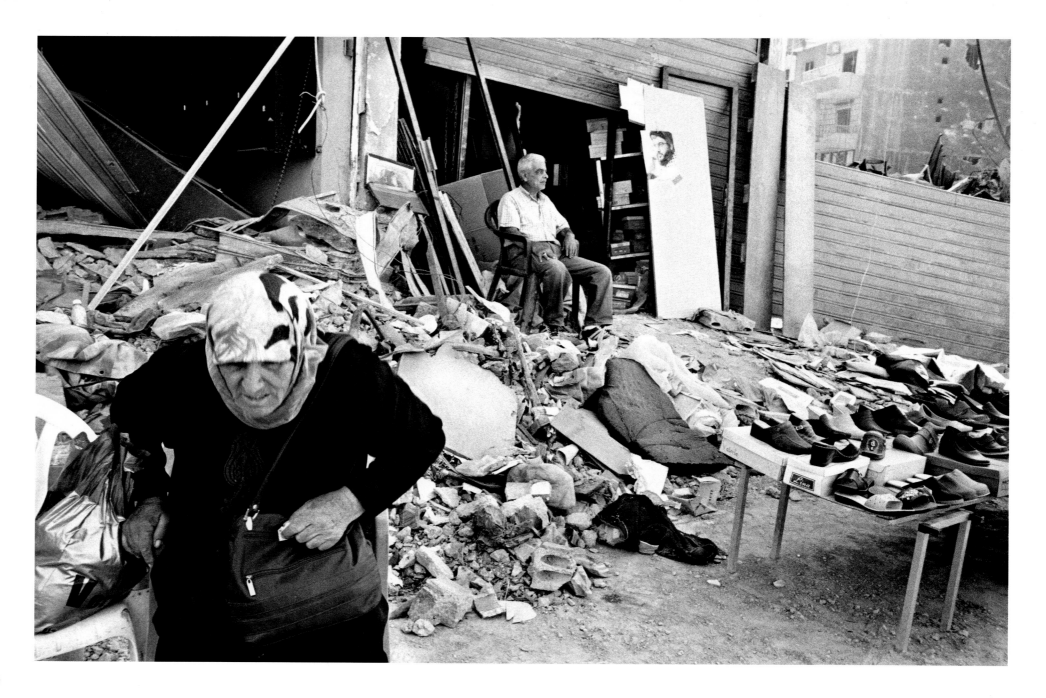

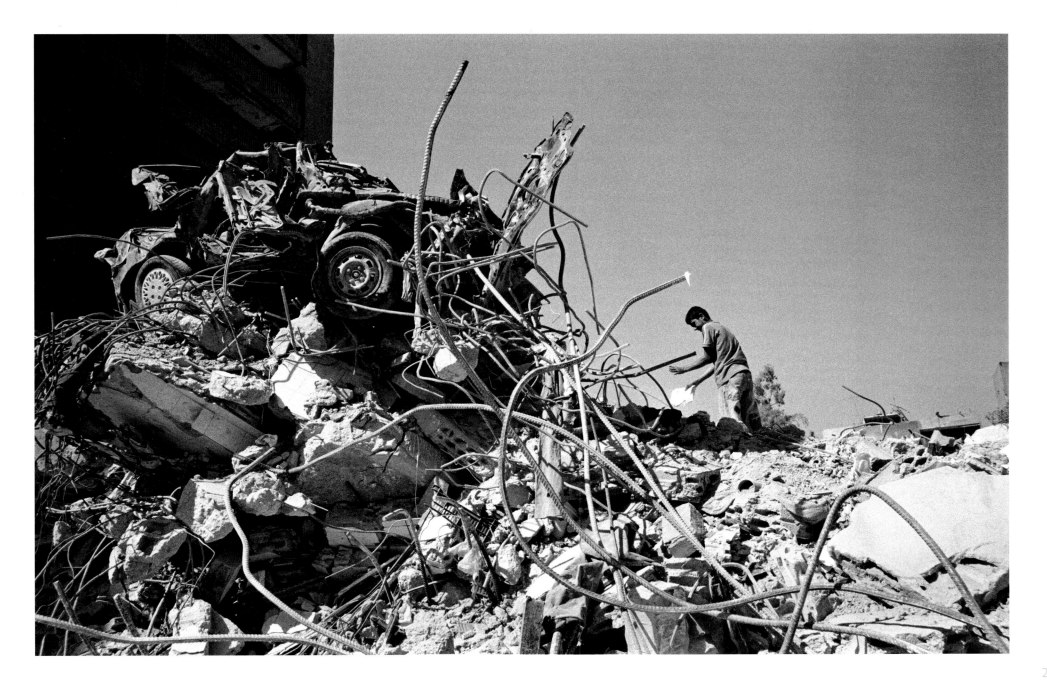

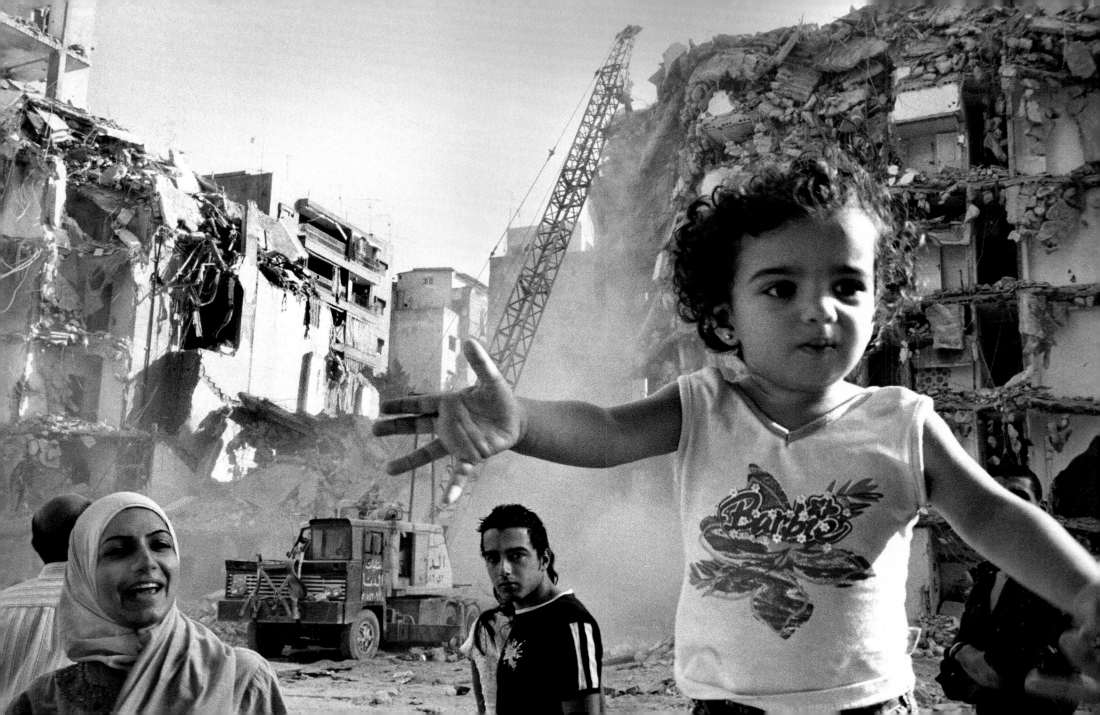

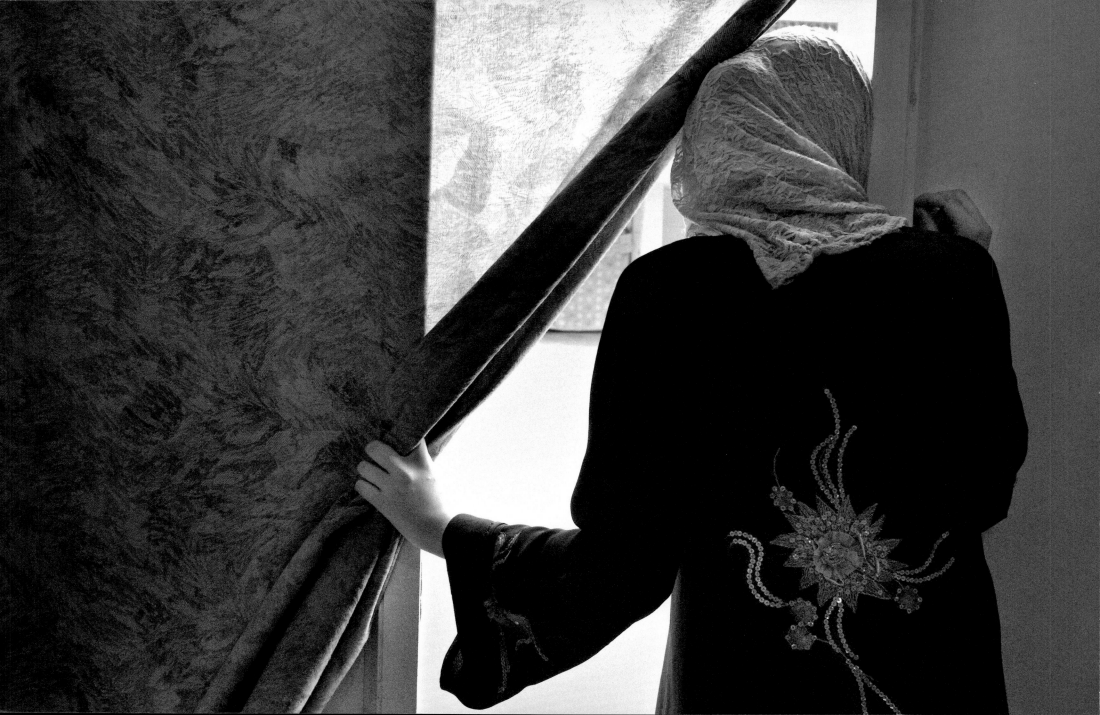

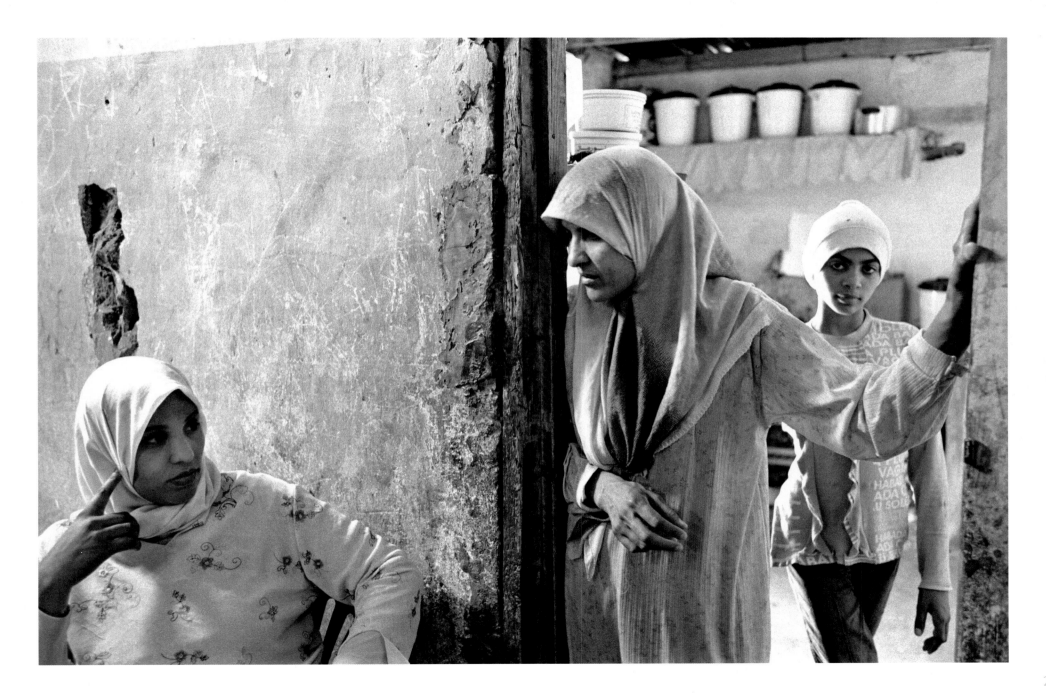

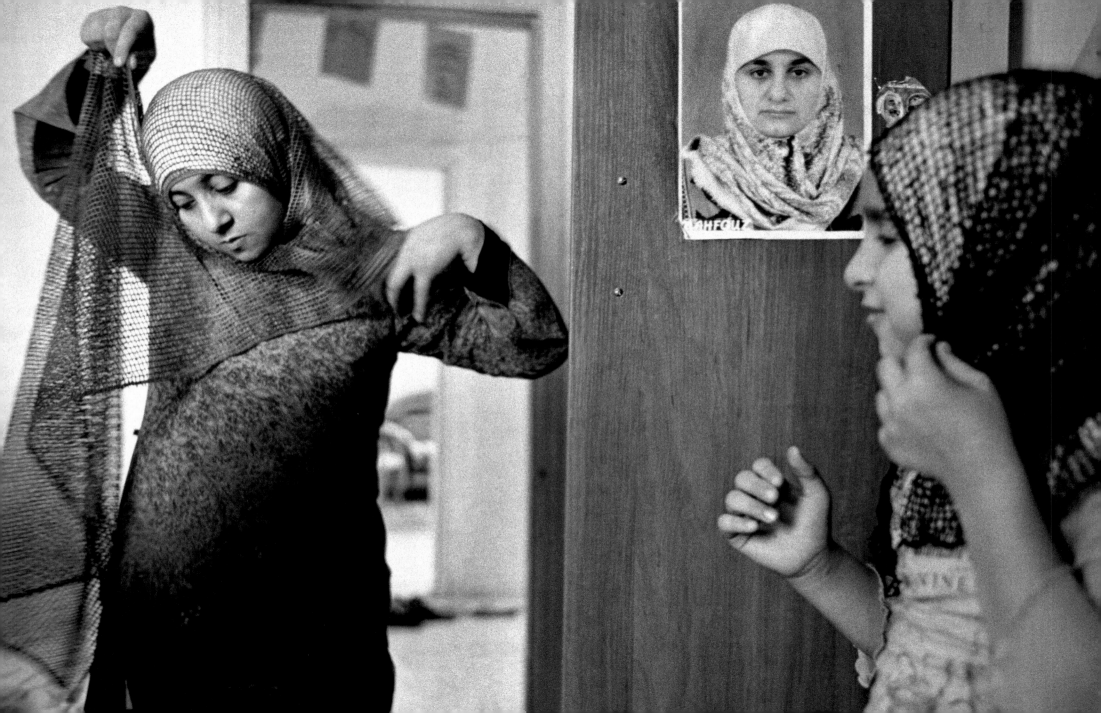

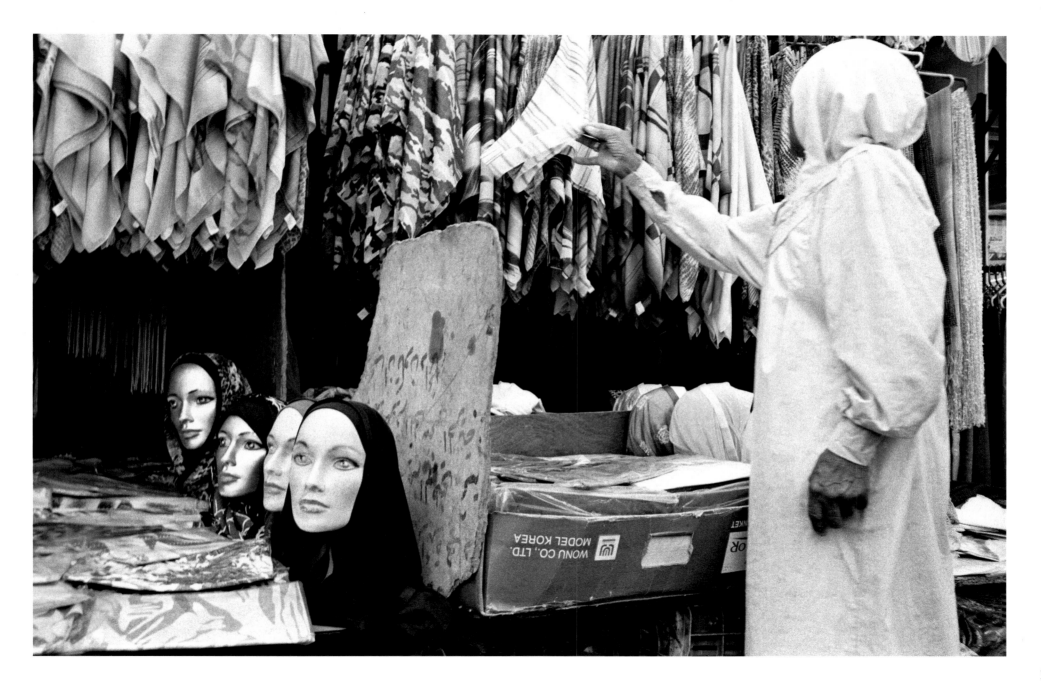

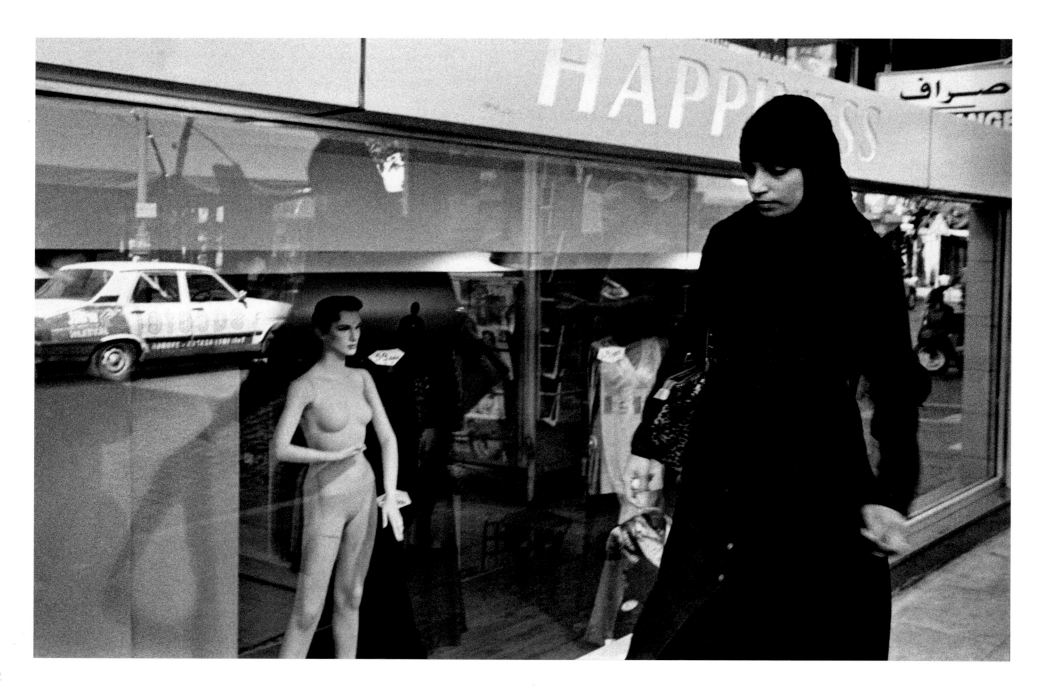

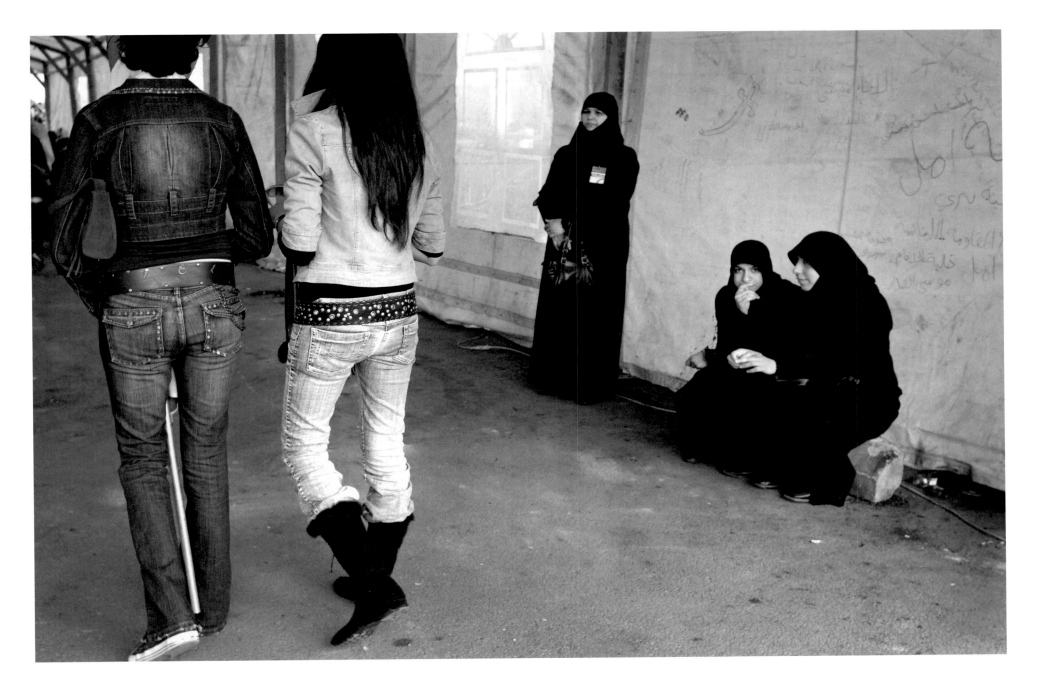

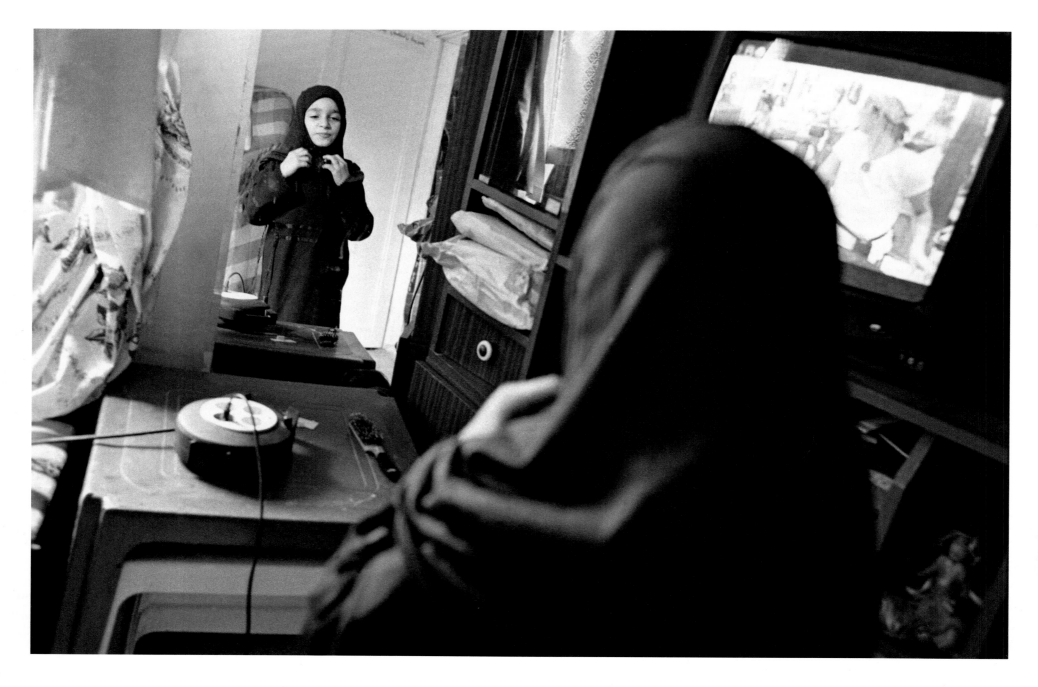

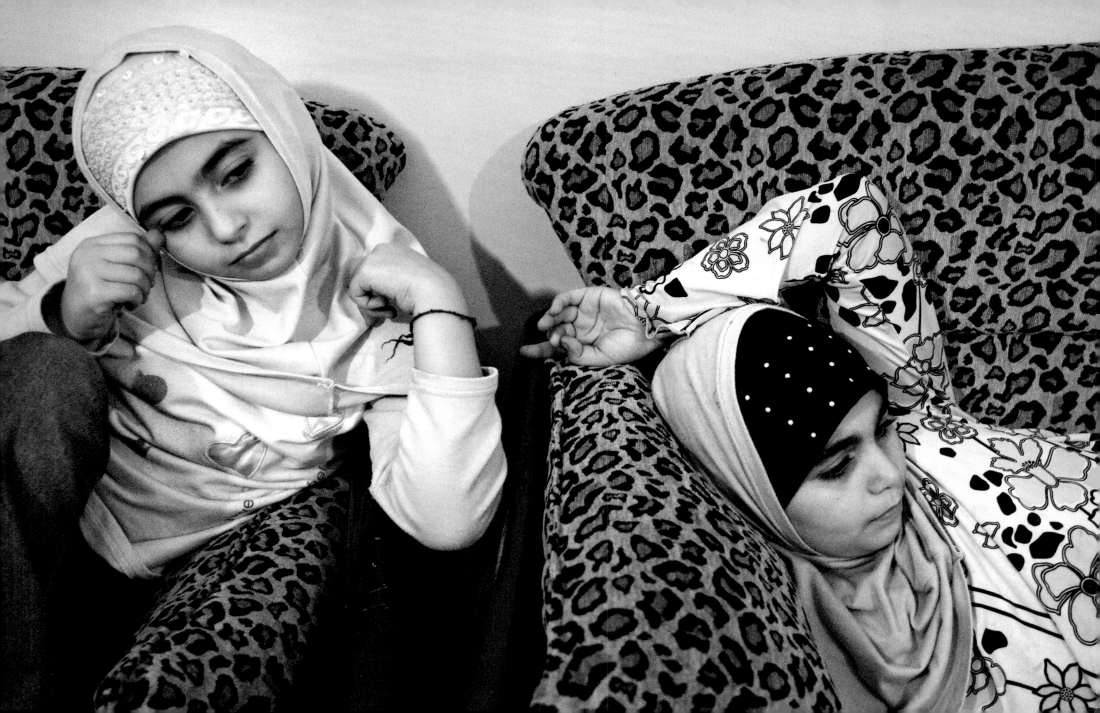

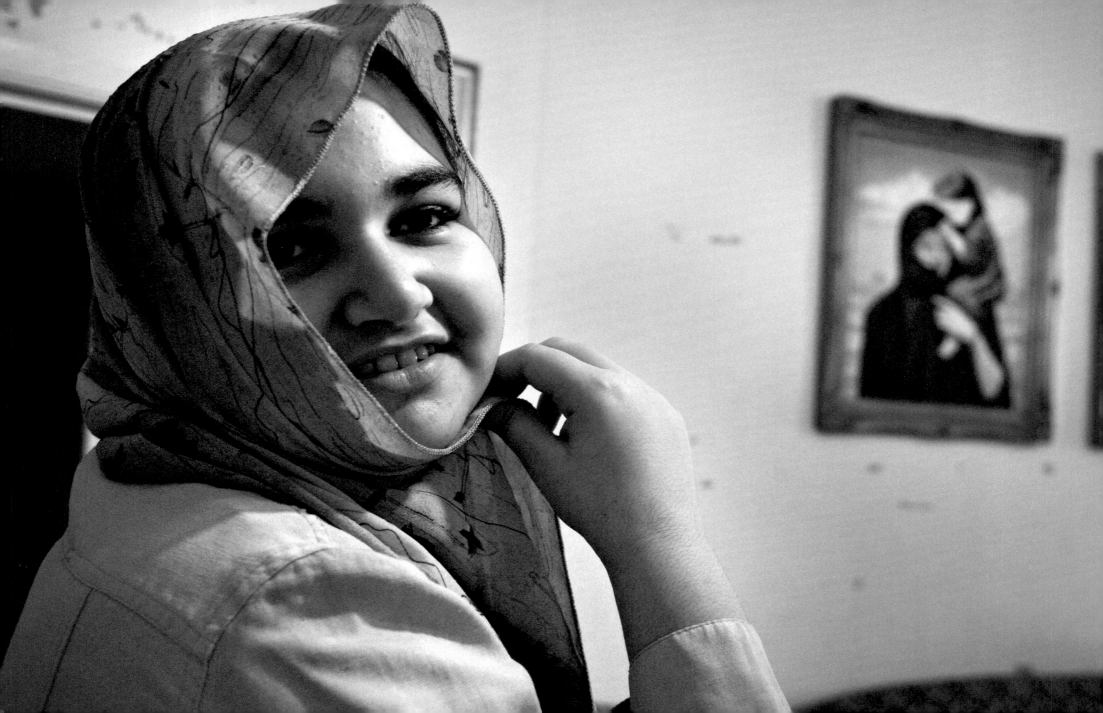

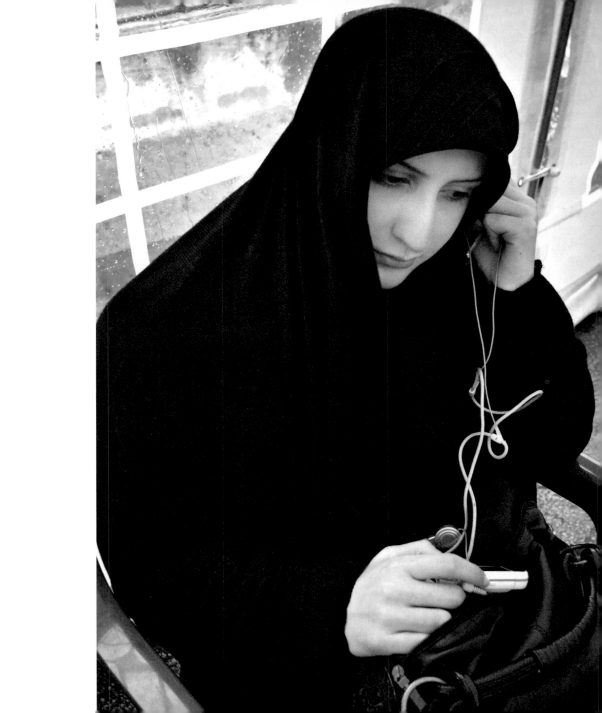

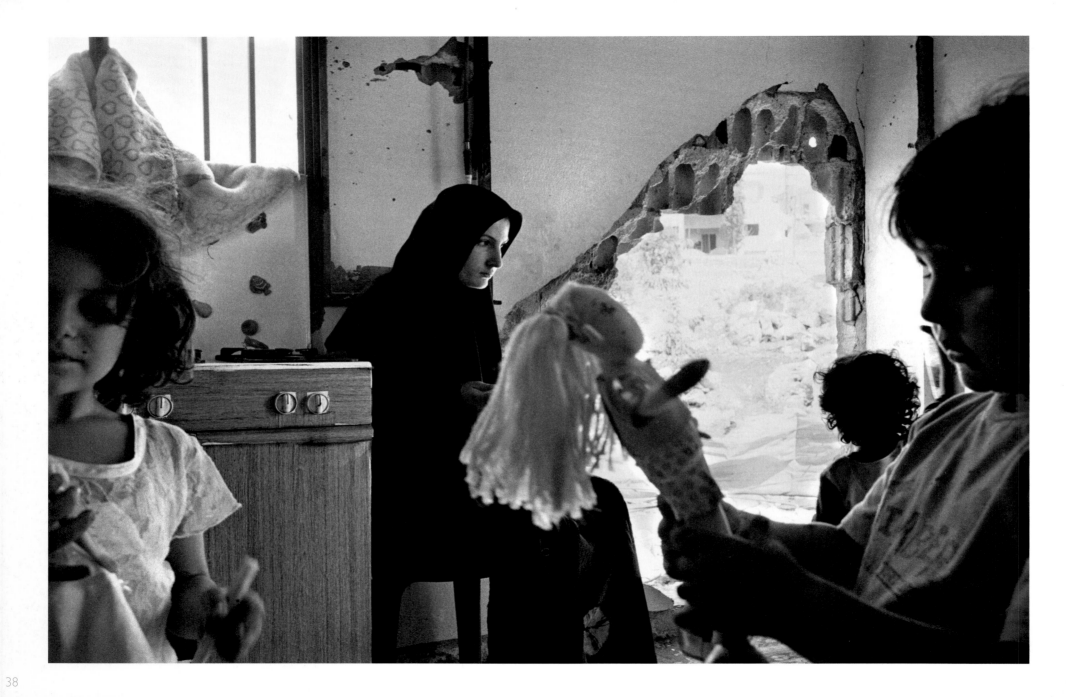

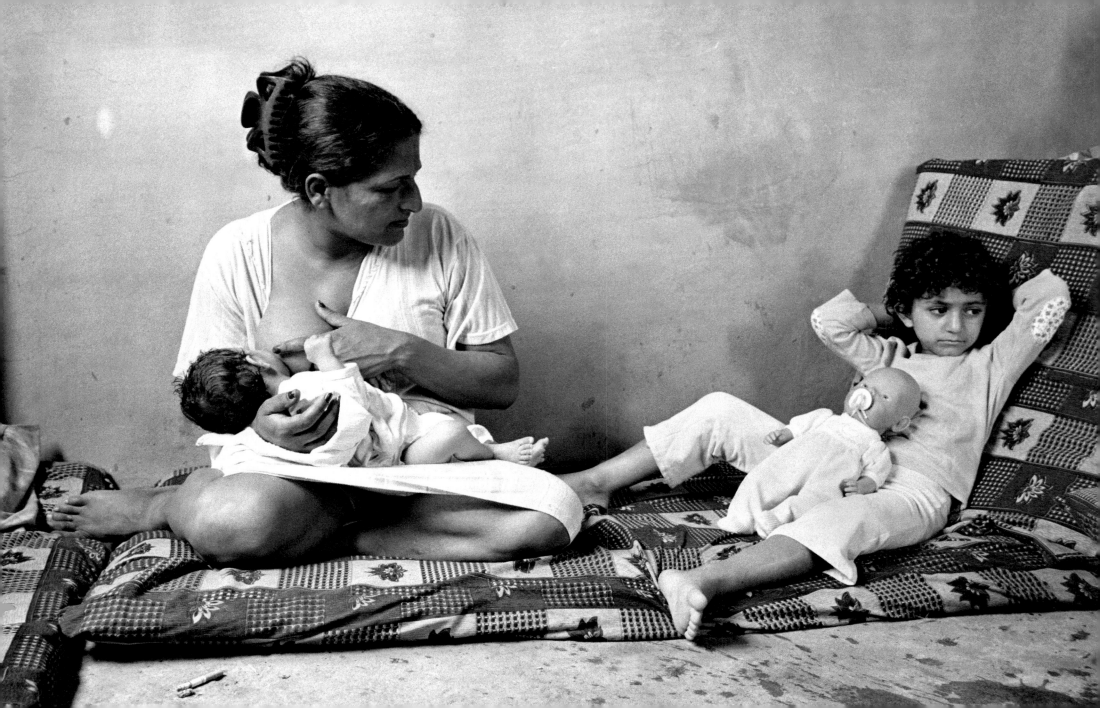

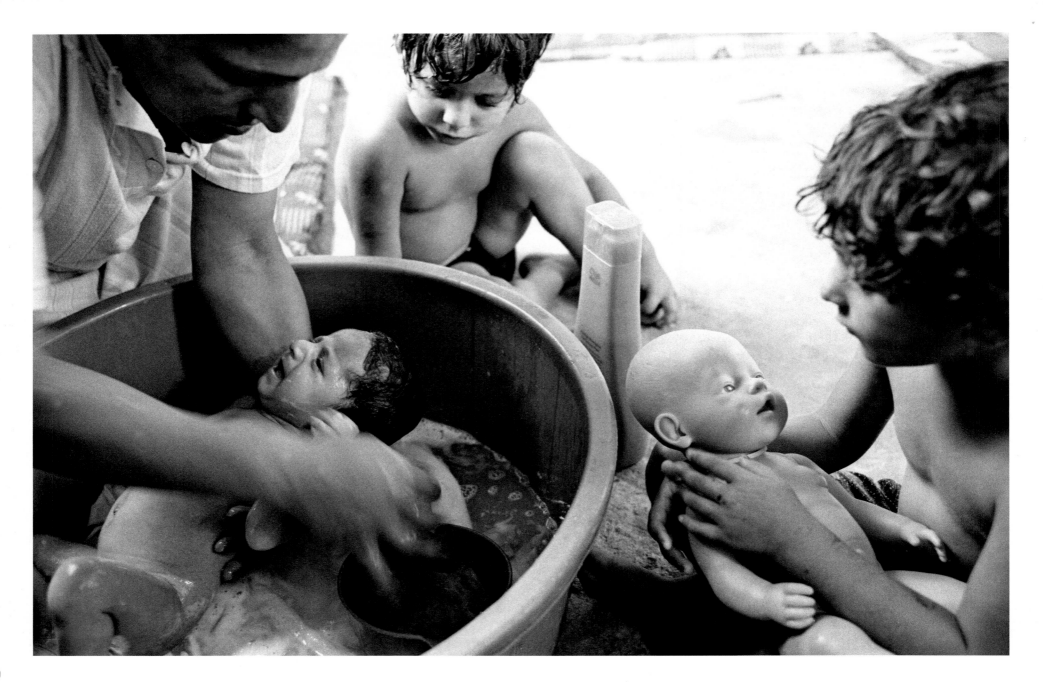

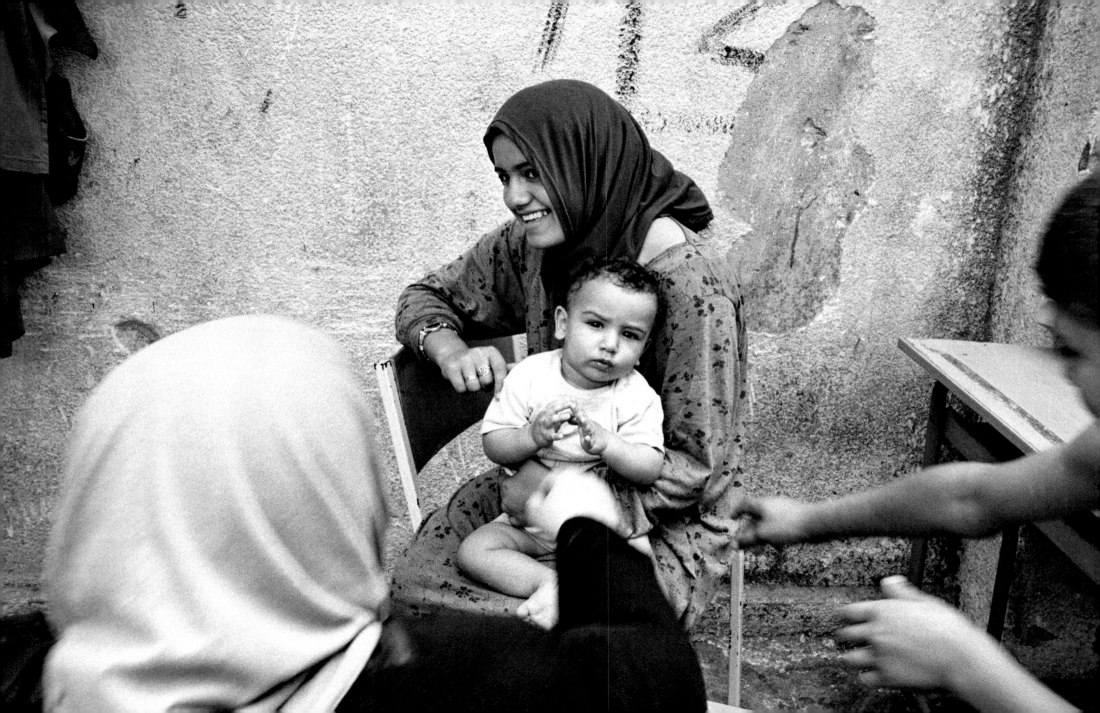

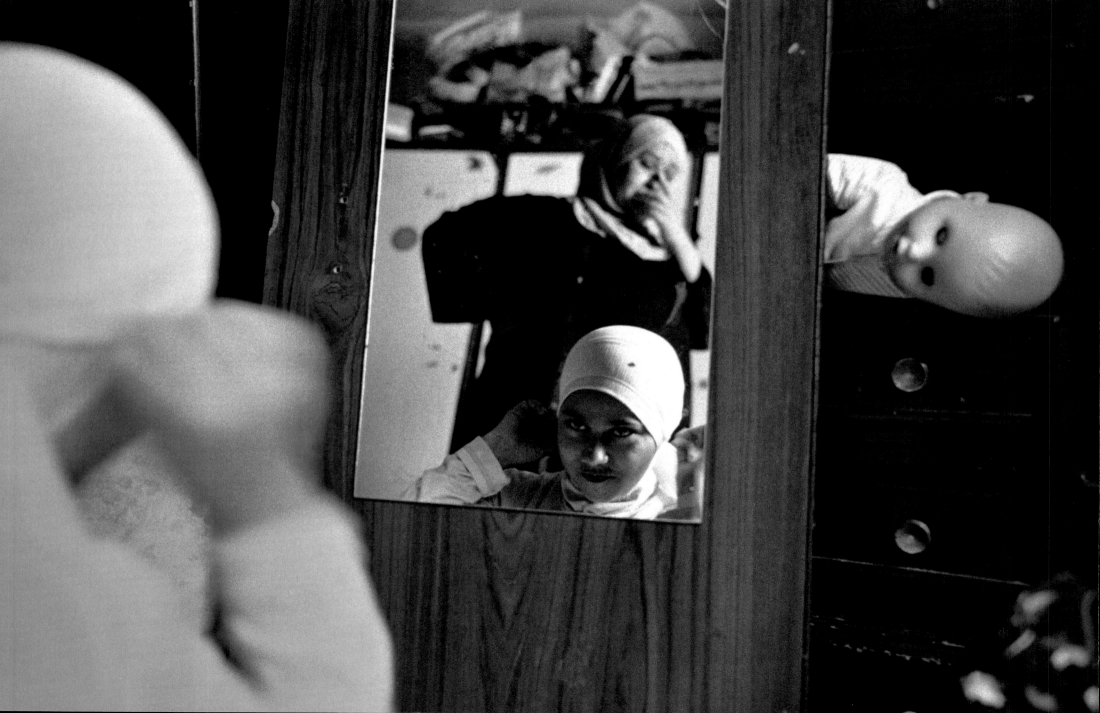

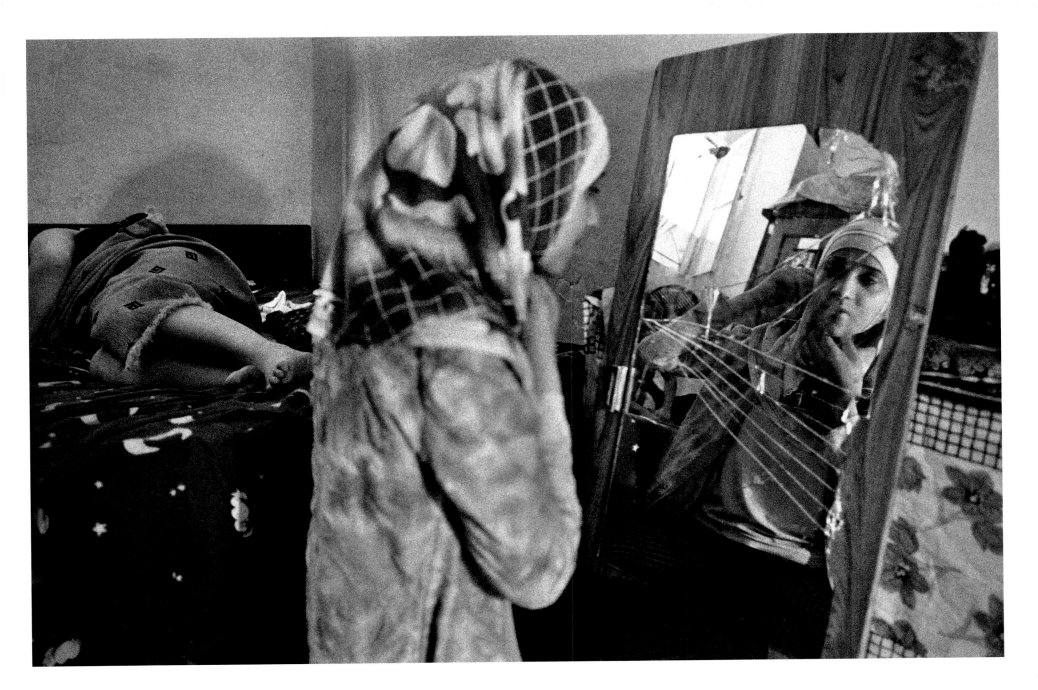

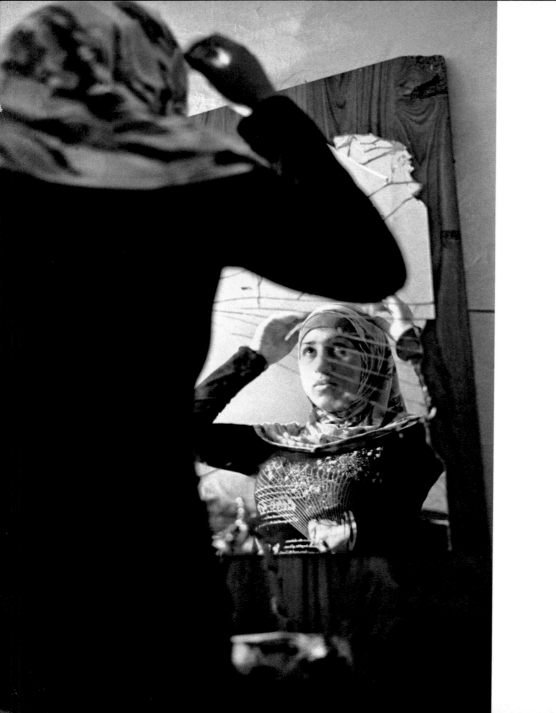

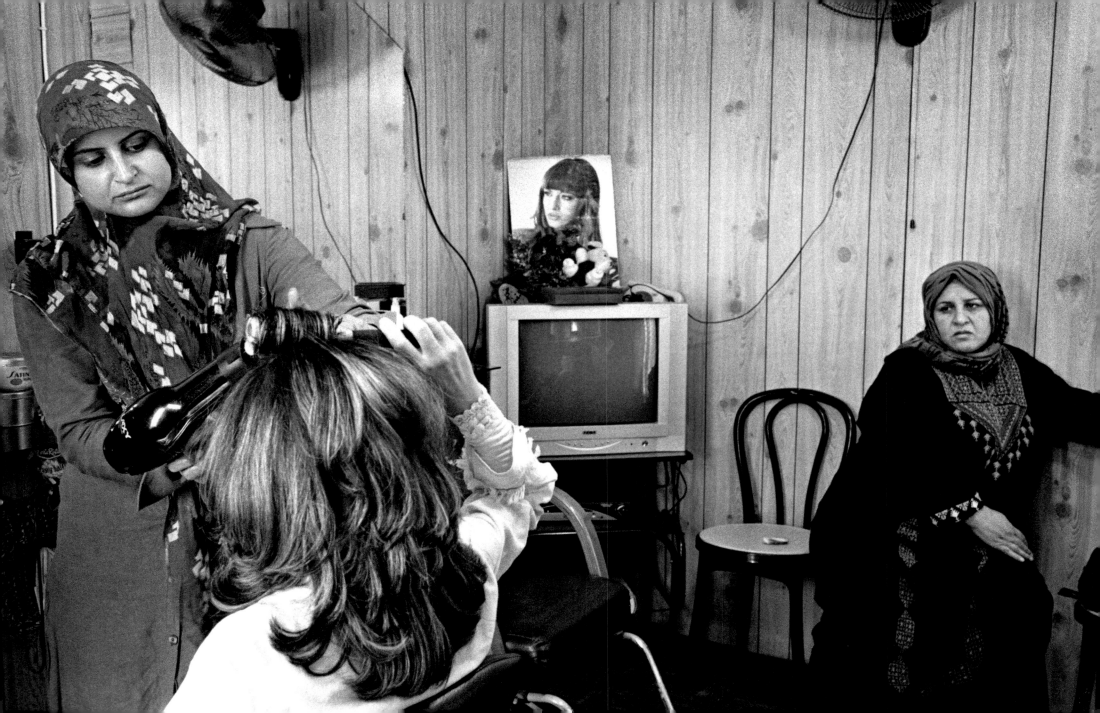

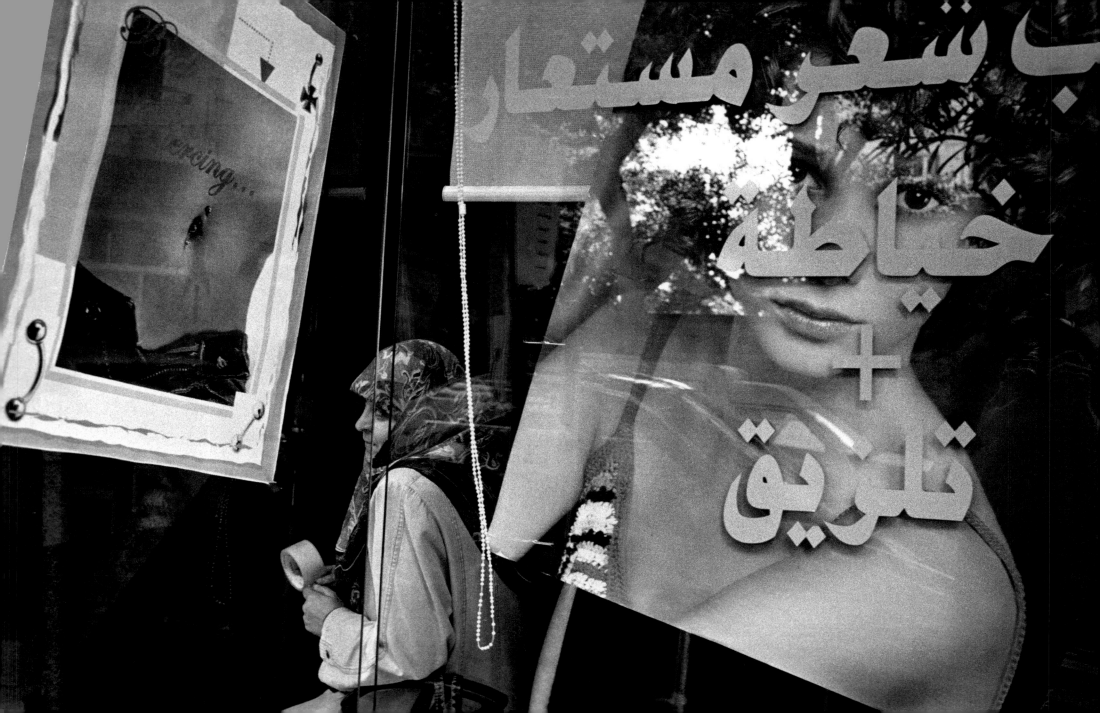

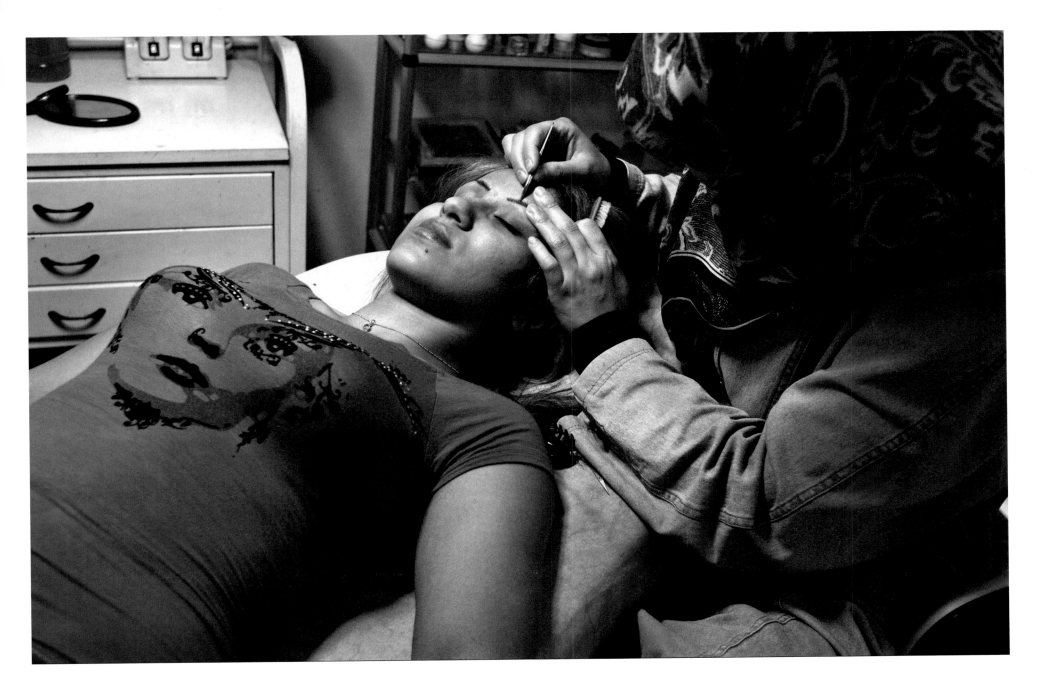

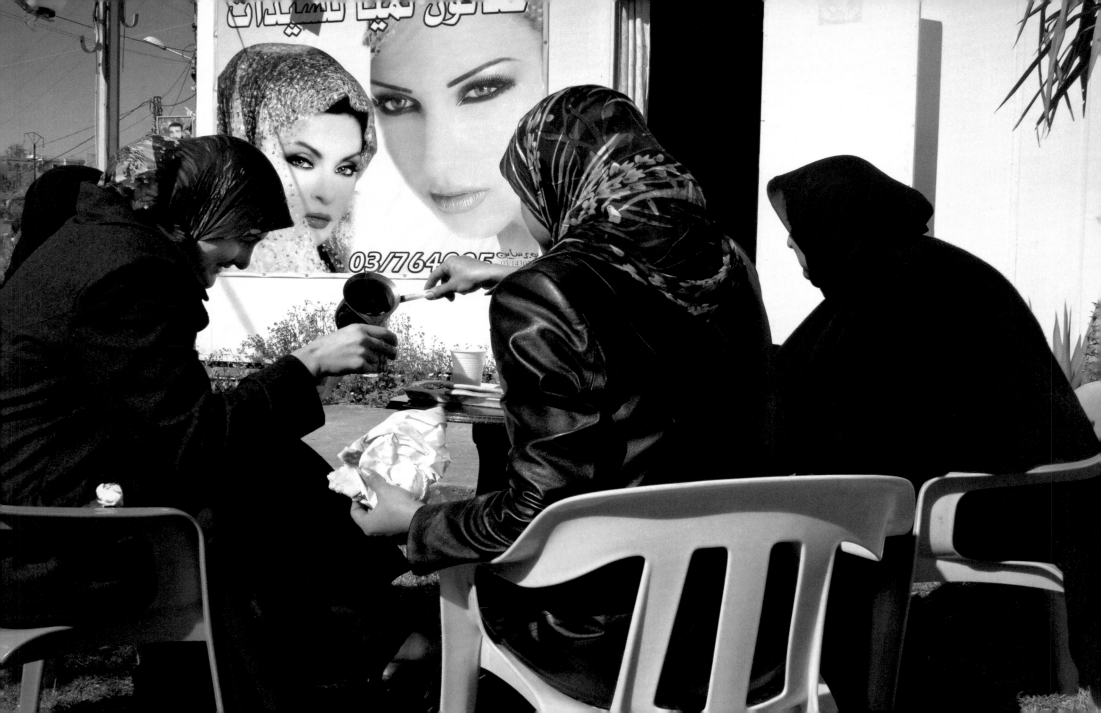

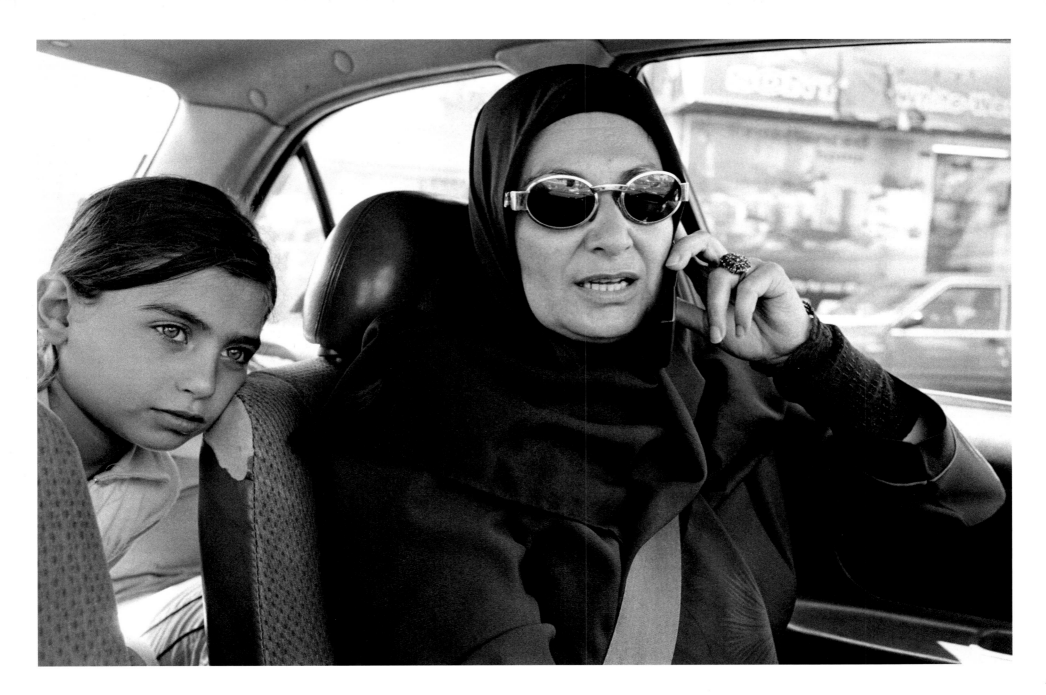

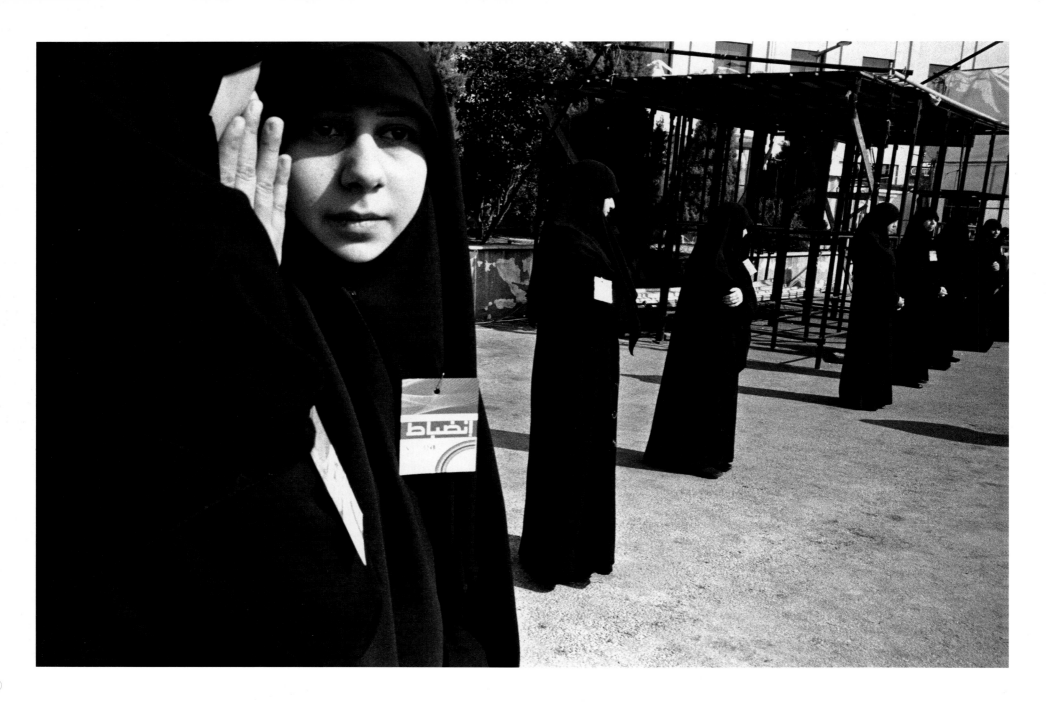

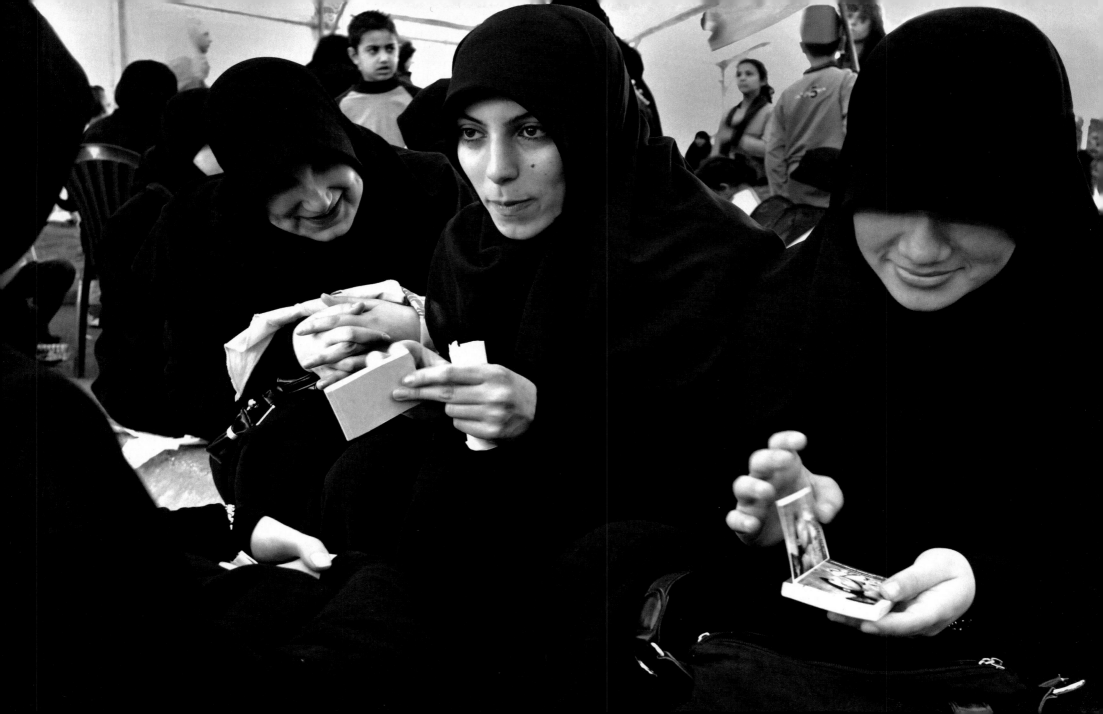

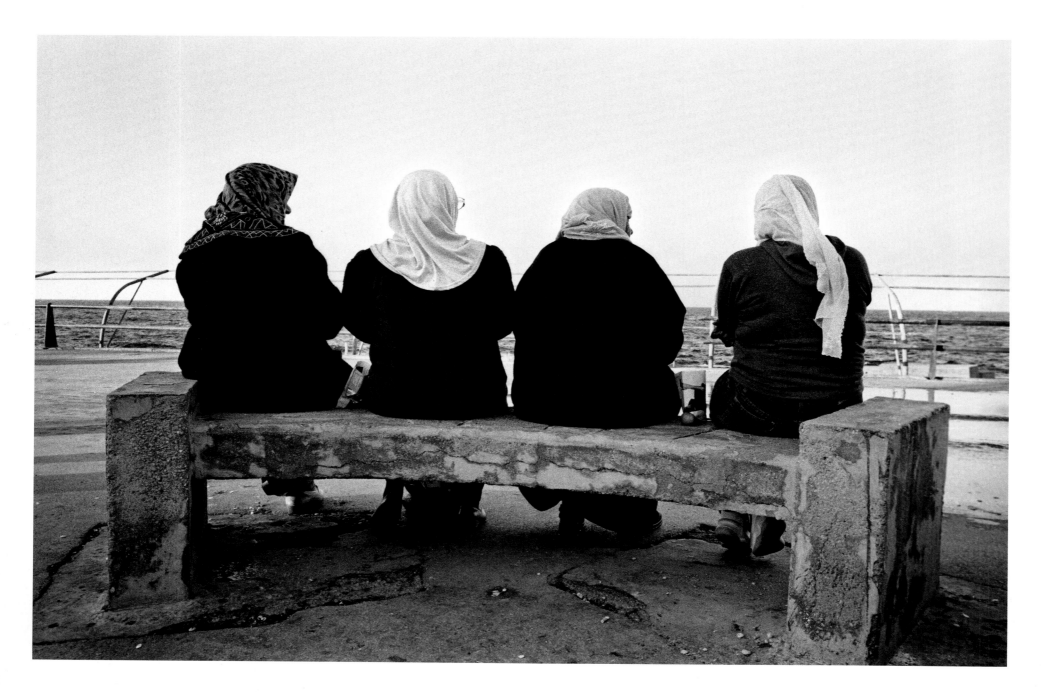

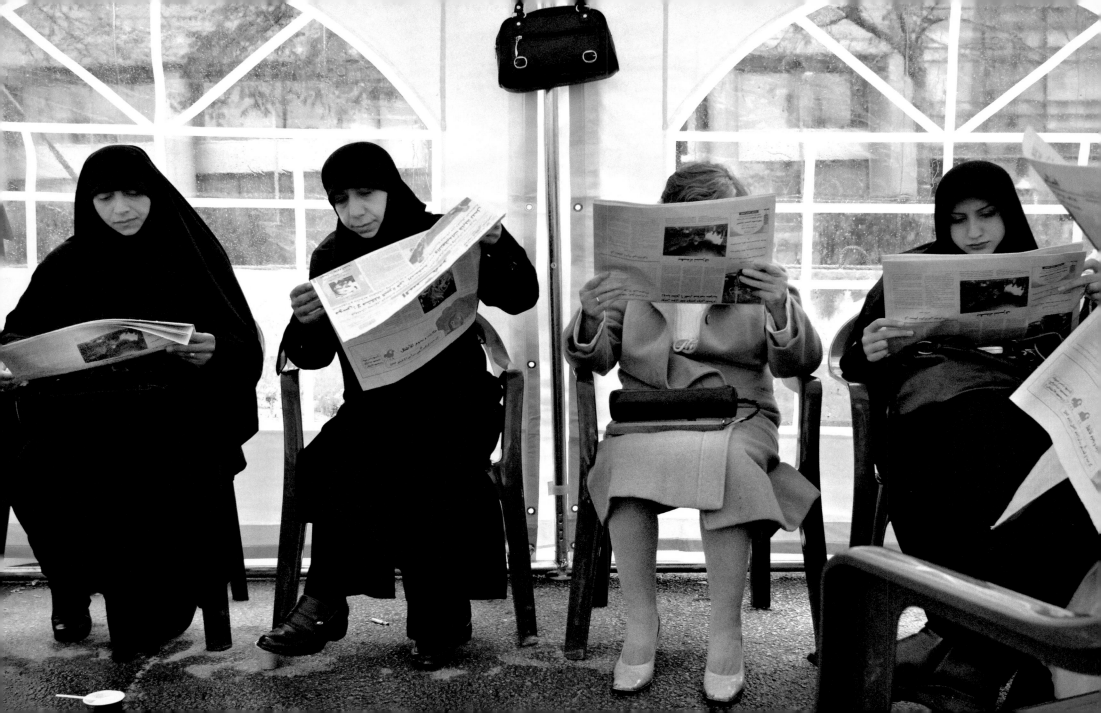

The Veil: Modesty, Fashion, Devotion or Statement?

She was nine years old and getting ready for school. After she got dressed, she laid out a few scarves of different colors and patterns on her bed, trying to pair two of them to match her jeans and shirt. A doll was hanging out of a drawer, a sweet reminder of an age she recently outgrew. She tried on scarves, layering them, braiding them, and switching colors, then repeated the same scenario all over again with a few more scarves before settling on a light blue scarf layered with a white one. I was thinking of my daughter, about the same age, who spends about the same amount of time every morning fixing her hair.

When I was growing up in Lebanon in the seventies, very few women wore the *hijab* or veil. Over the years, however, many Muslim women and girls have embraced the veil for different reasons. In Lebanon Muslim women do not have to wear the veil by law, but wearing it is rapidly becoming the decision of choice among many, young and old, modern and traditional.

Due to its location, its internal conflicts, its kaleidoscope of religions, and its politically vibrant population, Lebanon provides a microcosm of what is going on in the world today, reflecting both the growing differences and the existing interdependencies between the West and the Arab world, Christianity and Islam. While a large segment of the population is Western-oriented in its outlook, lifestyle and education, a growing segment, mostly Muslim, has its sights pointed eastward toward the rest of the Muslim world. In Lebanon these two apparent opposites coexist side by side, and their lives are intertwined on a daily basis, providing different interpretations of female beauty and fashion, and a juxtaposition of the veil and Islamic traditions with a Western dress code and lifestyle.

Muslims are increasing as a percentage of the population due to a higher birthrate. Feeling threatened in a world that sees any Islamic display of piety as suspicious, many Muslims are finding refuge in the overt symbols of Islam, and comfort in belonging to the worldwide Muslim community. The veil, almost nonexistent a few years ago in Lebanon, is making a comeback, even among younger generations and some women with a Western education. It has different undertones—from religious devotion, to self-assertion vis-à-vis the West, to a fashion accessory—all leading to an underlying social pressure among Muslim women of all ages to wear it. Some women described actually feeling liberated and at peace when they wore the *hijab*.

—R.M.

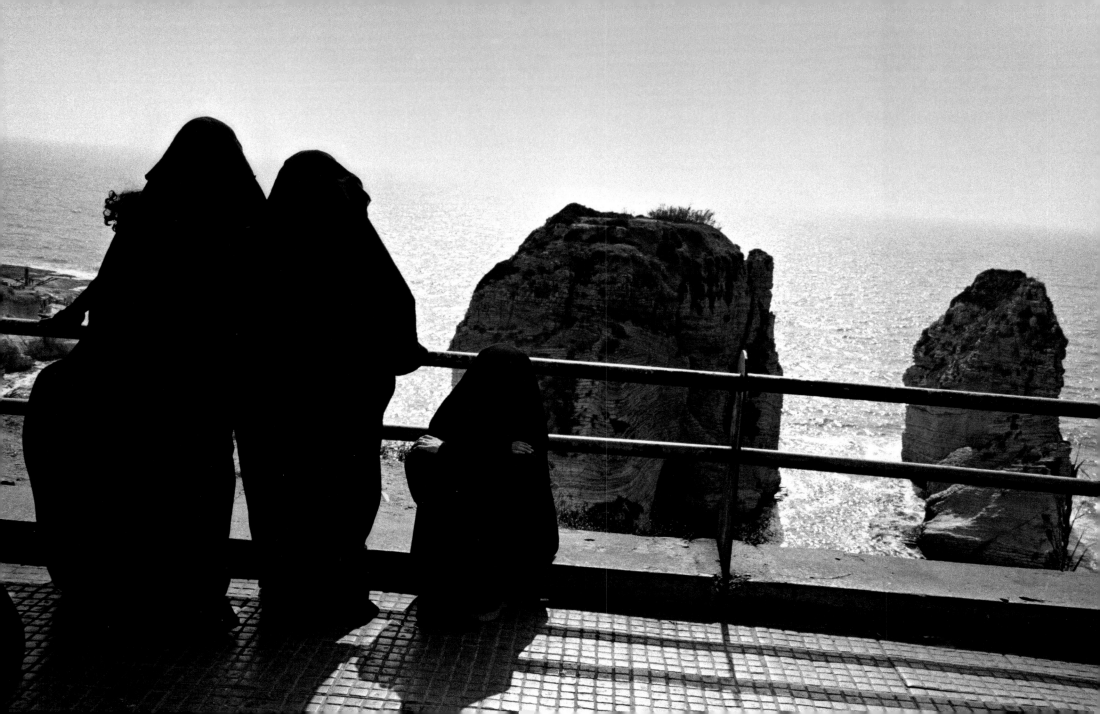

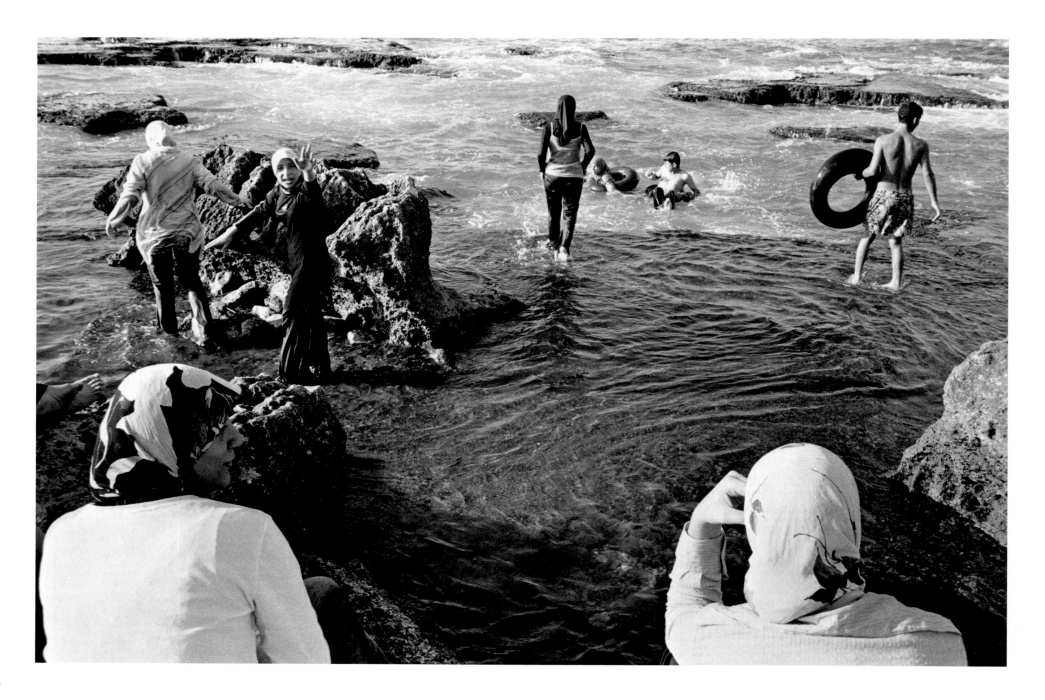

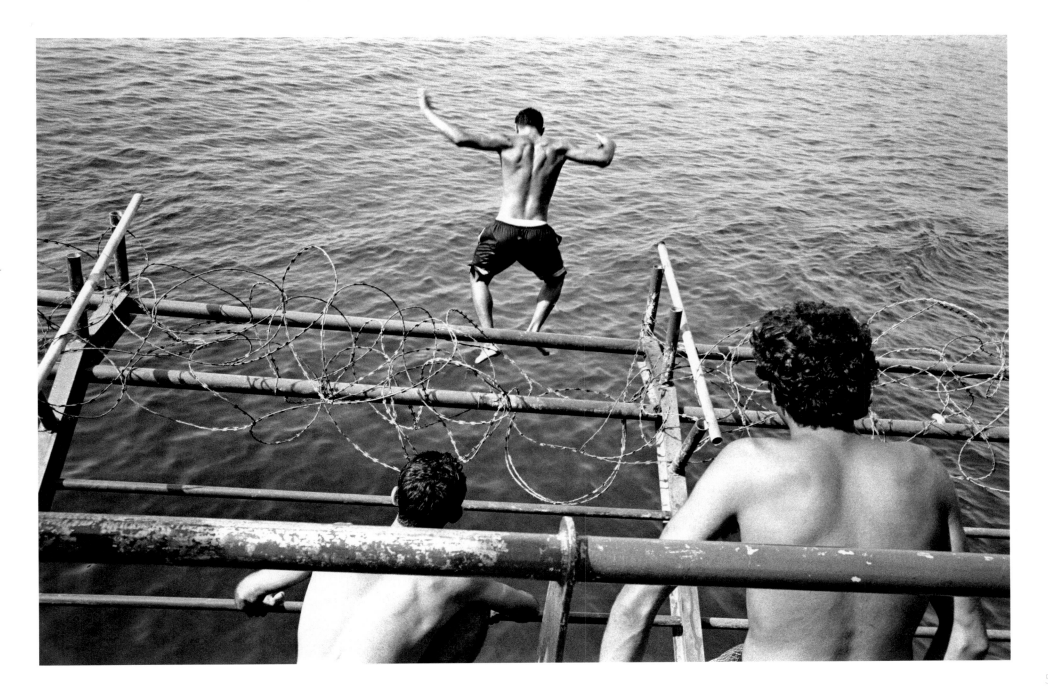

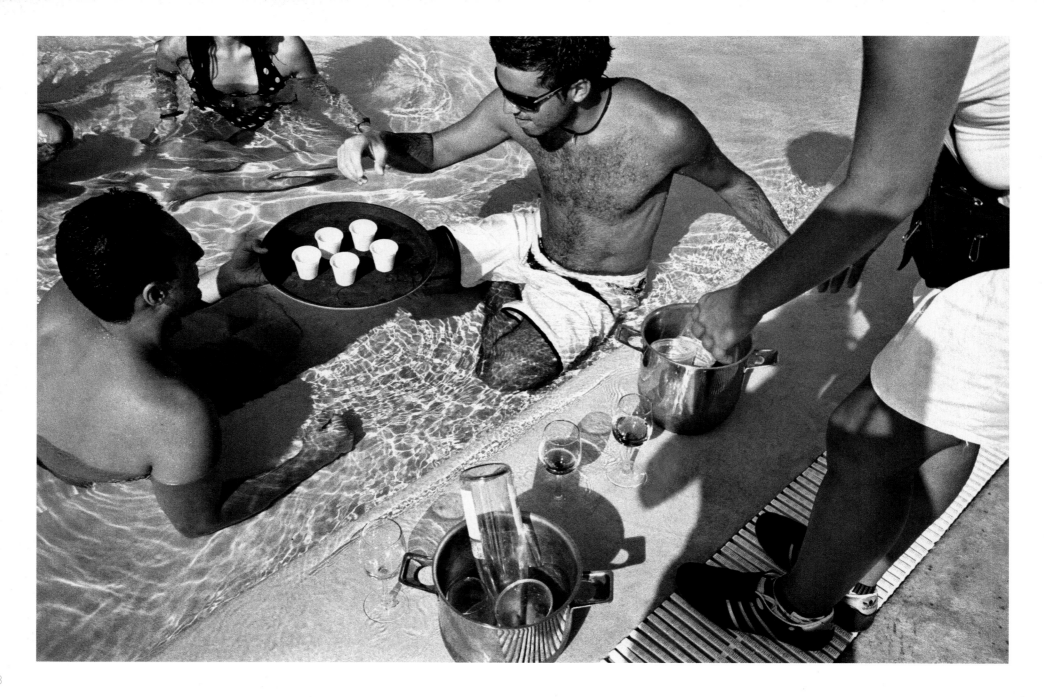

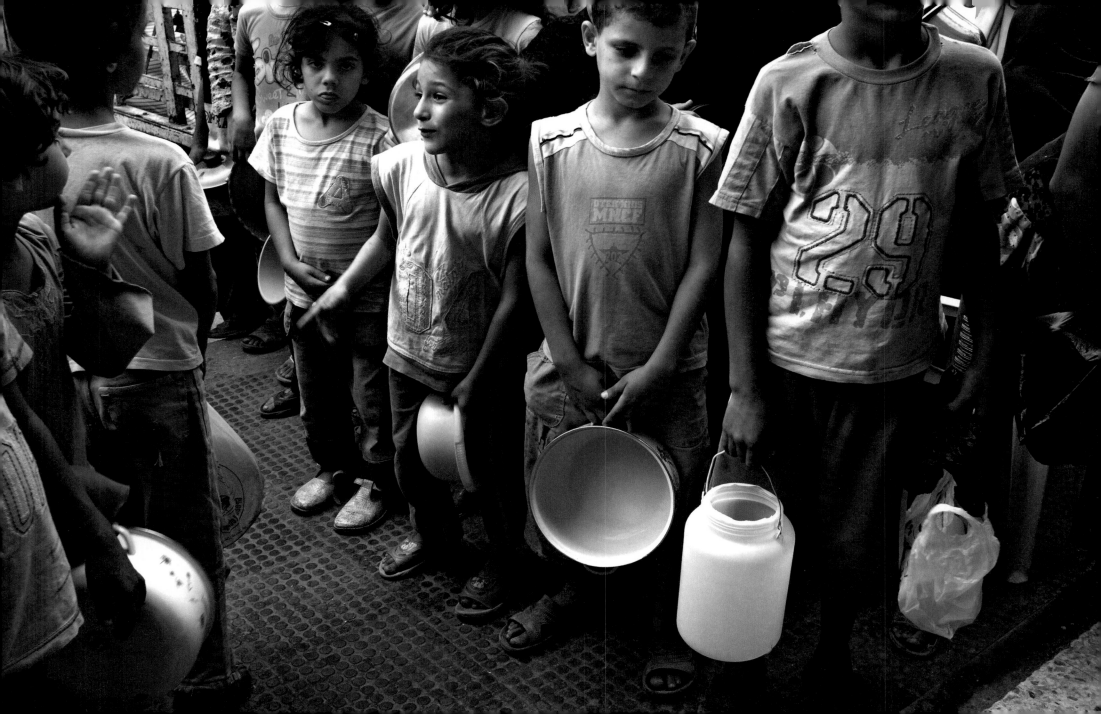

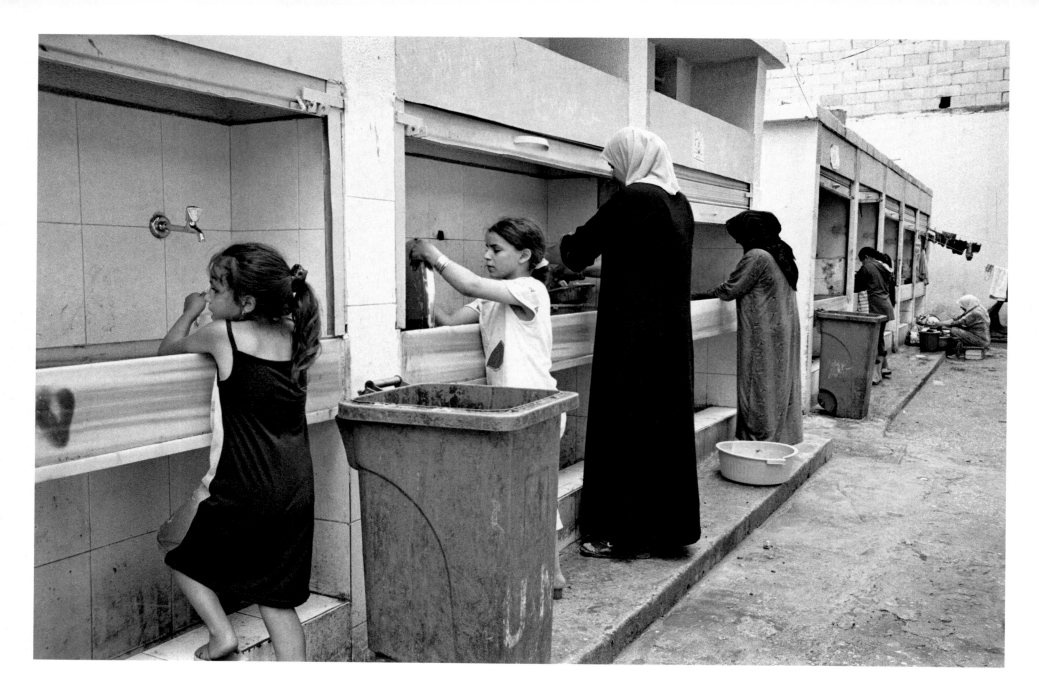

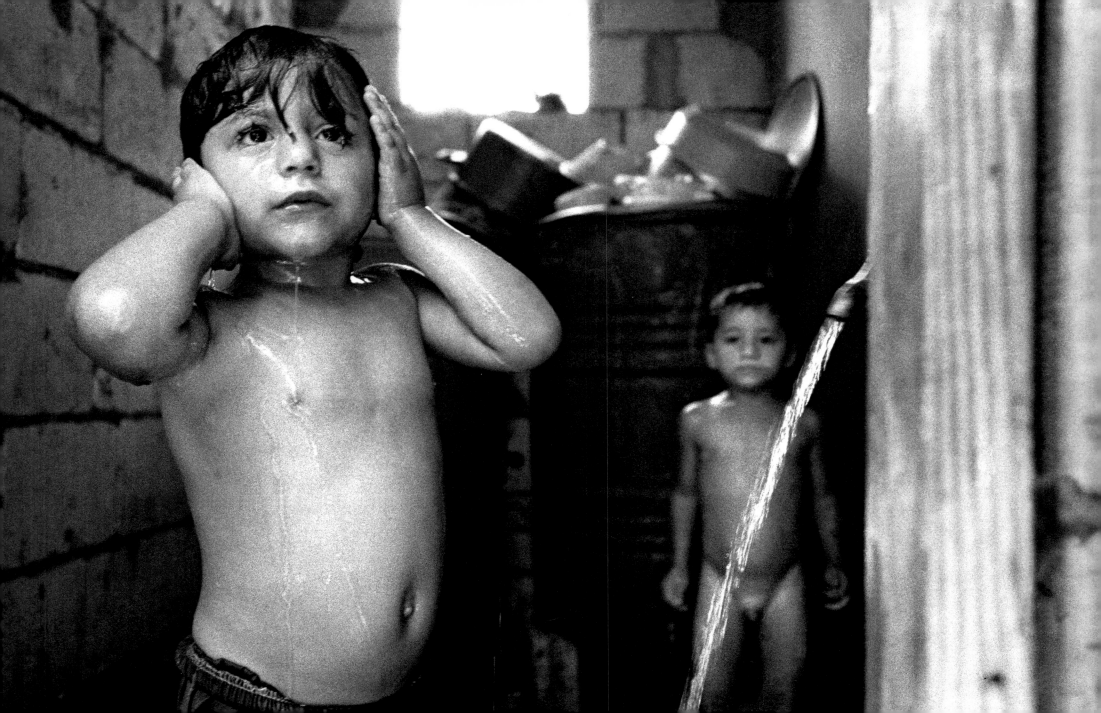

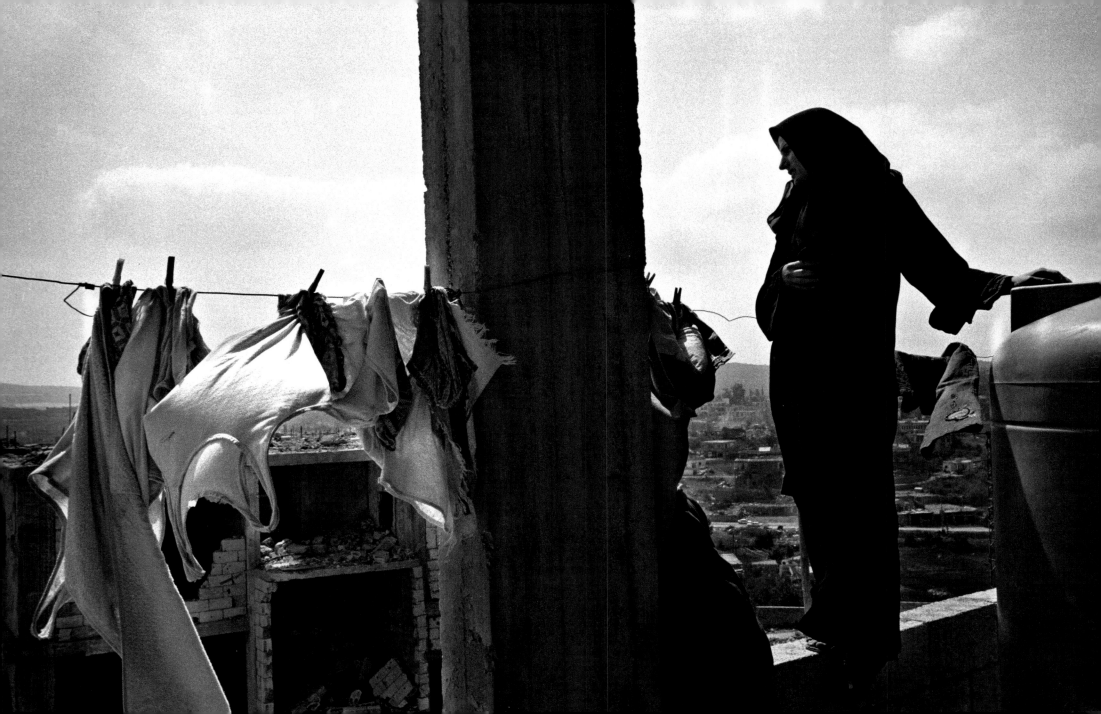

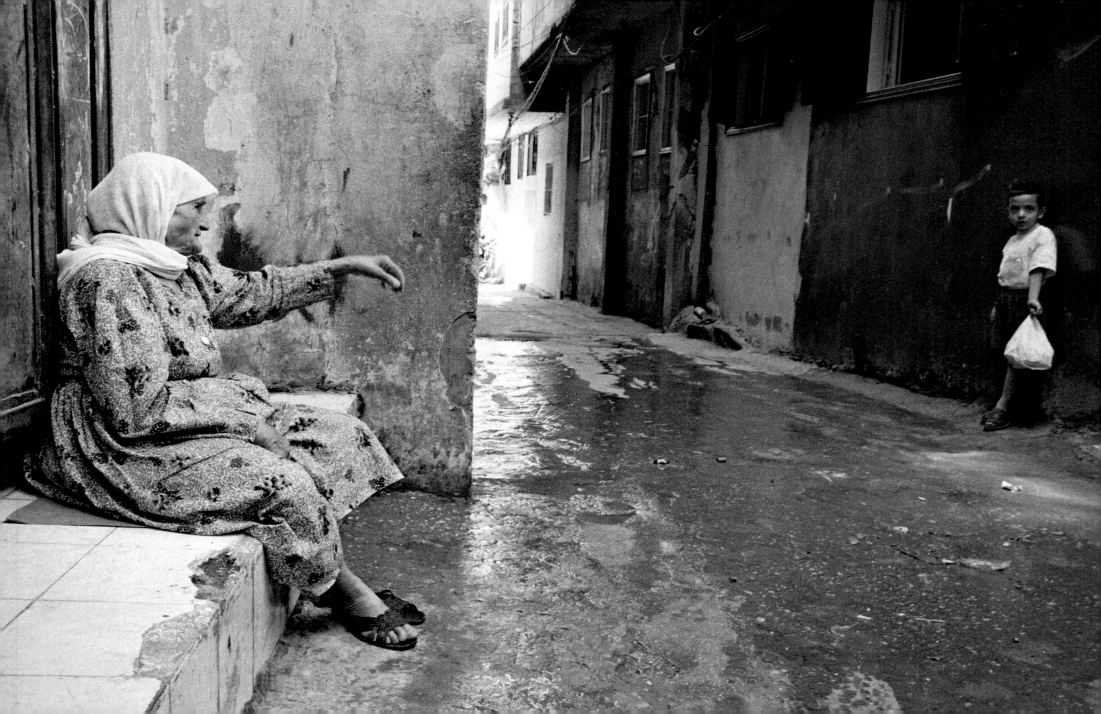

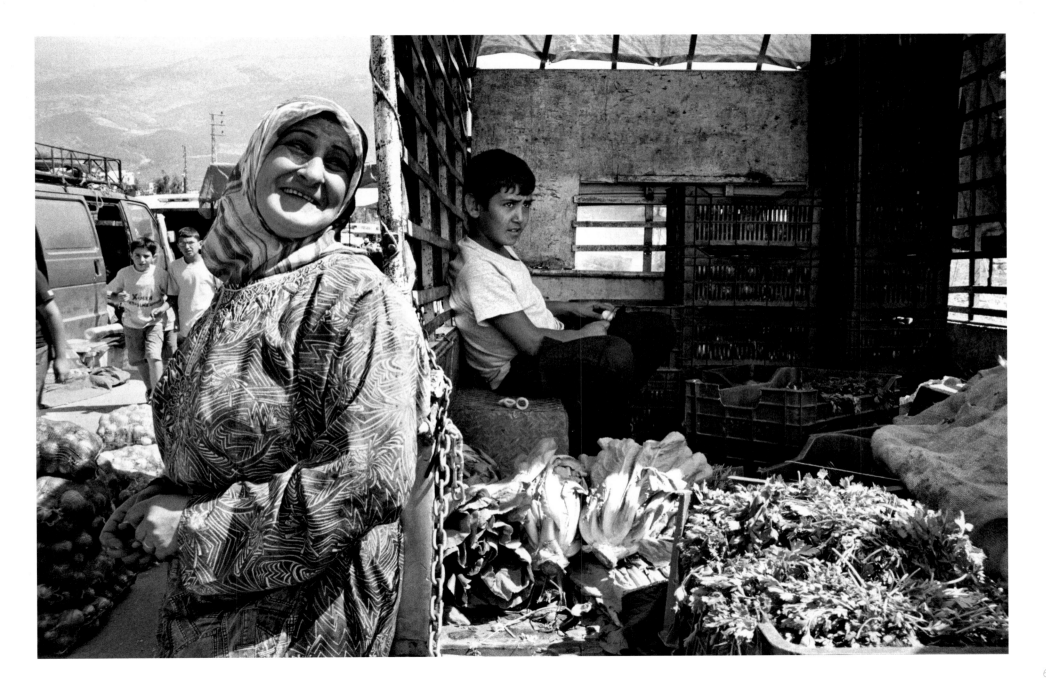

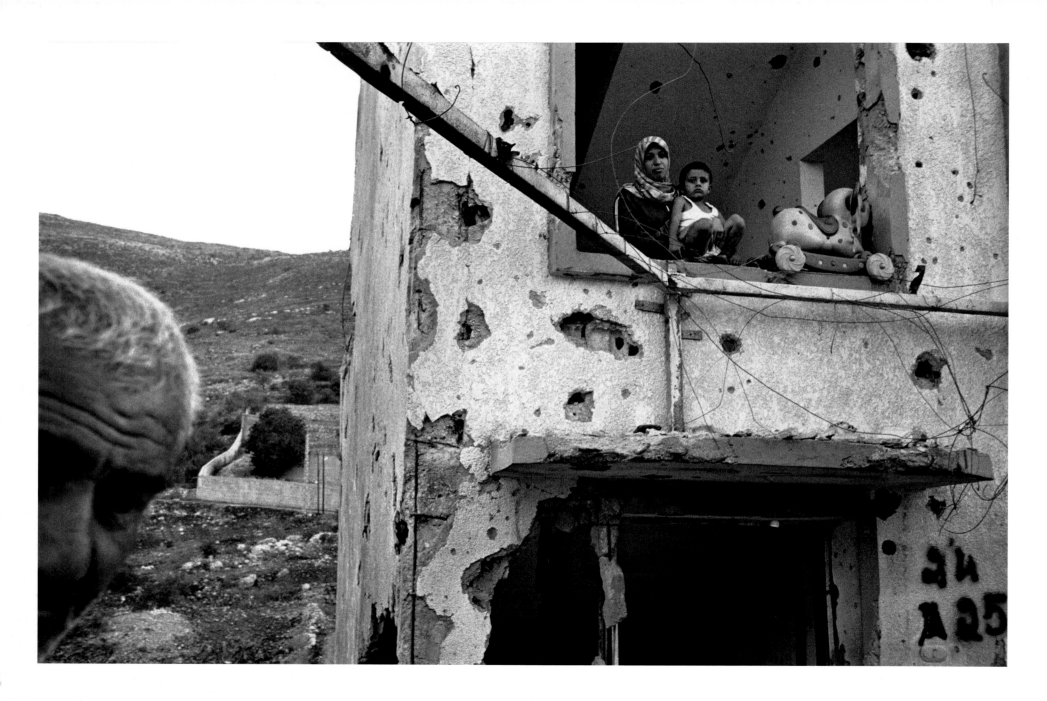

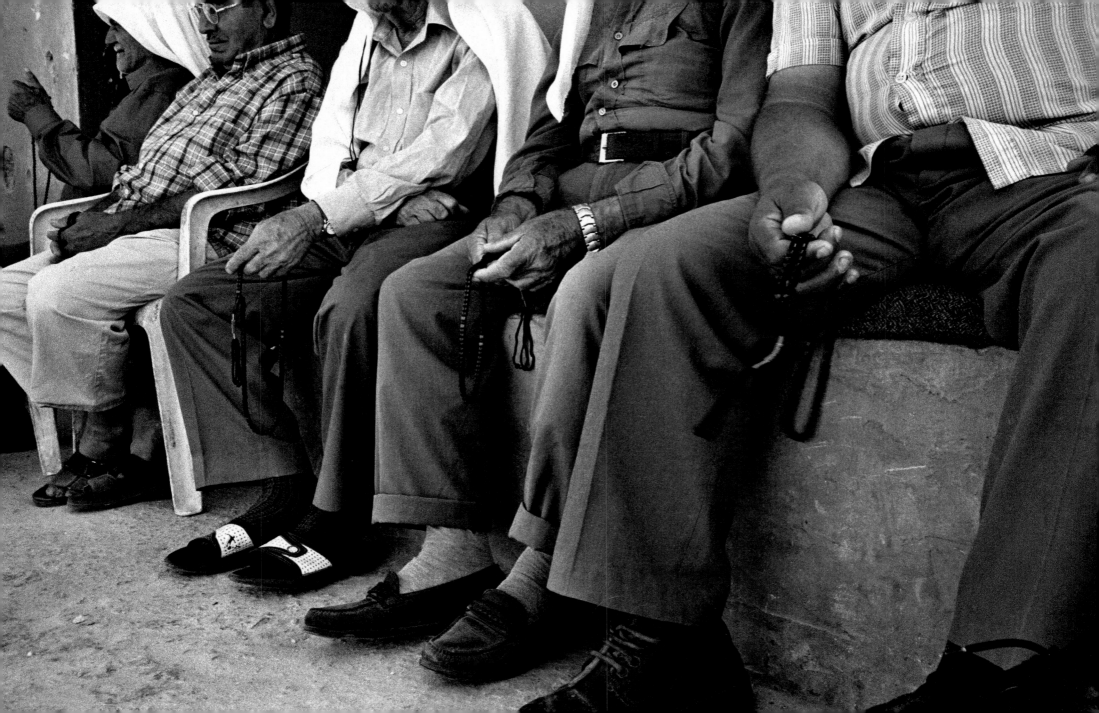

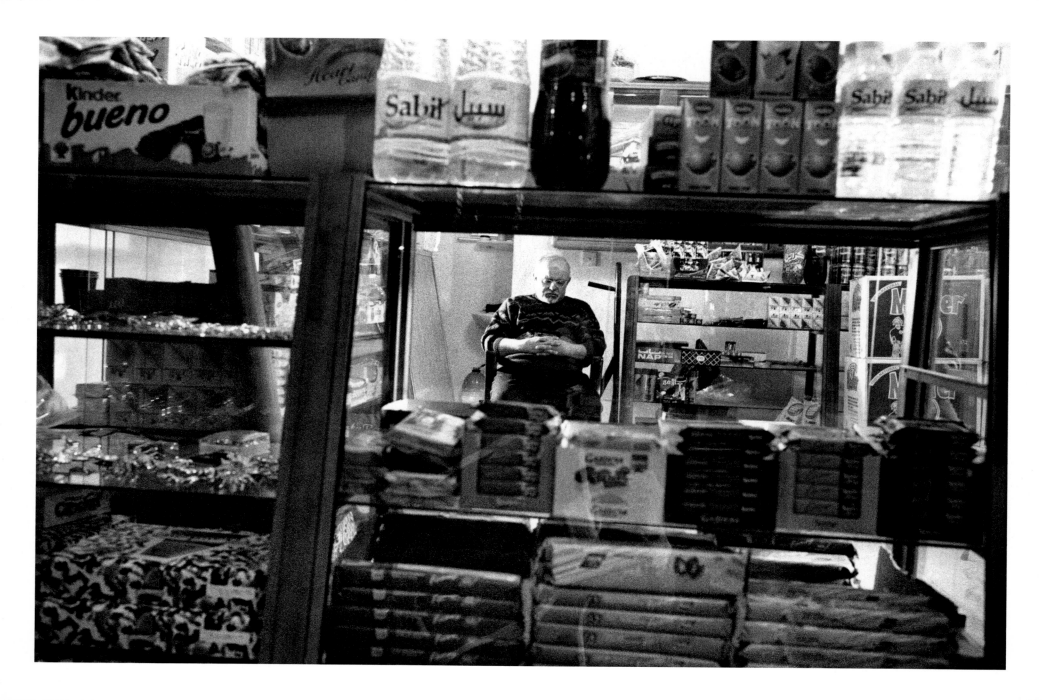

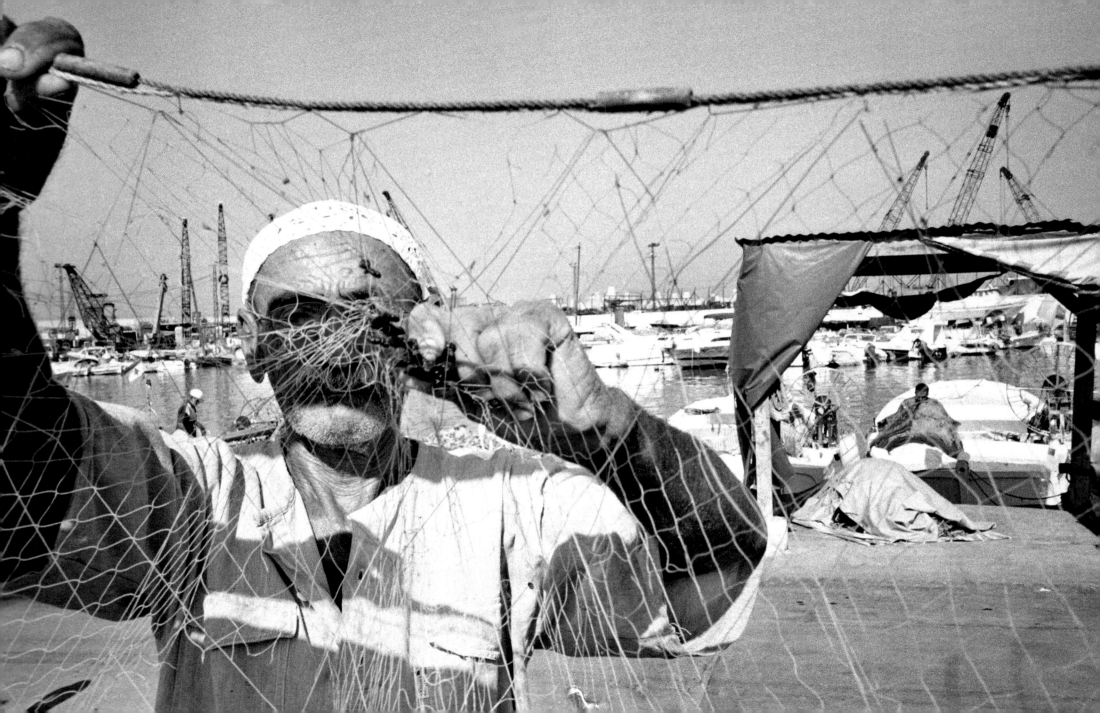

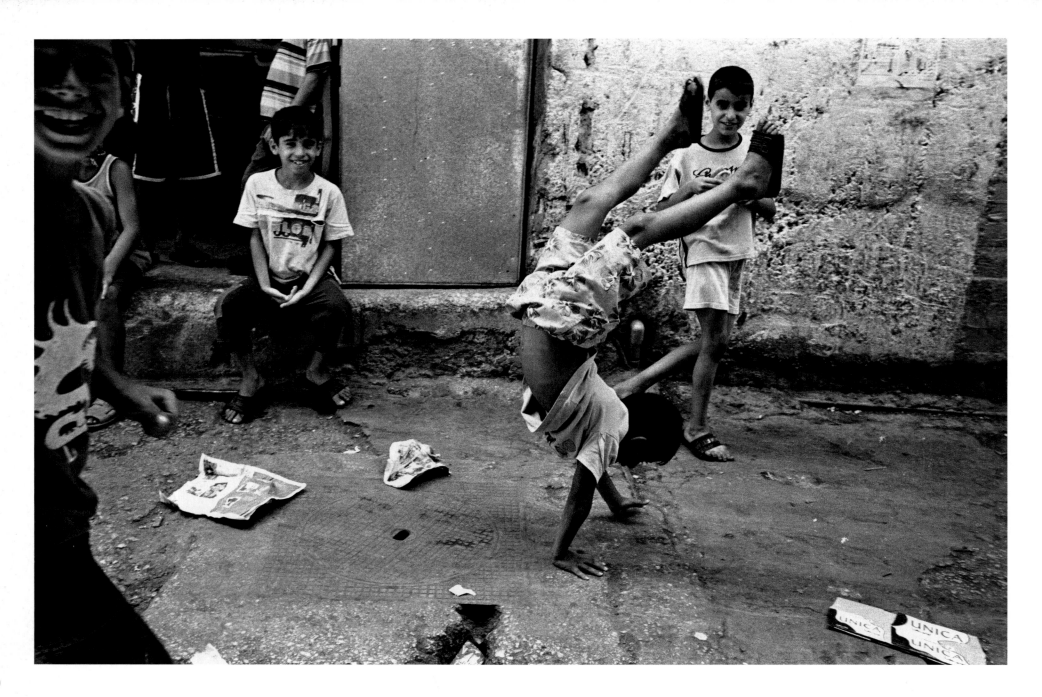

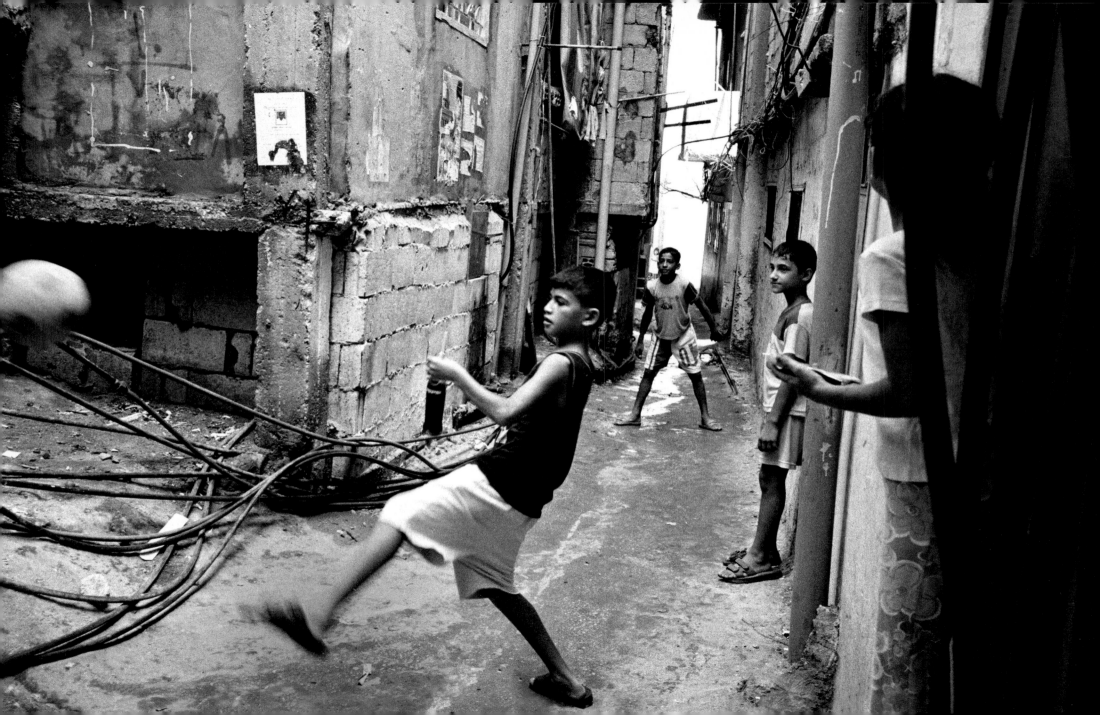

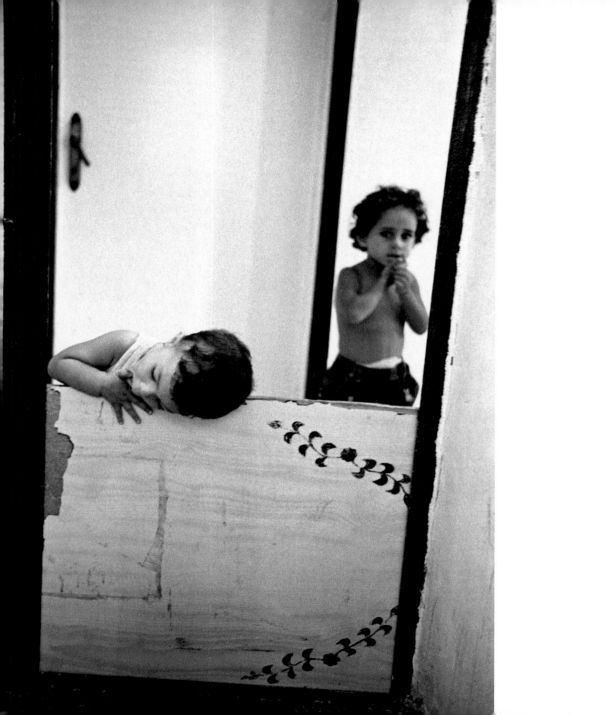

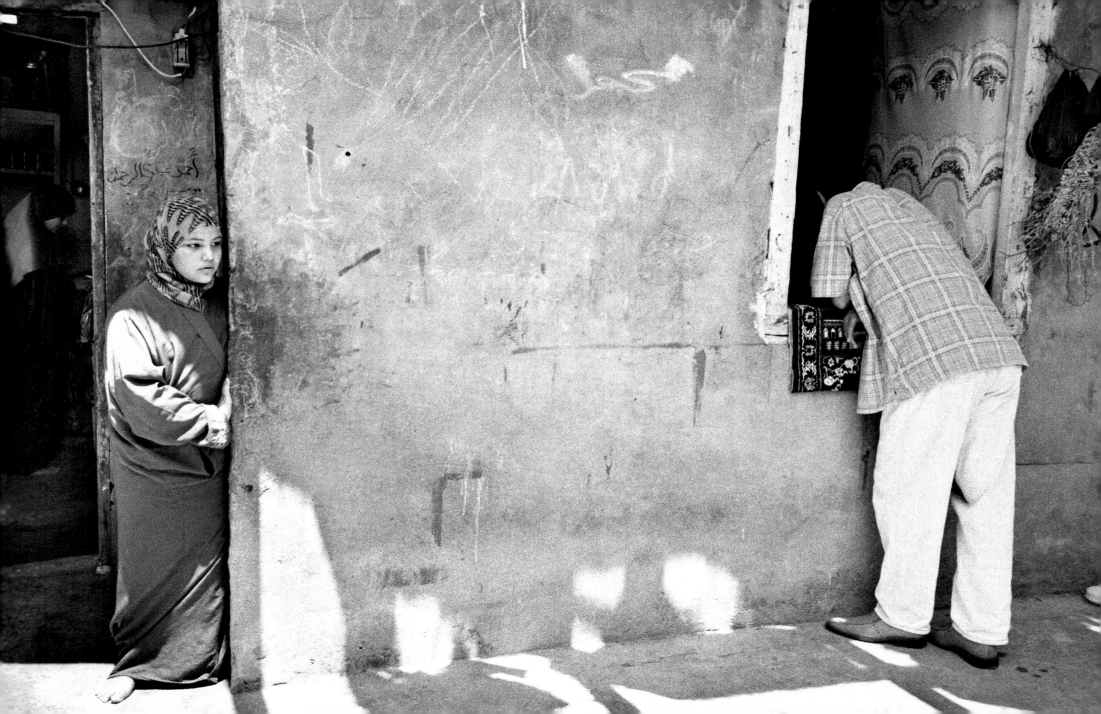

Reasons

because wind soughs in the branches of trees
like blood sighing through veins

because in each country there are songs
huddled like wet-feathered birds

because our bodies are soft and easily harmed
and destruction is a way of dying, not living

because we are so utterly human
and so prone to grief

because even though the news has nothing new to say
and keeps on saying it
NO still fights its way into the world

because although we have forgotten where our hearts are hidden
the children remember
and would tell us if we would only ask

because for every bomb that is readied
a baby nestles into her mother
latches onto a nipple beaded with milk

because the tulips have waited all winter
in the cold dark earth

because each morning the wildflowers outside my window
raise their yellow faces to the sun

because we are all, each one of us,
in love with the light

Lisa Suhair Majaj

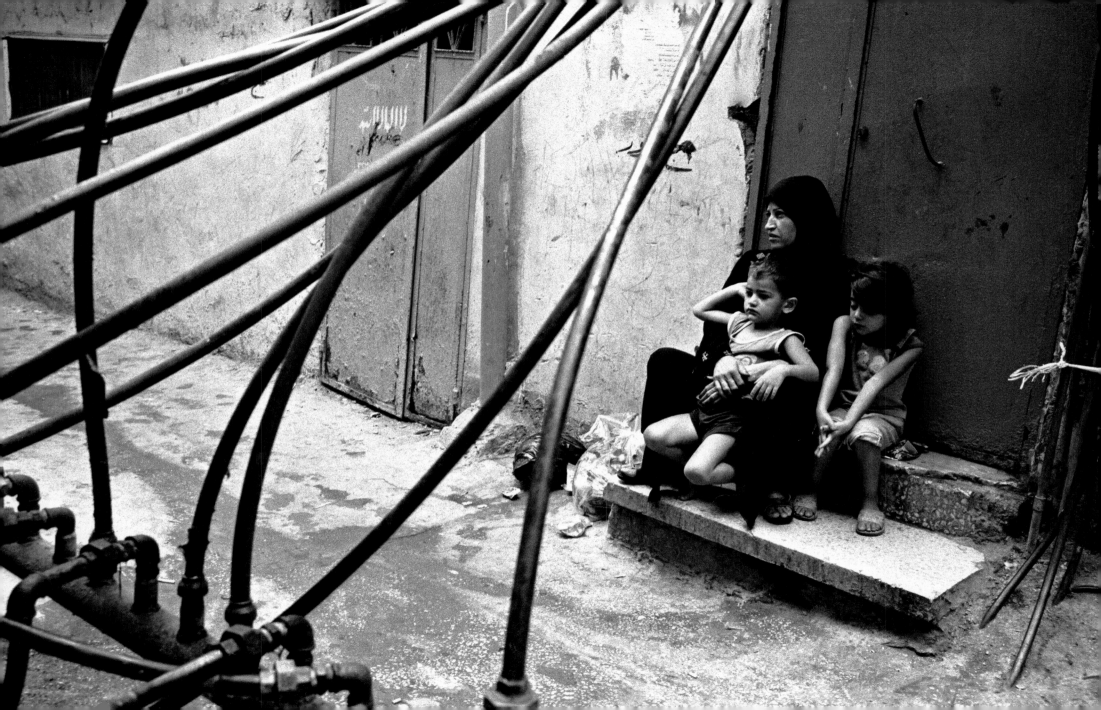

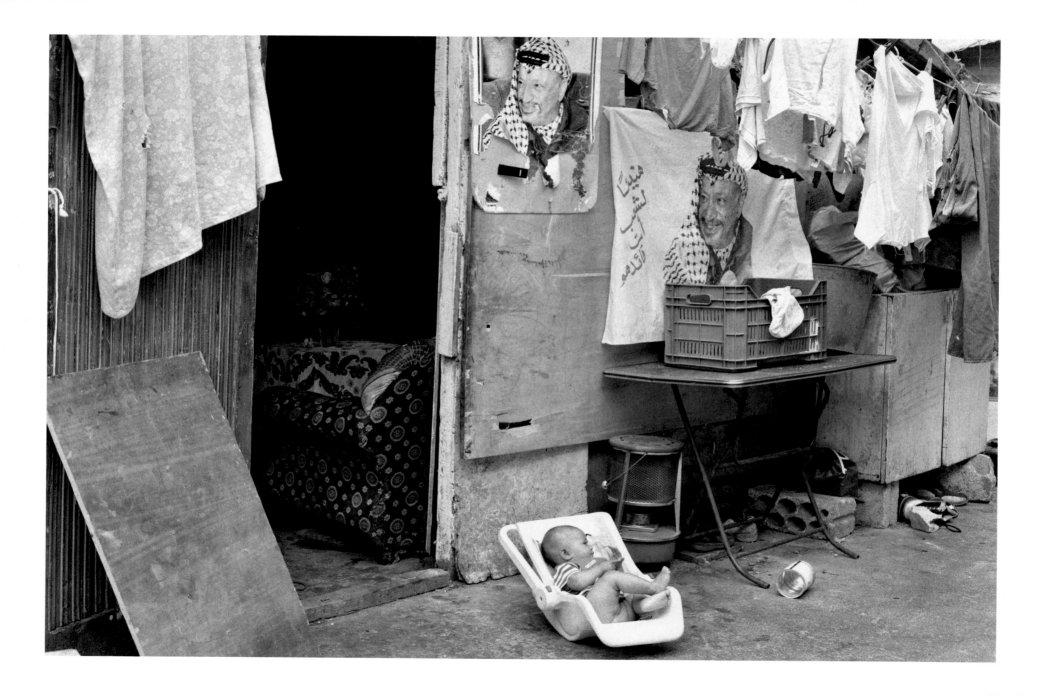

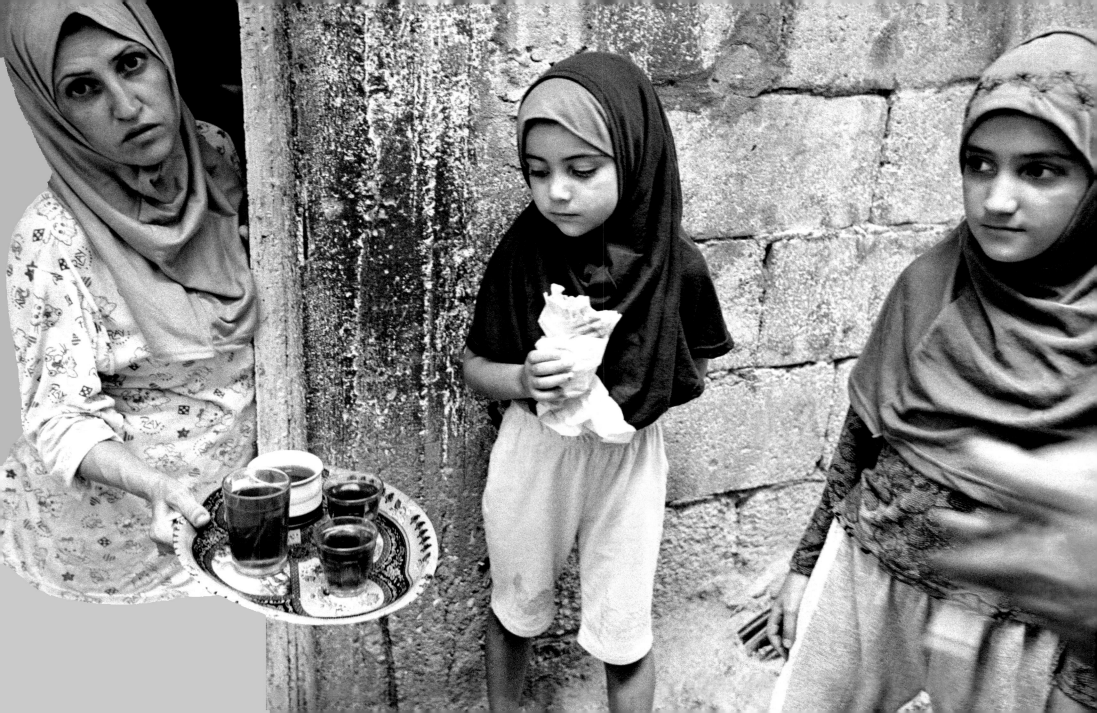

Forgotten People

The boy is about my son's age. He also loves soccer. He plays it in the alley with his friends, oblivious to the water pipes entangling the whole length of the alley, oblivious to the narrowness of the field, the lack of grass, the lack of light, and the constant interruptions of people walking by, oblivious to the fact that he isn't wearing fancy cleats, but just old plastic slippers. He is holding his Coke in one hand, kicking the ball, and having fun.

An older couple is sitting in another alley, in another camp, the man wearing nice shiny shoes and a neatly ironed shirt, the woman more casual with worry beads in her hand. She is sitting on the stone step to her house, facing him across a narrow alley. A young girl walks between them light and transparent as a ghost. She still has hopes of flying and fleeing, while the old couple is anchored down by years in the camp. In a few years, she will probably be anchored too.

Having grown up during the Lebanese civil war, many areas were off-limits to me as a child. Years later, I discovered places I had previously only heard of on the news, such as Shatila, a Palestinian refugee camp, less than a ten-minute drive from the house I grew up in. I was shocked by the conditions people were made to live in so close to Beirut proper, and for the next few years I photographed the numerous refugee camps around the country, gradually gaining better and more intimate access. These photographs intend to portray the humanity of this refugee population, to document moments in their lives, show their everyday situations—playing, working, talking—and put a face on a long-forgotten people in search of a home.

There are an estimated 360,000 Palestinian refugees who live in deplorable conditions in twelve refugee camps scattered around Lebanon. Their "temporary" status as refugees has become permanent after more than sixty years as third and fourth generations are born and raised in the camps. The camps are not integrated into Lebanese social or economic life. Lebanon, healing itself from a brutal civil war and fearful of upsetting its delicate sectarian balance, is afraid of granting Palestinian refugees rights that might seem to bring them closer to naturalization. As a result, they are excluded from most professions, and have to depend on the United Nations Relief and Works Agency (UNRWA) and the local NGOs for education, health, and basic human services. With a population increasing in the camps due to high birth rates and external funding dropping, conditions have worsened in recent years.

Despite such a gloomy picture, I found inspiration in the warmth and hospitality of people struggling to keep their roots and culture alive, and in their incredible capacity to adapt to their circumstances and to make the best of the little the camps offer them, generation after generation.

—R.M.

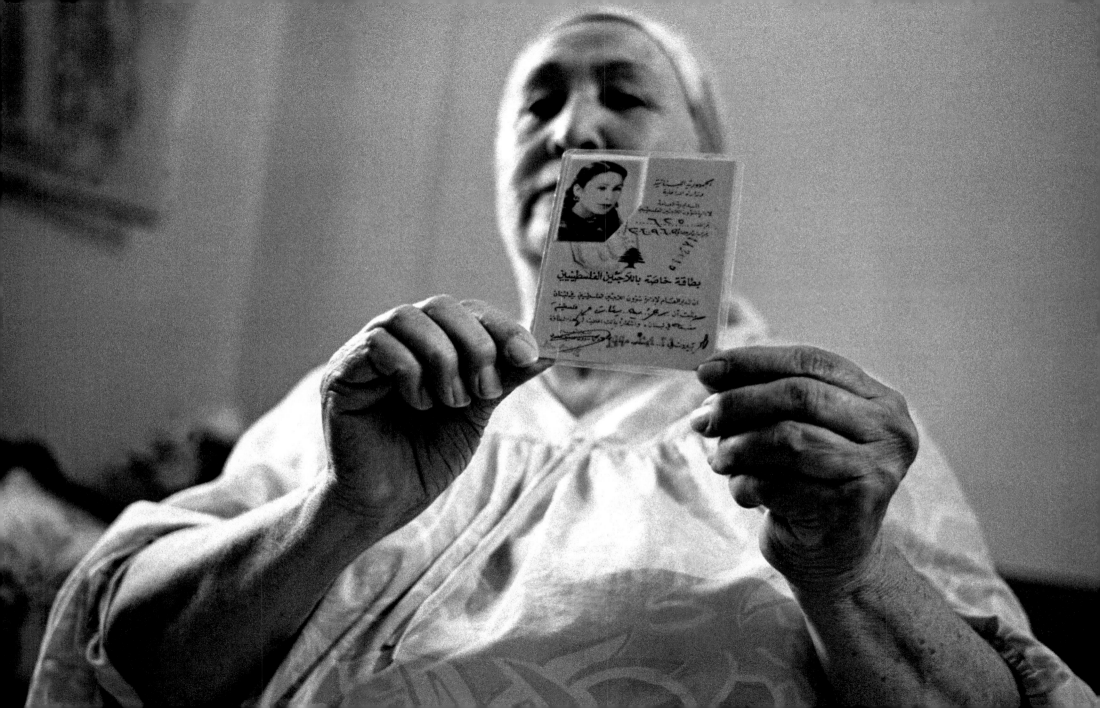

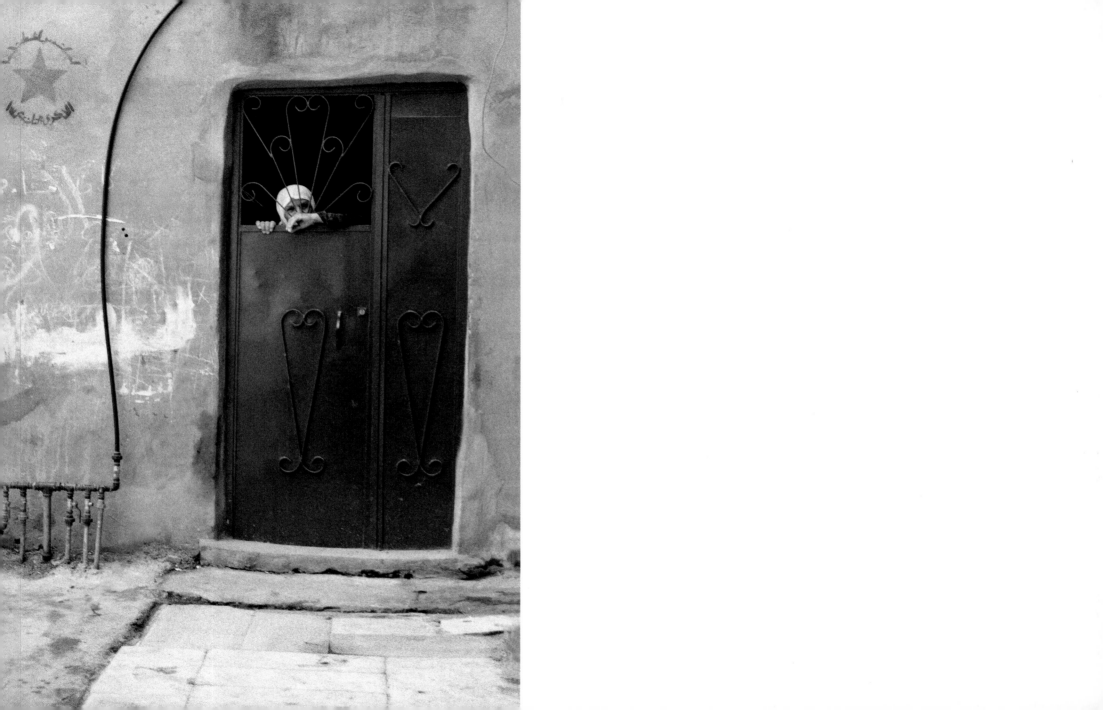

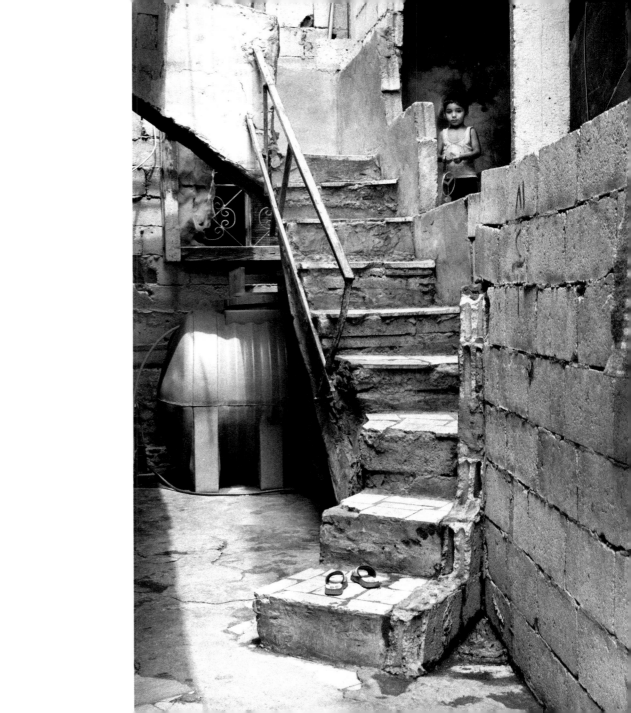

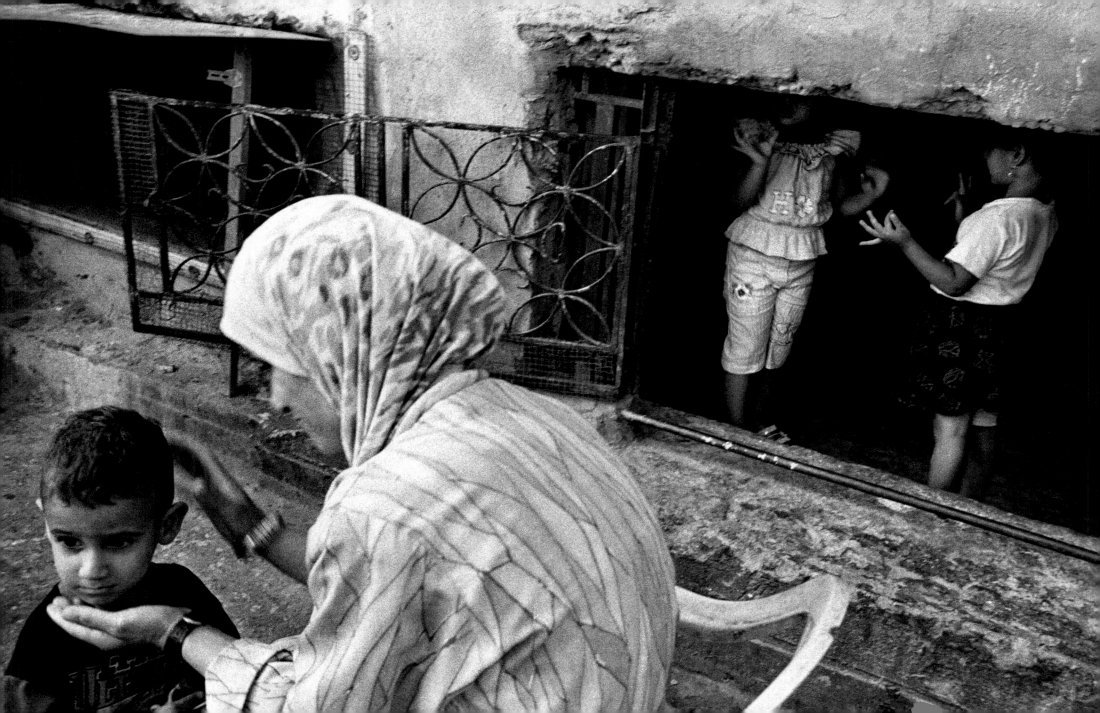

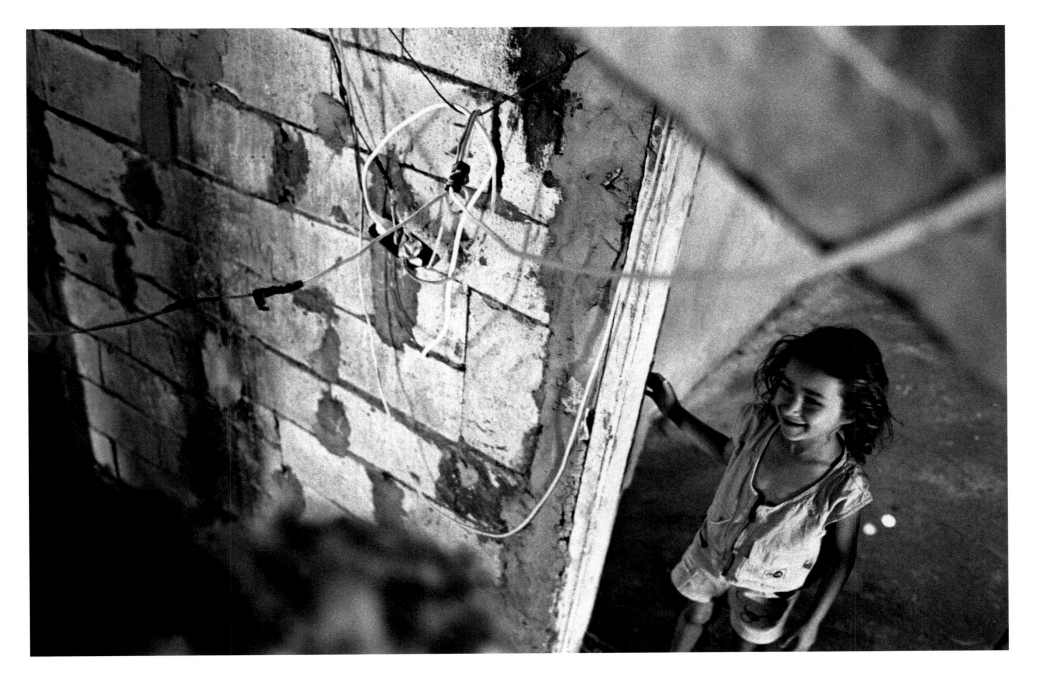

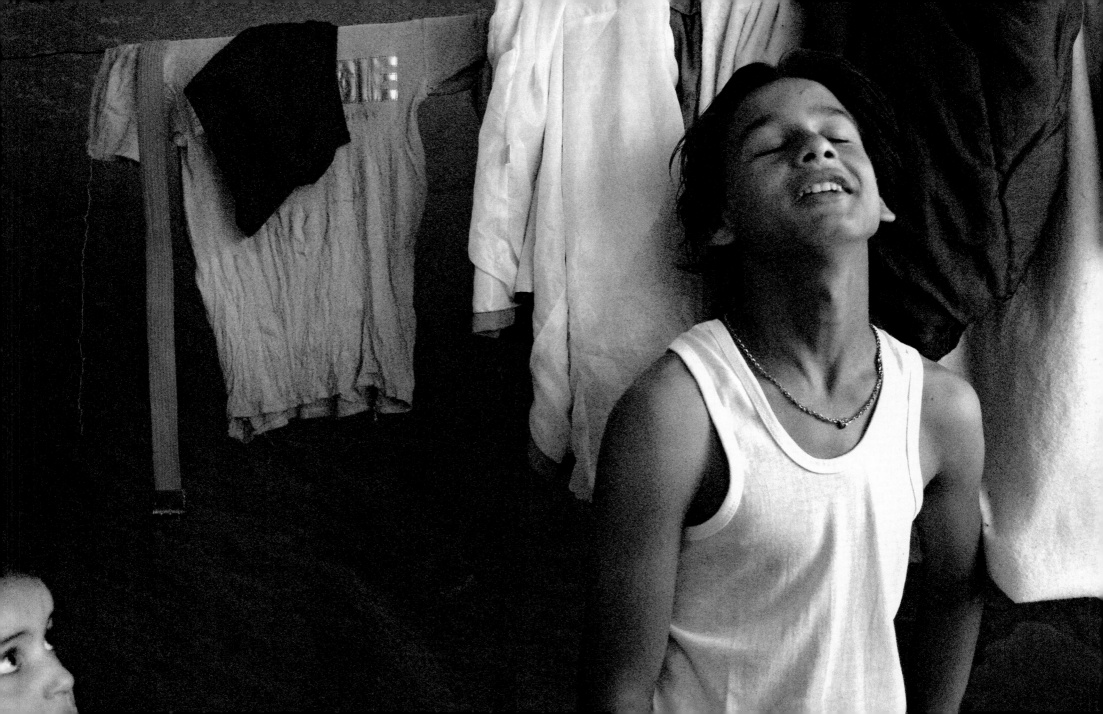

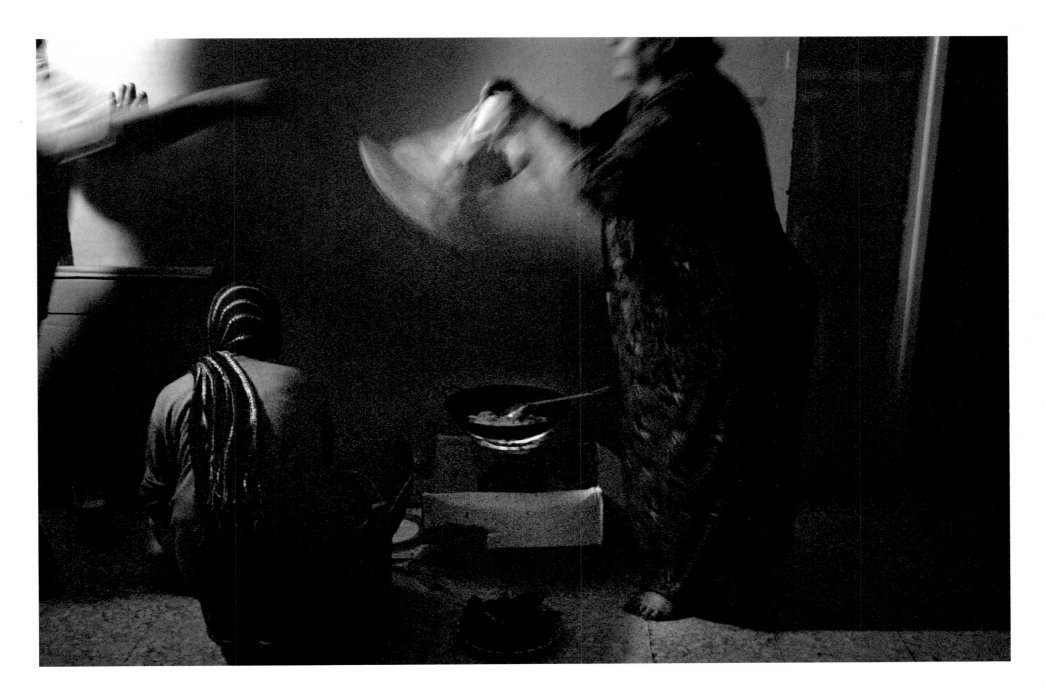

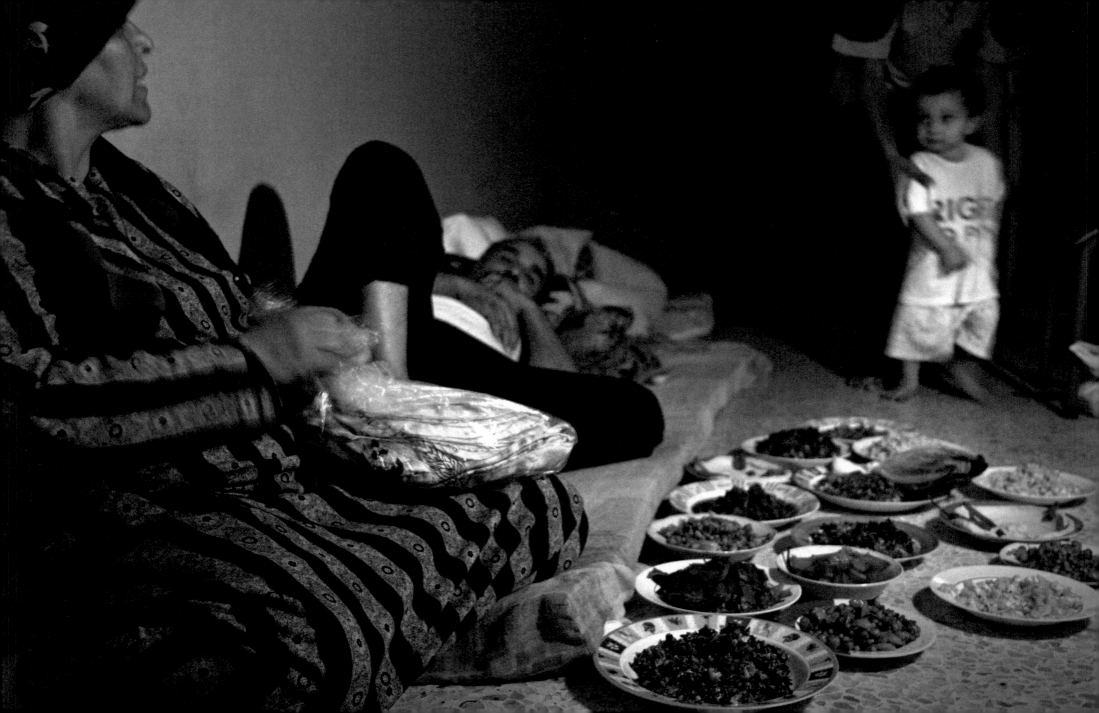

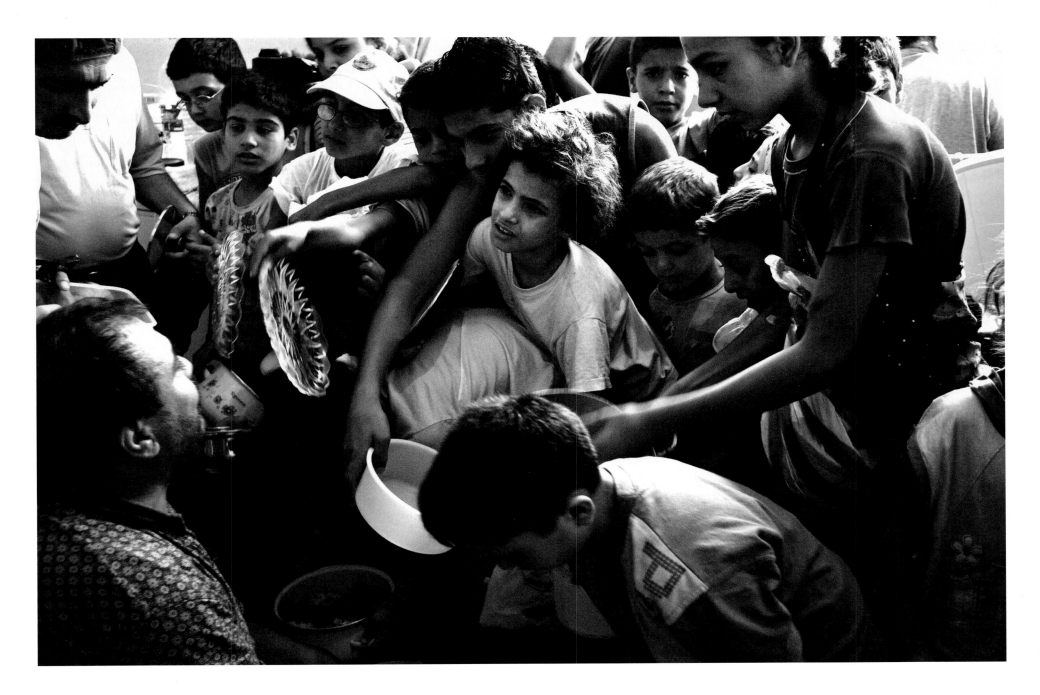

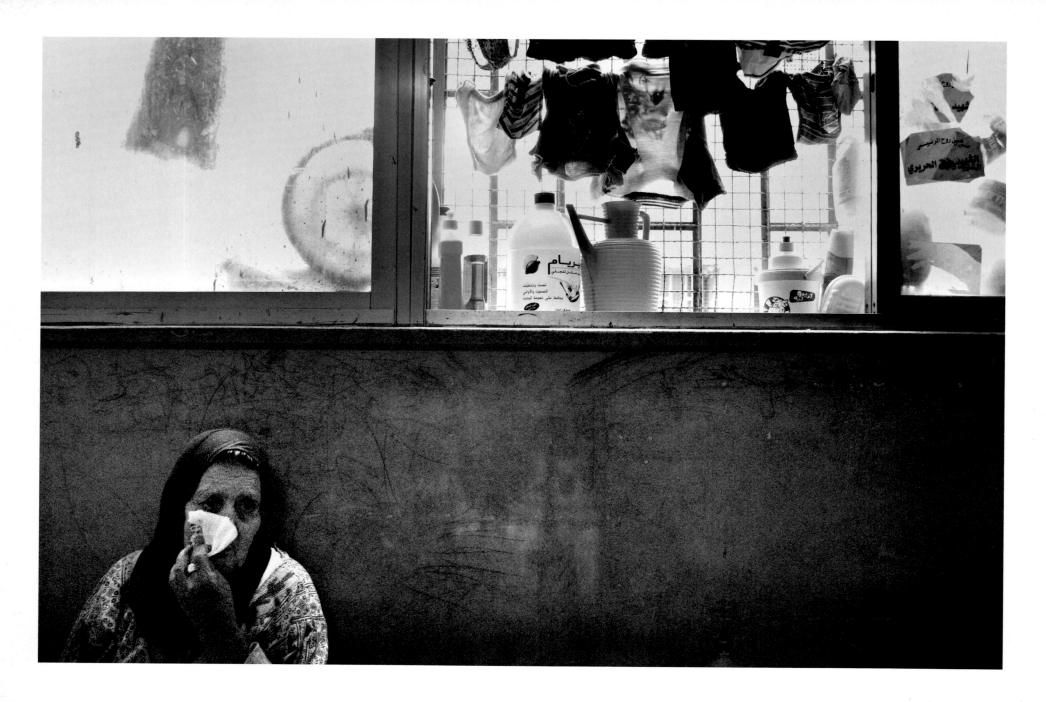

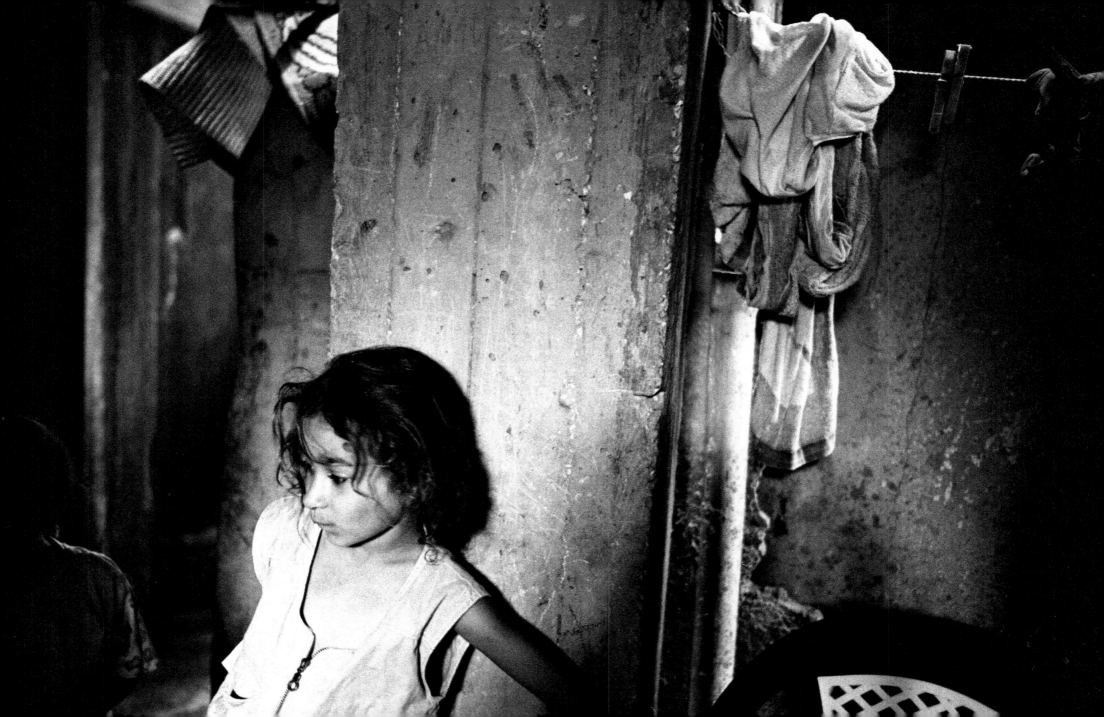

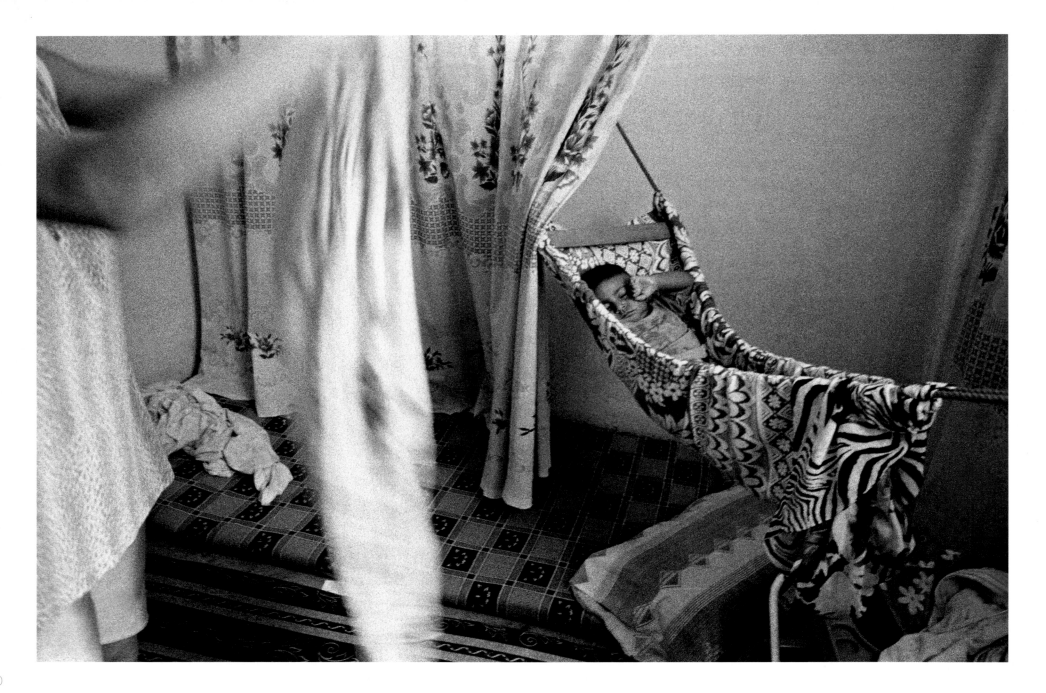

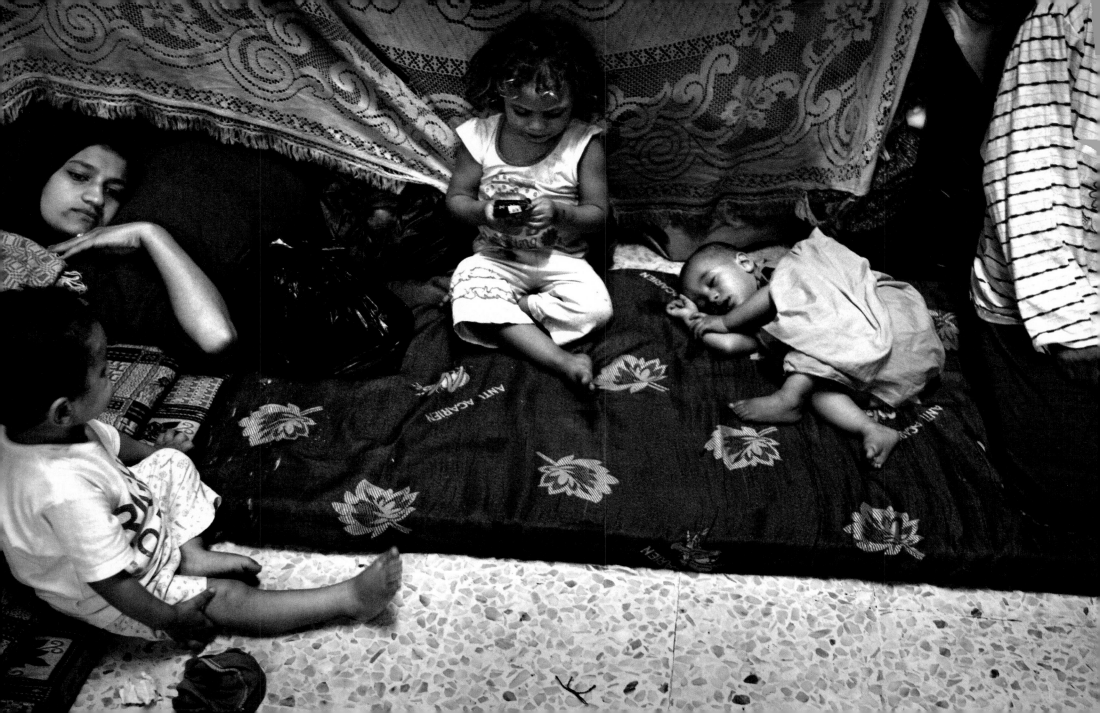

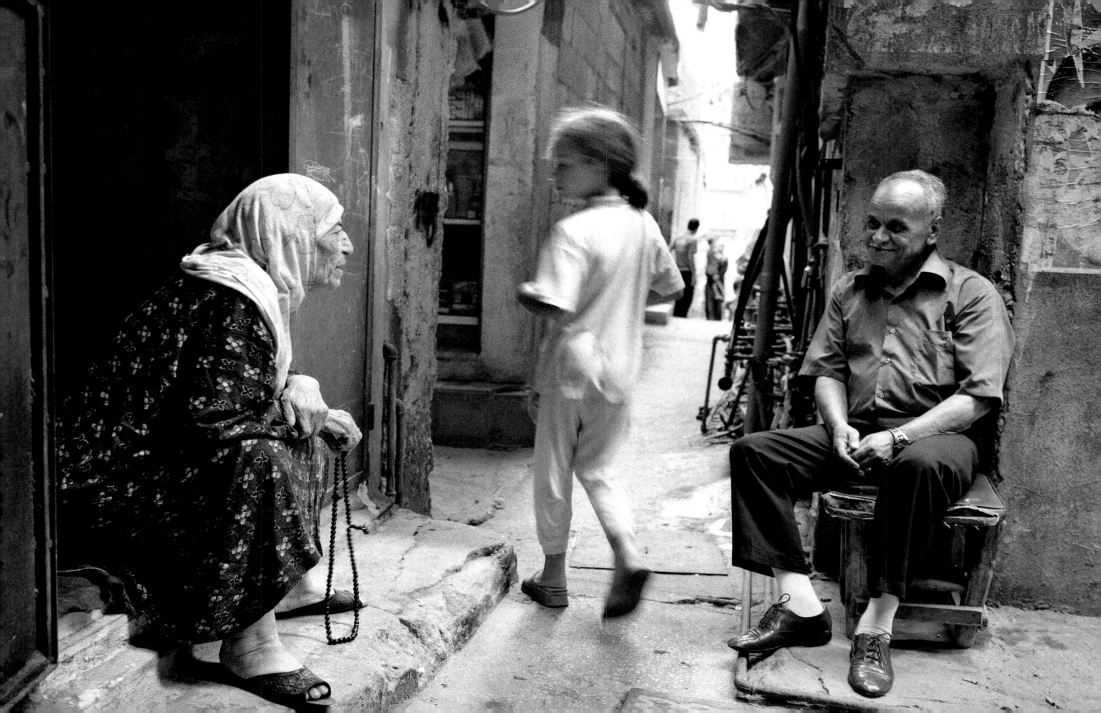

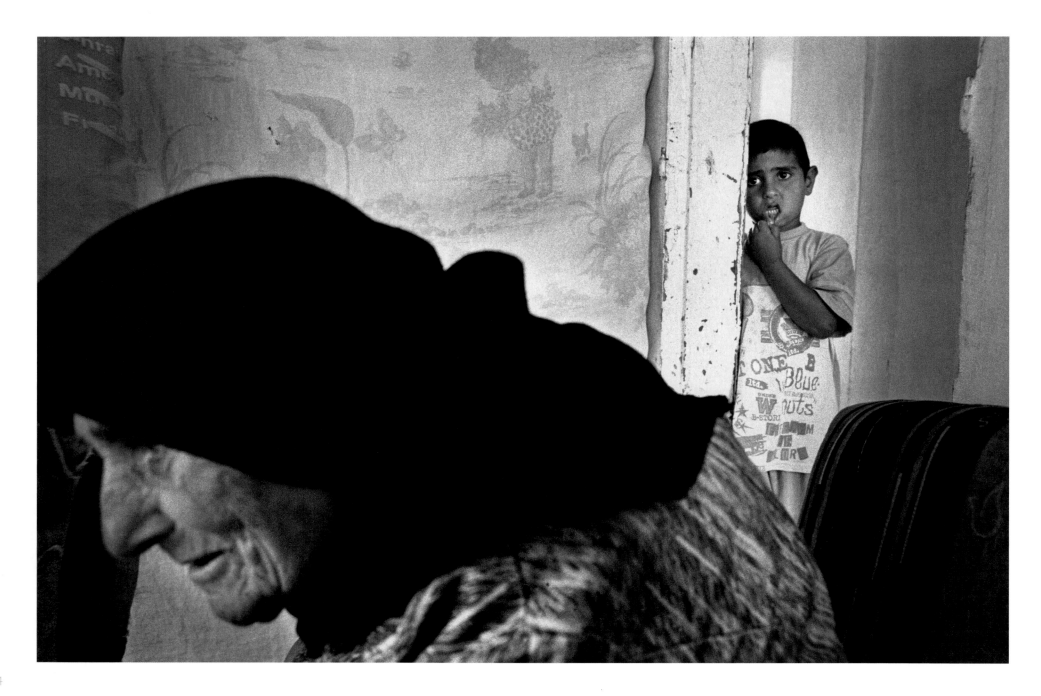

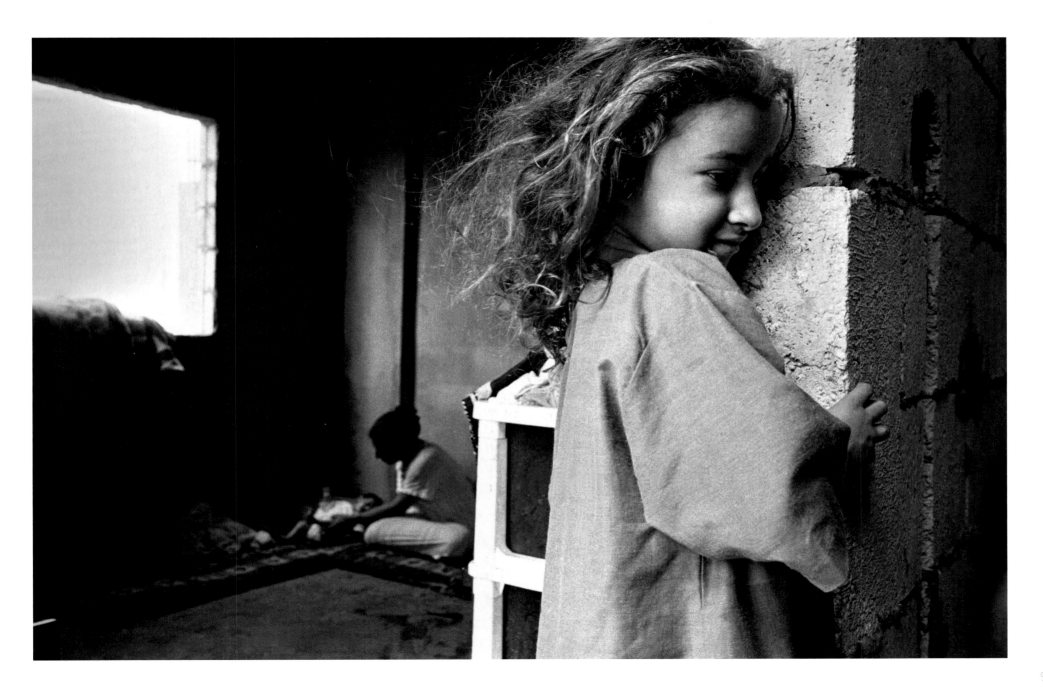

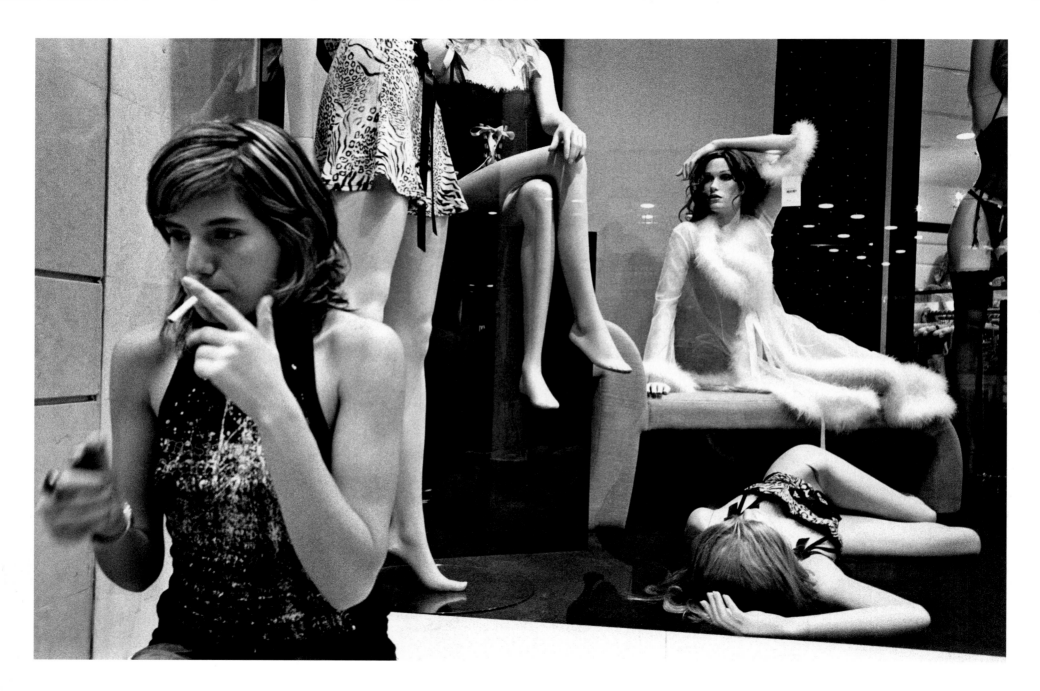

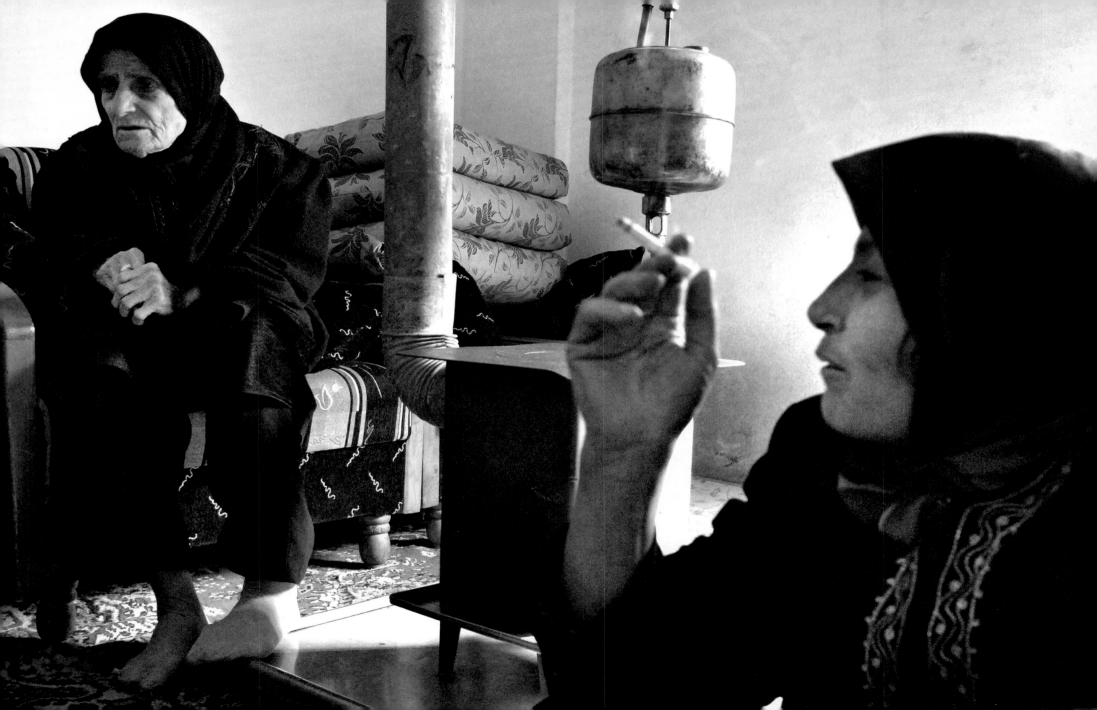

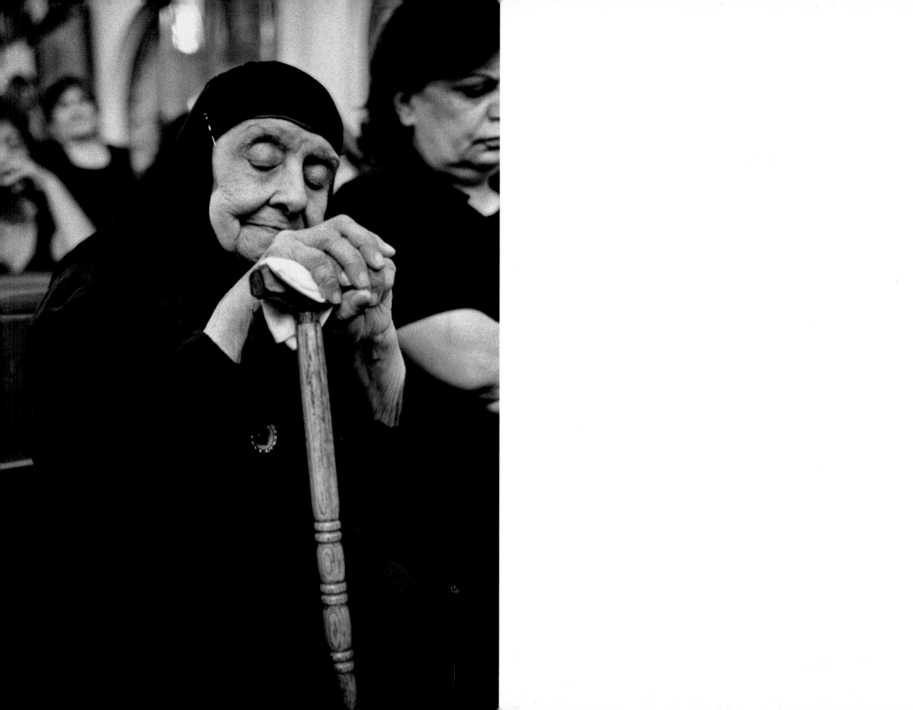

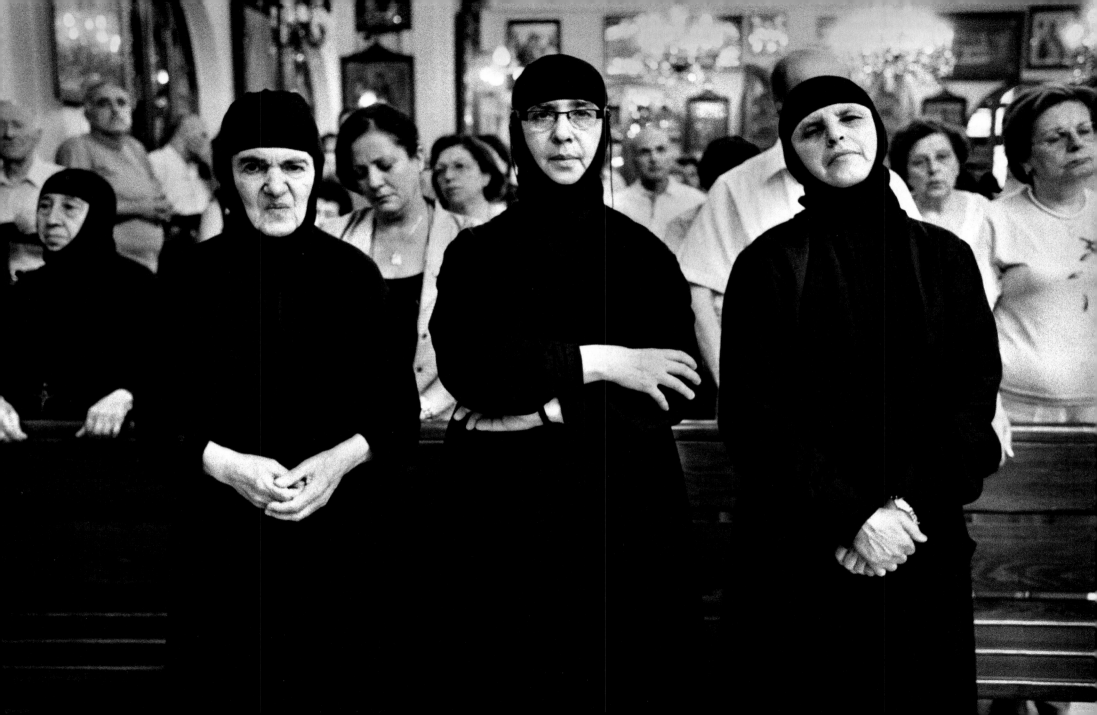

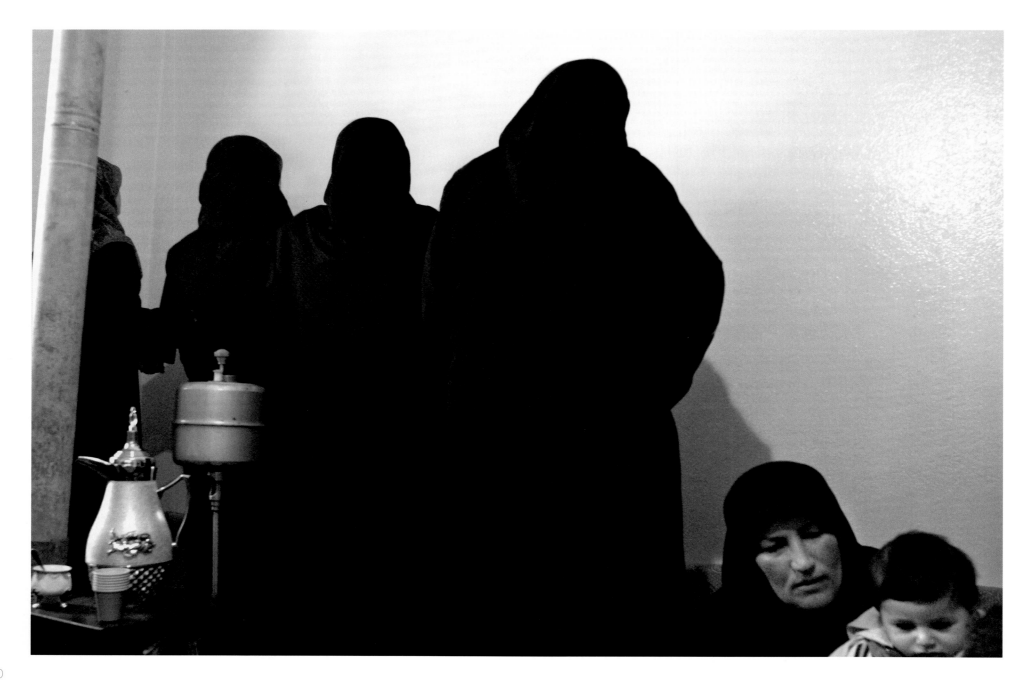

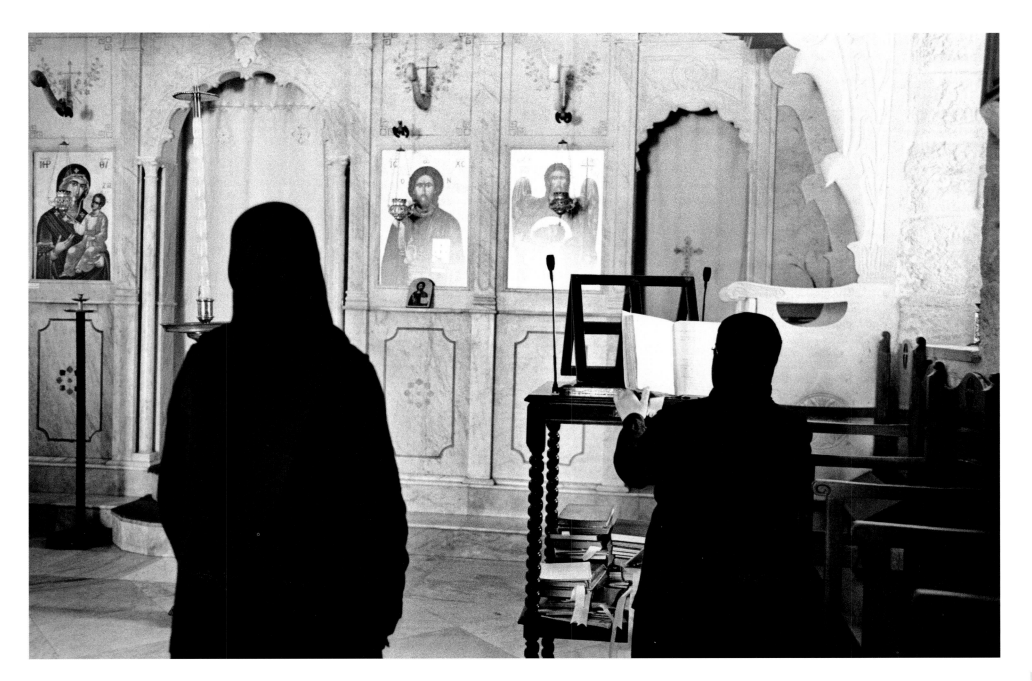

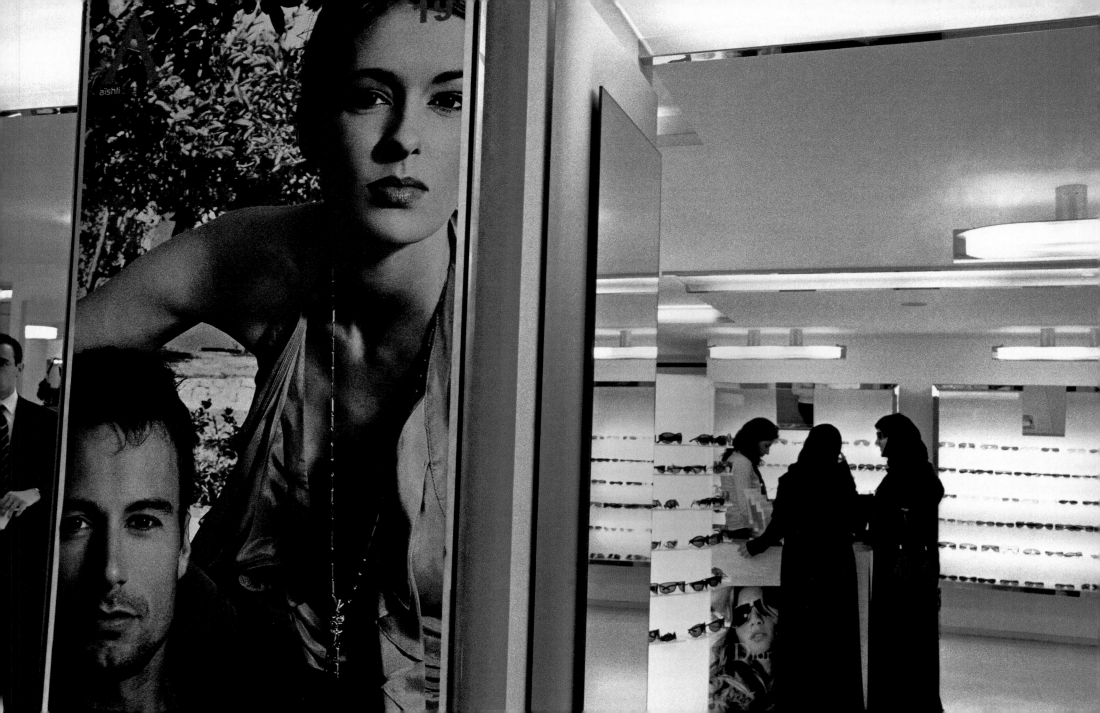

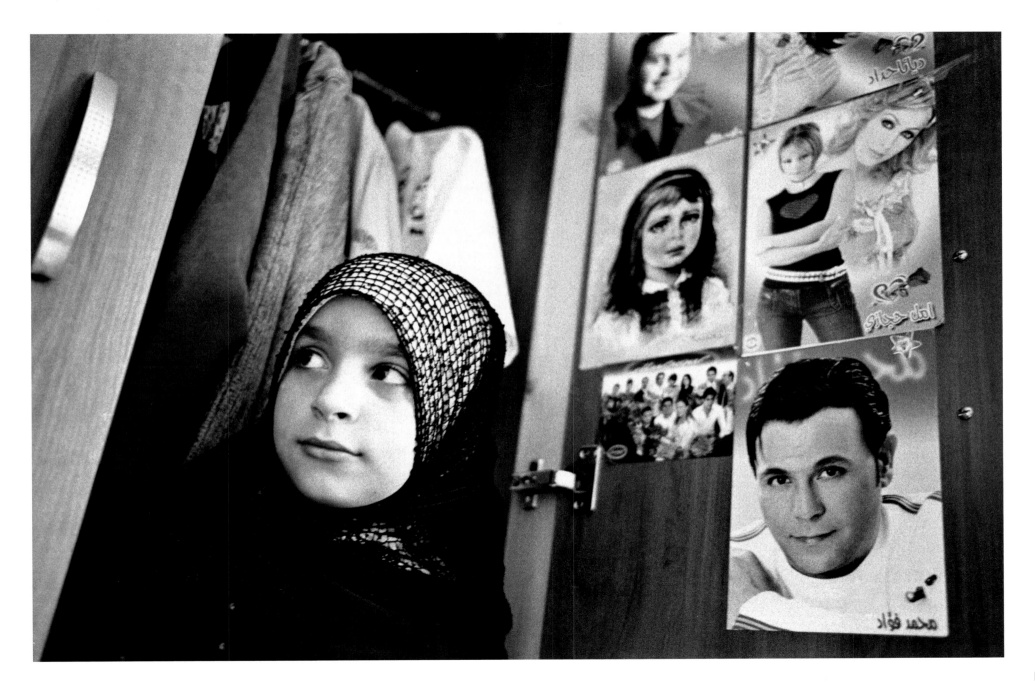

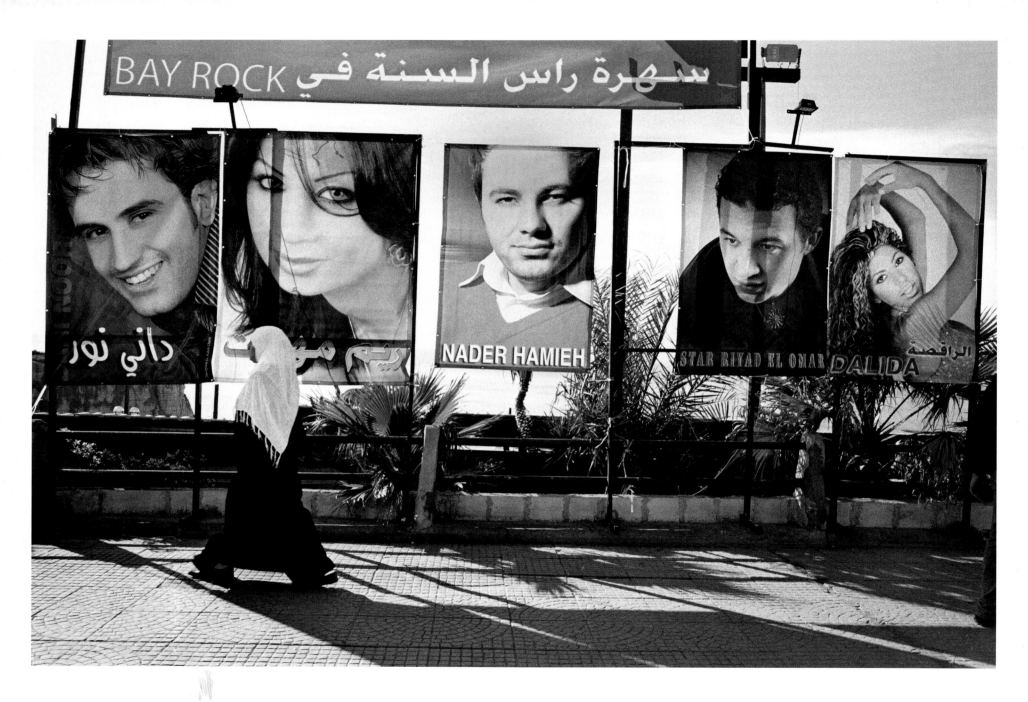

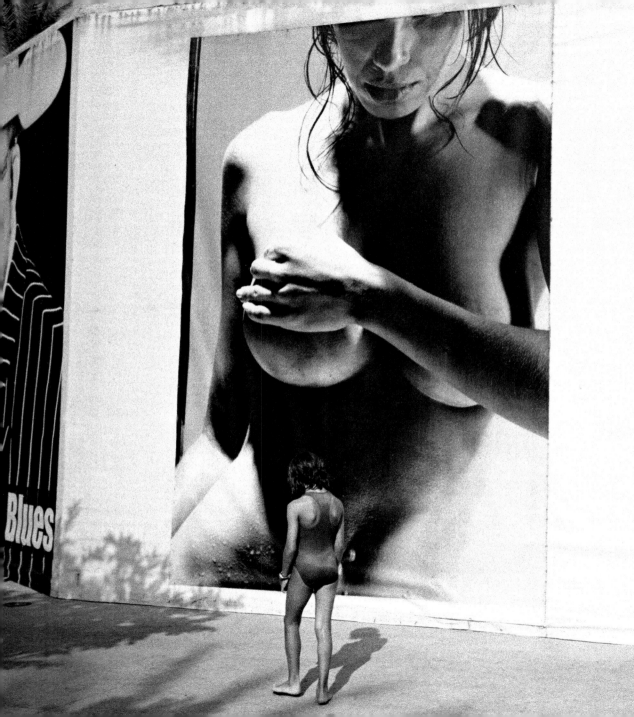

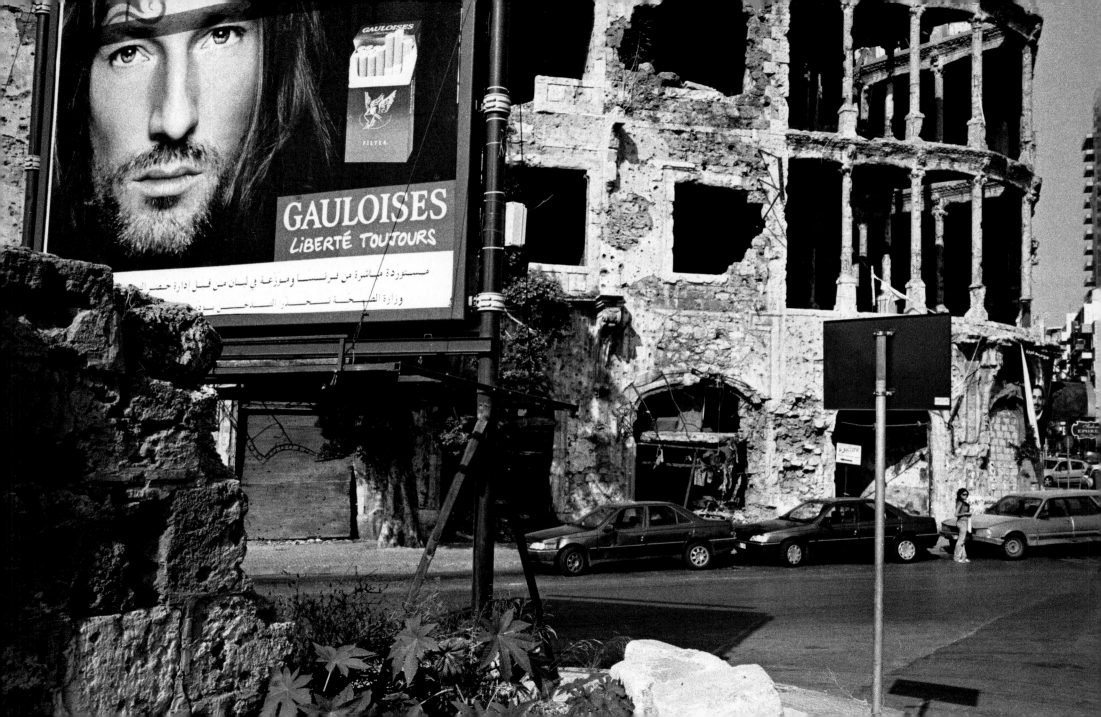

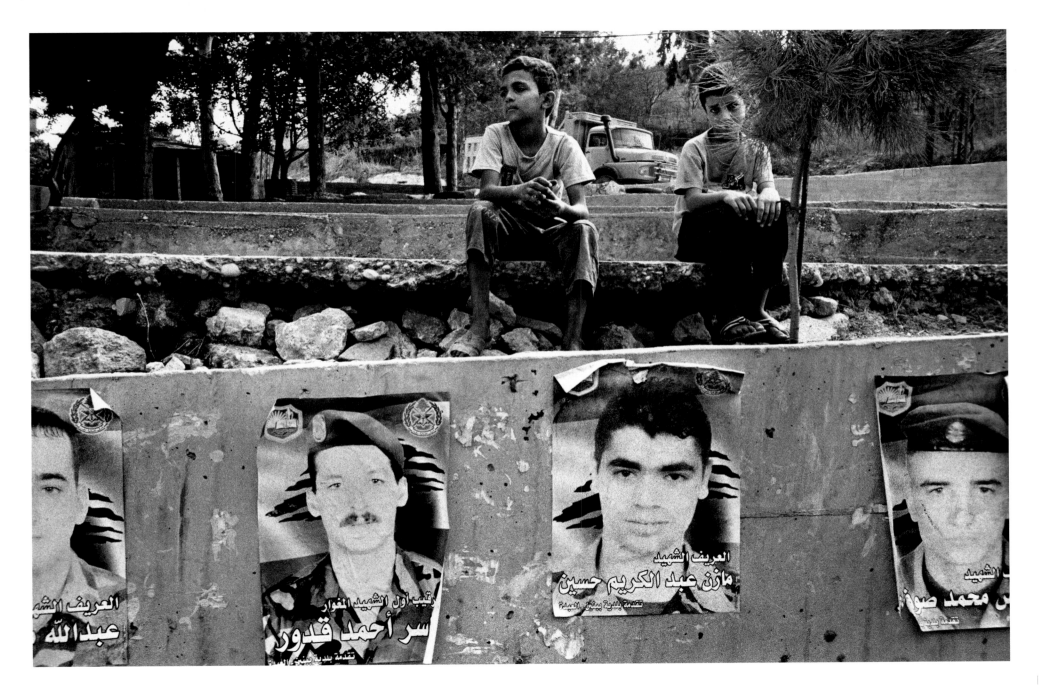

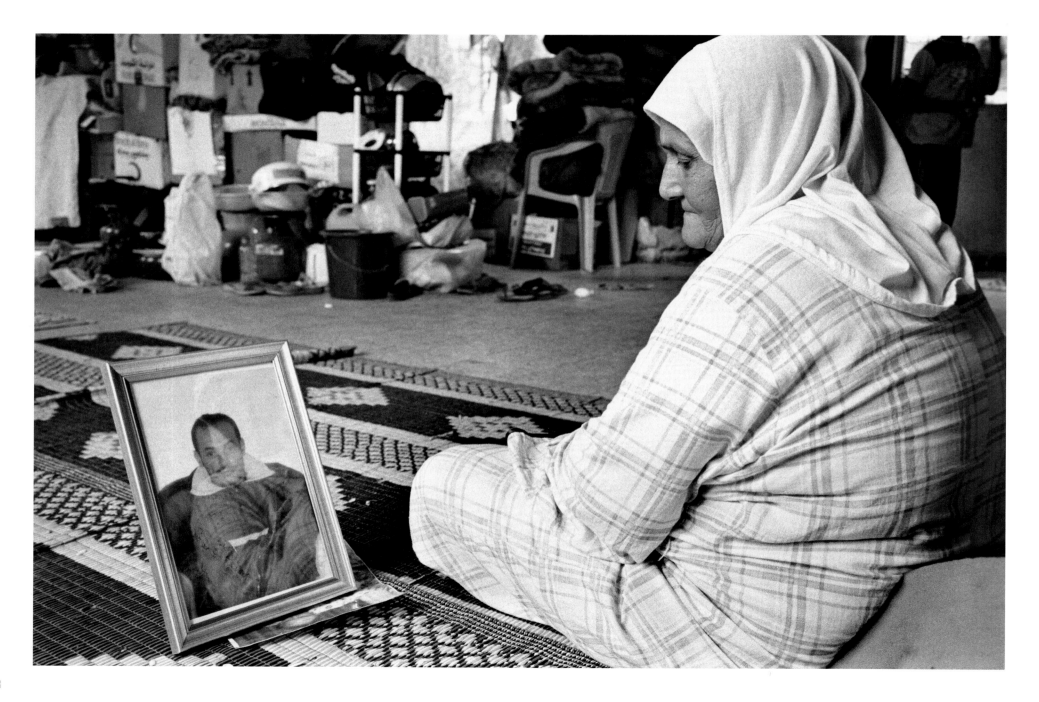

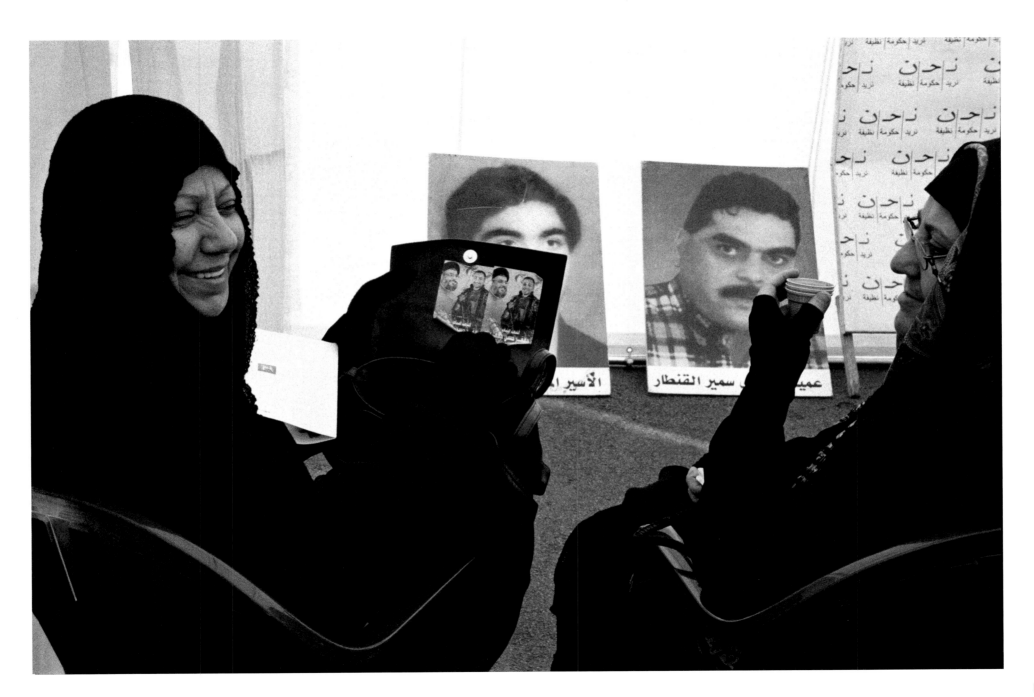

109

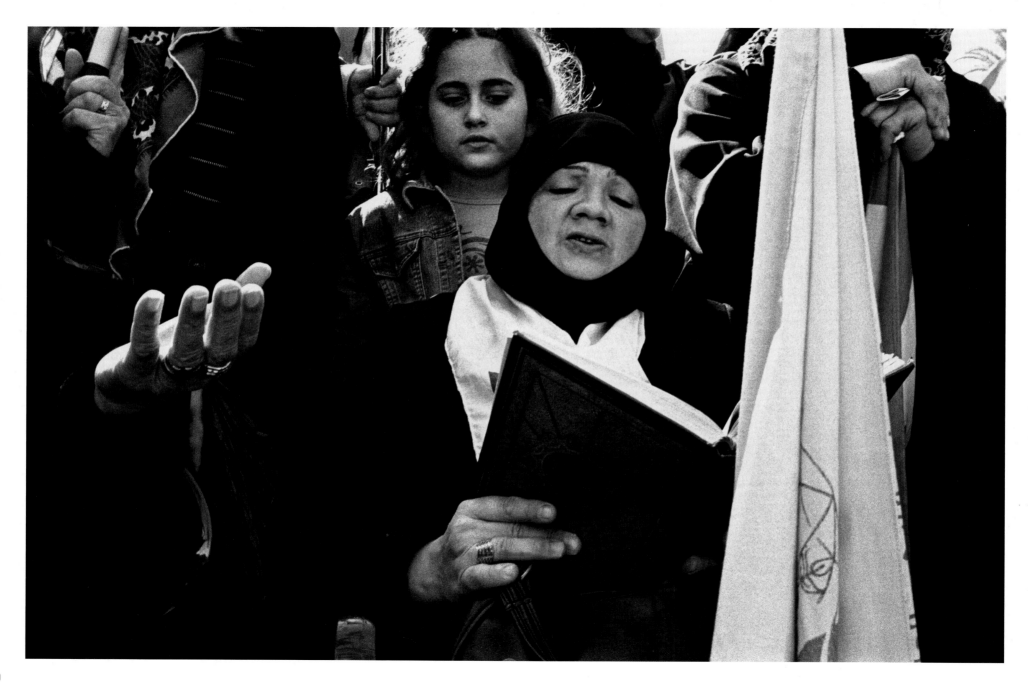

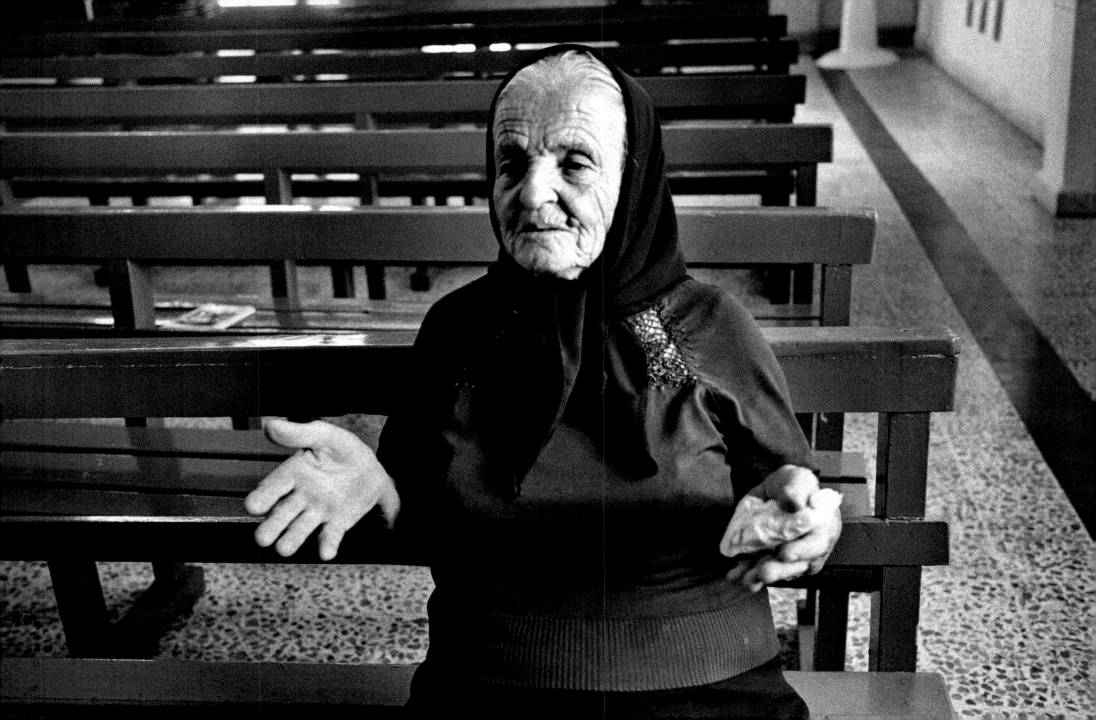

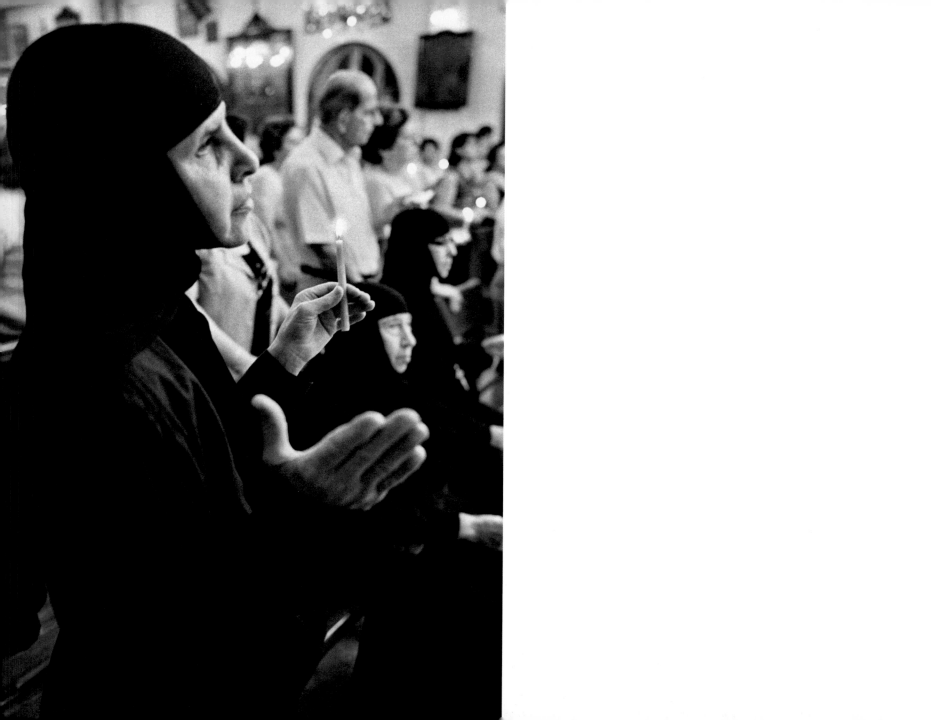

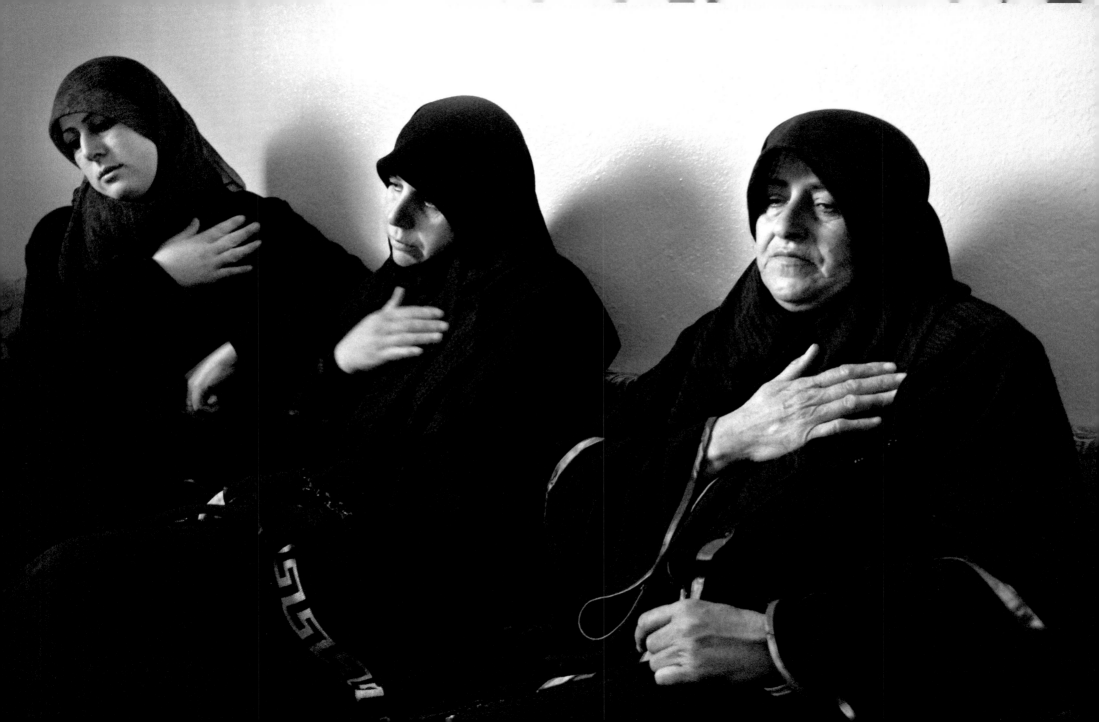

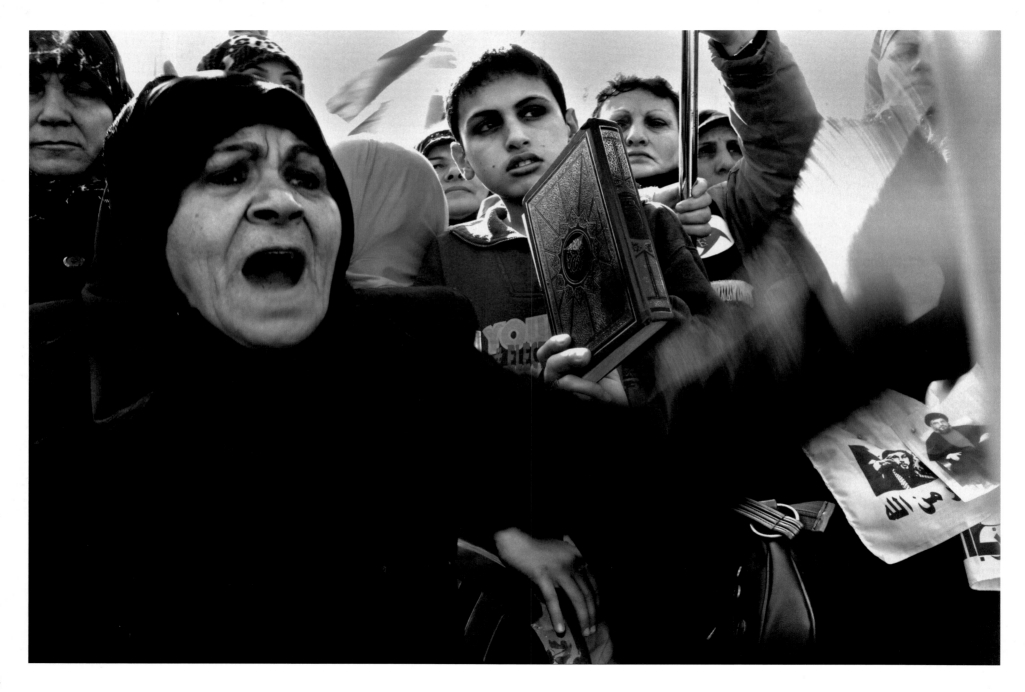

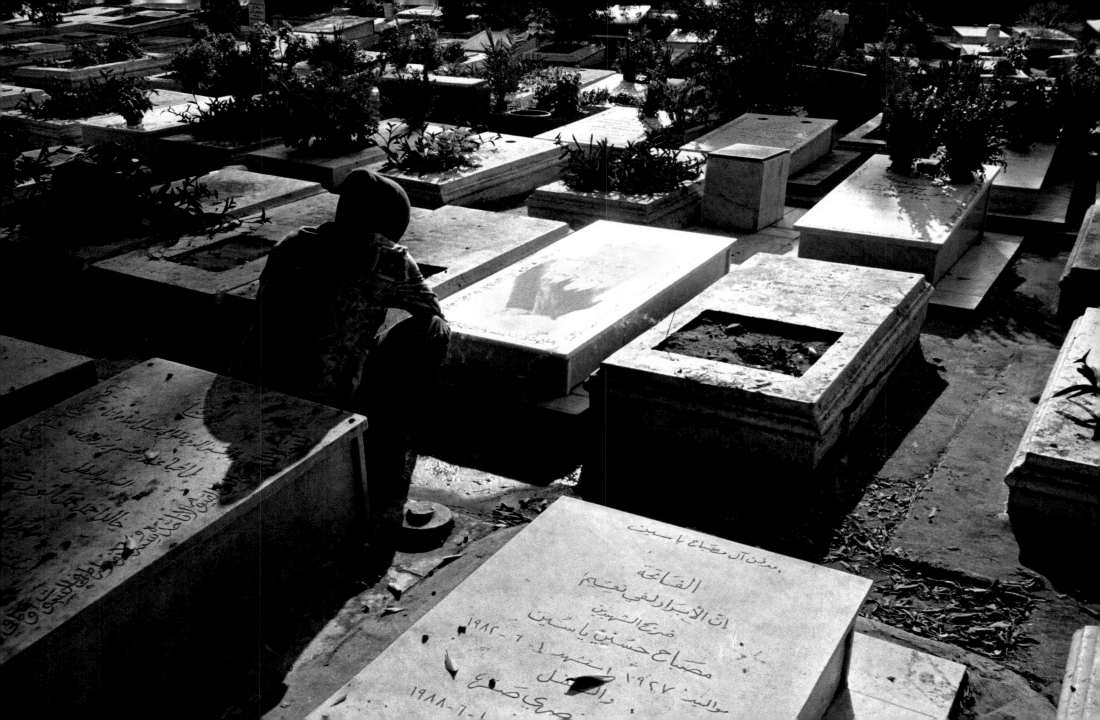

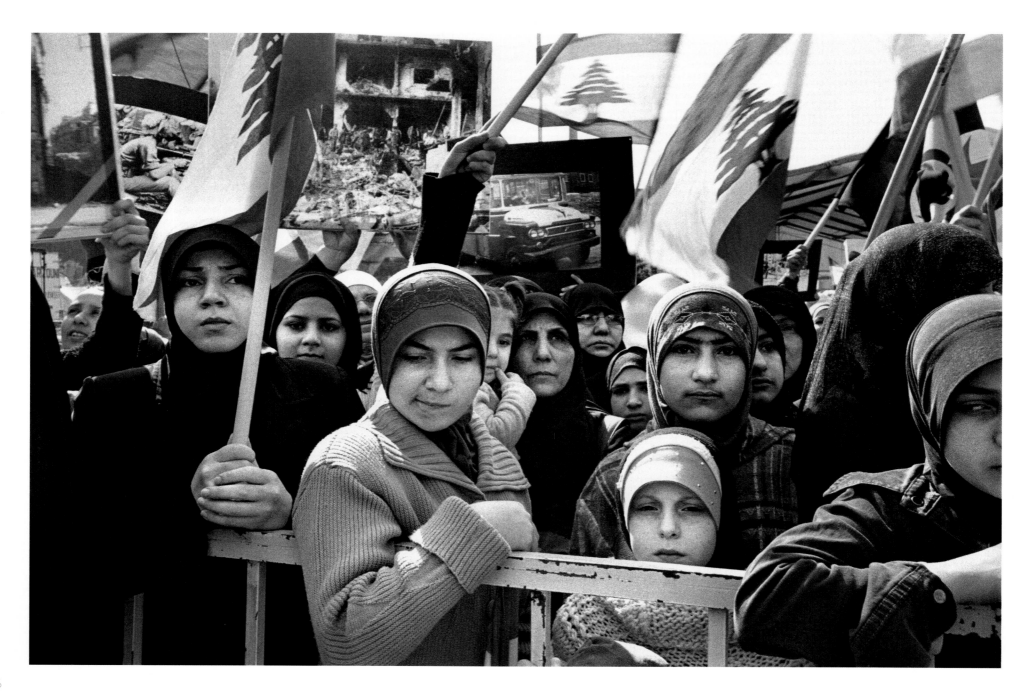

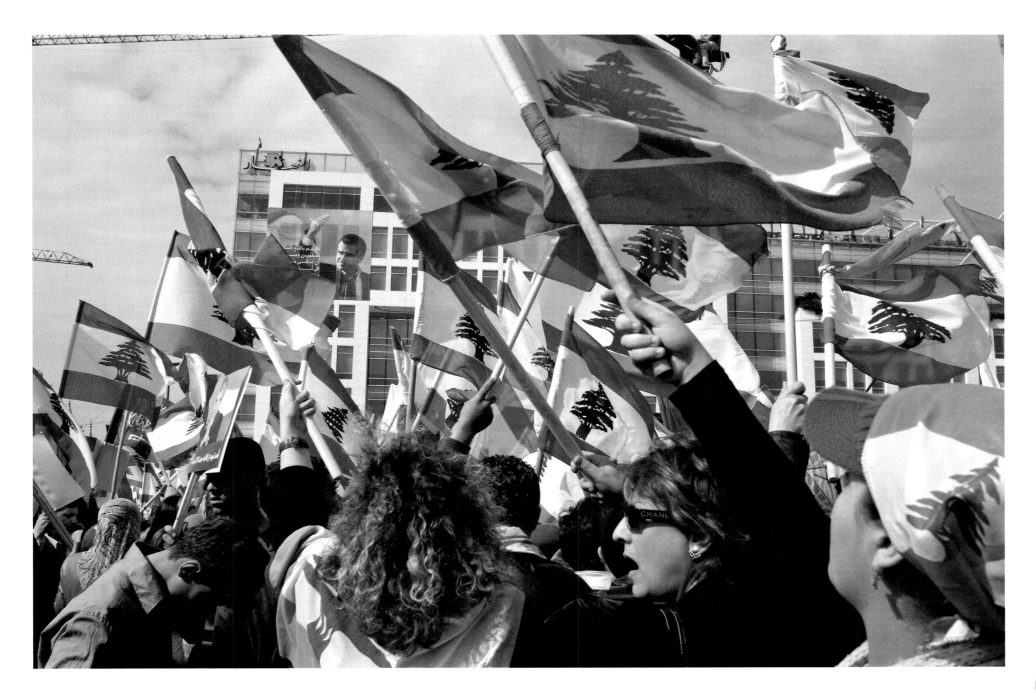

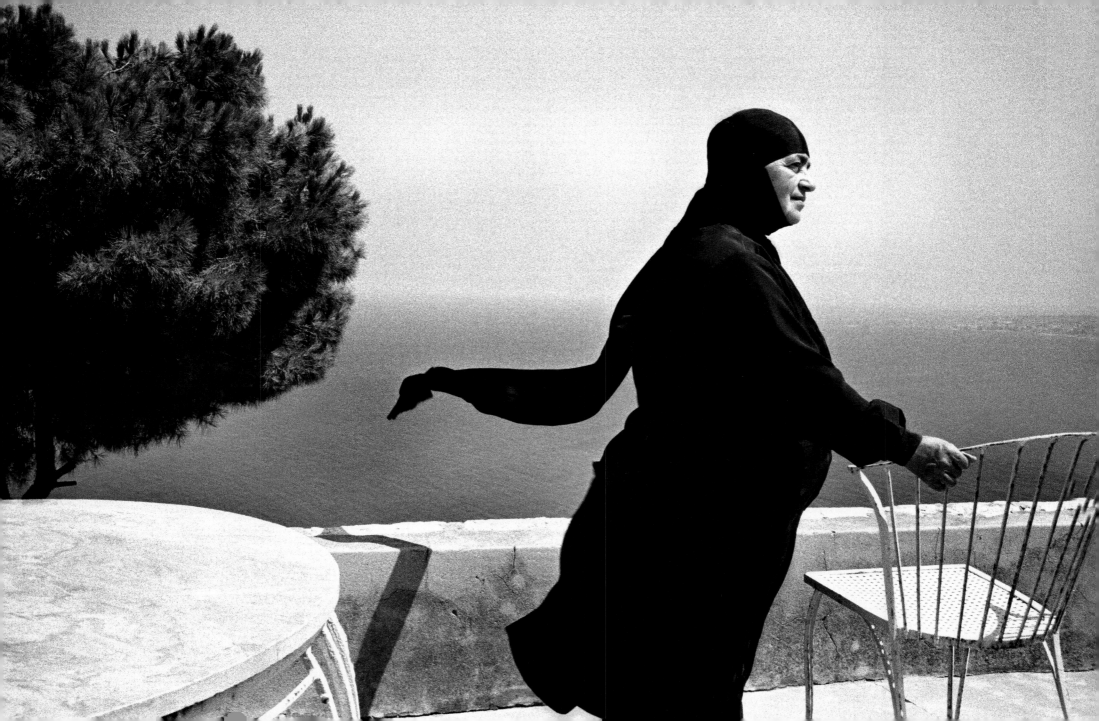

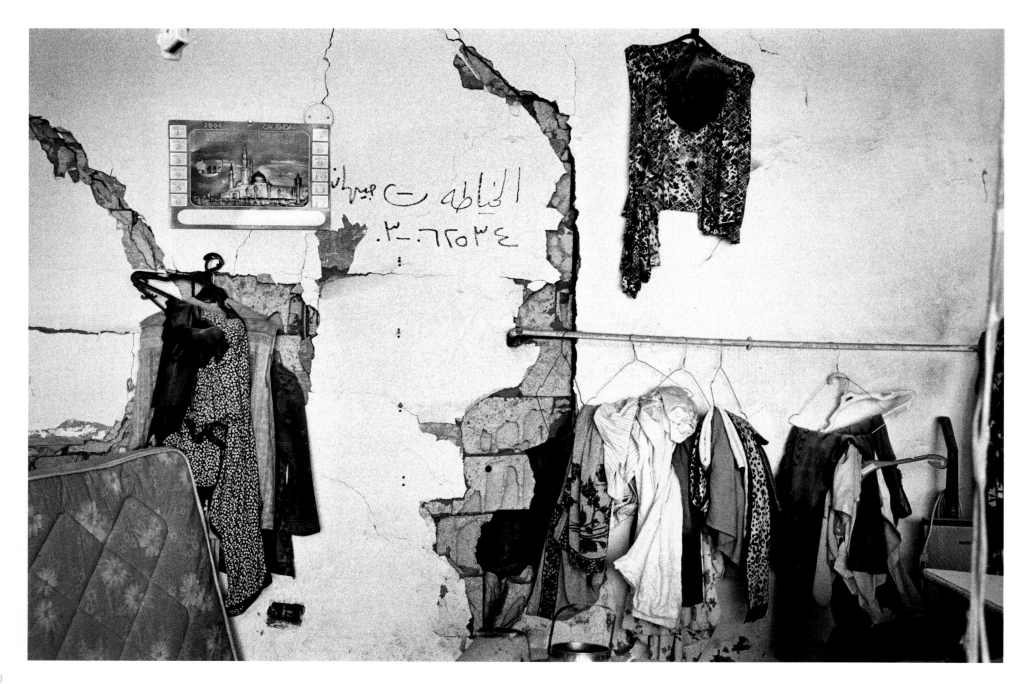

Ordinary Lives
Anthony Shadid

There was a bookstore I often visited in Baghdad over the years, its environs not all that much unlike the shattered but resilient venues through which Rania Matar has journeyed. It was along Mutanabi Street, an arcade named for one of the Arab world's greatest and haughtiest poets. Inside sat its owner, Mohammed Hayawi, a man who in time became a friend. Each day, he presided over business, such as it was, in a shop with shelves eight rows high, crammed with books by communist poets and martyred clerics, translations of Shakespeare, predictions by Lebanese astrologers, a 44-volume tome by a revered ayatollah, and a tract by the austere medieval thinker Ibn Taimiyyah. Dusty stacks spilled across the cream-colored tile floor, swept but stained with age. The smell of cigarettes hung heavy in the air. During that time, I always felt the doorway to Mohammed's store, the Renaissance Bookshop, was a border in a way, a passageway to another world. Outside, a few feet from those eclectic shelves of books, were the unsettled sirens of ambulances and police cars. Horns blared in two lanes of traffic, one more than Mutanabi Street had been built for. Soggy trash mixed with the hard rubble of war's detritus.

On a sweltering day, in summer 2003, when Iraq was still filled with the half-truths of occupation and liberation, before its nihilistic descent into carnage, I paid him a visit. Hayawi was trying to cool himself, a little vainly. He waved a fan as perspiration poured down his jowly face and soaked his blue shirt, tight against his girth. He bellowed a welcome as I entered. "Abu Laila!" he shouted, using the Arabic nickname taken from the name of a person's child. We chatted, aimlessly, with the luxury of what the ordinary affords. And a few minutes later, he delivered a line he would repeat almost every time we saw each other over the next few years. "I challenge anyone, Abu Laila, to say what has happened, what's happening now, and what will happen in the future." Over a thin-waisted cup of tea, scalding even on that hot day, he then shook his head.

Hayawi's words define Matar's Middle East, an always troubled region that has become ever more fraught with conflict, tension, and strife. Even the casual visitor can see the devastation wrought by war after war, from Lebanon's all-but-declared fratricide, to Iraq's grim entropy, to the most enduring of all the region's conflicts, Israel and Palestine. Each, on its own, is traumatic. Today, all are happening at once. As a journalist, I often ask the question of how do we cover those conflicts that define the region in which we work. The very nature of war leaves little room for subtleties, what reporters and photographers are supposed to grasp. How does a journalist convey the ferocity of violence without losing meaning in a mind-numbing array of adjectives, a repetitive series of images? How do we keep distance? As I reflect on Matar's images, I realize perhaps we shouldn't.

I often think about an episode in the Israel-Lebanon War of 2006, the same conflict that Matar chronicled. I was in southern Lebanon, on the road from Naqoura, winding through red-roofed, hilltop homes and concrete shacks, tobacco farms and olive groves, sometimes just a short walk from the Israeli border. On those days, a martial racket filled the air, paced unpredictably: artillery shells soared, sometimes met with volleys of Hezbollah rockets. Israeli aircraft were omnipresent. On this morning, the crack of an explosion prompted the call of a rooster, which was wandering aimlessly in the street.

"You should have heard it before," Abu Ali, a fifty-four-year-old father of ten, told me that day. "This is a break for us." Like villages along the road, it appeared deserted at first. Then slowly, a few of the scores of residents emerged, gathering

for conversation. Abu Ali sat with neighbors in front of an unfinished, cinder-block home within sight of the border. His neighbor, Abu Wadie, came. So did their children. And soon Ilham Abu Samra, a cheerful sixty-year-old matriarch, followed. They had a litany of woes: no electricity since the war's first day, too little food, no medicine for the sick. Abu Wadie bummed a cigarette, his first in ten days. The neighbors' only contact with the world was a battery-powered radio, tuned to Israeli and French stations in Arabic. Kept up by the fighting at night, they napped for a half-hour or less during respites in shelling that punctuated the day.

"Bread?" Abu Ali asked. "We haven't seen it." The conversations were familiar in those days. It was war, after all. But what followed was unusual. Abu Samra, the matriarch, soon brought coffee in a tin kettle, served in small cups. As explosions reverberated, others offered their figs, and a plate of grapes.

"You're welcome any time," Abu Samra shouted. A moment later, she disappeared. She returned in a few minutes, with a smile, and offered three roses—red, dark pink and blood orange.

"Don't think I'm giving you the flowers for a funeral," she told me, with a wry smile. "I'm giving them as a wish for your safety." Abu Ali looked on, in a moment that seemed somehow tranquil. For that fleeting instant, in their faces, in Abu Samra's gesture, I grasped humanity in war.

Humanity in war is Matar's arena. It is the terrain she understands, with intuitive power. She captures the moment. Her images treat conflict as a backdrop, a sideshow to a far more powerful narrative unfolding. That narrative is about life—its resilience, its endurance, its courage—taken together, the most human of stories. At times, that narrative is even mundane, a quality that is sometimes the most important to capture, and of course, the most elusive. Moments in conflict can be gentle simply by virtue of being ordinary. I say those words again: they are gentle simply by virtue of being ordinary.

I think again to Hayawi, the bookseller on Mutanabi Street. The last time I saw him, in 2005, he was sitting behind his battered wooden desk, sipping a cup of tea that cost ten cents. There was a pack of Gauloises cigarettes next to it. Hajji Sadiq, the money changer, ambled into the bookstore as he did every morning, hour after hour. "What's the rate?" I remember Hayawi bellowing. "I won't tell you unless you're going to buy," Hajji Sadiq answered. Hayawi waved to friends passing along the street outside. An elderly woman stood at the door, asking for alms. Vendors entered, offering everything from books to beach towels. The day went on, in the rhythm of a life that now no longer exists in Iraq, with a cadence that I'll probably never encounter again. Two Kurdish booksellers came in, bringing a gift of honey from Sulaimaniya in the north. They greeted Hayawi in Kurdish, then the conversation continued in Arabic. As I sat there, Hajji Sadiq returned, quoting an exchange rate that had barely changed. The electricity cut off, with no one seeming to notice. Customers from Balad, in the north, told of the situation there, as did visitors from Basra, in the south. By afternoon, the always-intermittent electricity came on and a water pipe filled with sweet-smelling apple-flavored tobacco was brought out. Hayawi dragged on it. He was as relaxed as I had ever seen him. "Life goes on," he told me, in words that I suspect I will never forget. He smiled. "We are in the middle of a war, and we still smoke the water pipe."

In a way, Matar understands the meaning of a water pipe in war, and through that familiarity, she captures those same moments in a fragile Lebanon that Hayawi lived in a precarious Iraq. Her images haunt me. They are what writers struggle to bring to life in so many words. In these images, I see resilience: that moment in the southern suburbs of Beirut, devastated by the war in 2006, where a boy idly snacks on an apple, a young girl in her best clothes props a hand on her maturing hip, and a mother, somehow divorced from her surroundings, takes a break in a plastic chair where her house once was. It is an ordinary moment in a time that is anything but. I see endurance: there is a moment Matar chronicles in Aita el-Chaab where, in the cavernous remains of a room, its walls chiseled by war, a young girl learns to juggle, and a man jumps rope. The experiences are so dis-

sonant that they hew to their own logic. I see hope: the suggestions of an apoca-lypse around them, a young mother smiles as her infant girl, dressed in a Barbie t-shirt, raises her arms outward, as if embracing life. The infant's emotions stand as an antidote to conflict. And, in the spirit of Hayawi, the Iraqi bookseller, I see the mundane, those moments of life that not even war can disrupt: a young boy bathing in Bourj el-Shemali Refugee camp, near the southern port city of Tyre. He washes with a small faucet in a room that also serves as kitchen. Around him are cinder blocks, the building blocks of poverty and flight. Against that backdrop, painted in a cemetery gray, his body is innocent; the water is pure. It is an inci-dental act that, in Matar's rendering, speaks to all those qualities of humanity in war—resilience, endurance and hope.

In some ways, Matar straddles two worlds, East and West, the Arab world and the United States, two cultures that at times cannot occupy the same space. By virtue of residence, and perhaps outlook, she is more Western. But through intuition, language, and the culture that informs life, she belongs to the East. As my eyes linger on each picture, I sense those two worlds. In some ways, she is like the fisherman in her photo in Sidon, clipping the thin threads of a net that obscures our collective view. Matar's work is feminine, a graceful, resonant attribute all the more difficult in war, conflict and violence. She gives voice to women and children; her narrative is their lives—be it a soccer game, an appointment at a hairdresser, or the conversation of women sharing a cigarette around a kerosene-burning stove whose pipe stretches to the roof. There is a tranquility to these images, the way groves of olive trees grace the rock-studded wadis and hilltops of southern Lebanon. And finally, it is essential to note Matar's original training as an architect. That profession's sensibility infuses almost every image in this book. The photo-graphs could only be rendered in black and white, the hues of a draftsman's work. She appreciates destruction—not as the antithesis of construction, but rather as the absence of the ordinary. There is a symmetry, too, in her art—of emotion and expression, of form that intersects with community.

Lebanon, the subject of this book, is a country of almost clichéd complexity. In the work that follows, Matar does not try to bring an authority to her ren-dering of Lebanon. Her images are not exhaustive, nor should they be. There is no attempt to speak to either Lebanon's breadth or depth or Beirut's claus-trophobic frontiers. In fact, perhaps only one image stands as authoritative of a country whose destiny has never matched its expectations, of a country that feels it deserves better but has inherited worse at almost every turn in its his-tory. It is an image on a street corner, along the Green Line that divided Beirut from 1975 until the civil war ended in 1990. The building she photographs looks like an archaeological dig—a generation-old structure that suggests centuries of deterioration and decline. In the background is a high-rise building, its lines sleek. In the foreground cars are parked neatly along a curb, under an ad for Gauloises. Taken together, these objects suggest modern Beirut, a city still haunted by the ghosts of its past, with a veneer of crass commercialism and foolhardy confi-dence. It is a city still trapped in the nihilism of a long-ago war, perched on the precipice of another. I suspect Matar would not agree with that rendering of her photo, but I feel it captures the city's fractured soul. In that vein, there is another quality that emerges so powerfully in Matar's work. I have seen it often, in the Arab world's greatest, most shattered capitals. Baghdad was resilient, even in its medieval heyday. Beirut, more so with every passing year, is resilient as well. Matar may not try to represent the soul of Lebanon, but her images understand that essence evocatively well. The country has failed in so many ways, crumbling under its own contradictions. But Beirut—and for that matter the Lebanese—have endured, have managed the obstacles and negotiated the pitfalls. They have persevered, and Matar's images are most spectacularly about endurance and resilience, the tapestry of life.

I often come back to Hayawi the bookseller as I wander through this book. Matar tells a story of Lebanon, buffeted by war. Hayawi, Mutanabi and his Renais-sance Bookstore told me a story of Iraq, awash in another conflict's currents. In

March 2007, a car bomb detonated on Mutanabi Street, a few doors down from the store. At least twenty-six people were killed, another attack on another day, consigning yet more Iraqis to the anonymity that death brings there, that war has brought so many times to Lebanon. Not all were nameless, though. I soon learned that Hayawi was one of those victims. He was buried in the bookshop that had always resisted the forces that killed him. He was murdered on Mutanabi, a maze of shops and stores housed in elegant Ottoman architecture and anchored by the Shahbandar Cafe, a street that spoke to another Arab world—before the deprivations of intolerance, of imperial arrogance, of hopelessness and loss. There is a story that I often thought about when I was in Iraq, over those years I visited Hayawi. It was about Baghdad's destruction, more than 700 years ago. When the Mongols sacked Baghdad in 1258, it was said that the Tigris River ran red one day, black another. The red came from the blood of nameless victims, massacred by the ferocious horsemen of the Mongols. The black came from the ink of countless books from libraries and universities, the very stuff that made Baghdad one the greatest cities the world has yet seen. On that March day, a Monday, the bomb on Mutanabi Street detonated at 11:40 a.m. The pavement was smeared with blood. Fires sent up columns of dark smoke, fed by the plethora of paper. A colleague of mine went to find out what happened to Hayawi. He told me that near his shop, a little ways from the now-gutted Shahbandar Cafe, a black banner was hung. In the graceful slope of yellow Arabic script, it mourned the loss of Hayawi and his nephew, "who were assassinated by the cowardly bombing." A few days later, even that was gone.

There was no one to chronicle the small moments of Hayawi's life—Hajji Sadiq and the tea, the bookseller and his water pipe, all now buried in the rubble strewn along Mutanabi Street. Years from now, I suspect no one will even remember them, those images forgotten. But no one will forget the women and children in the preceding pages, the ordinary lives in times that are cursed by being anything but ordinary. Matar's book, most importantly, is a chronicle. In it is memory, and memory is an appreciation of loss.

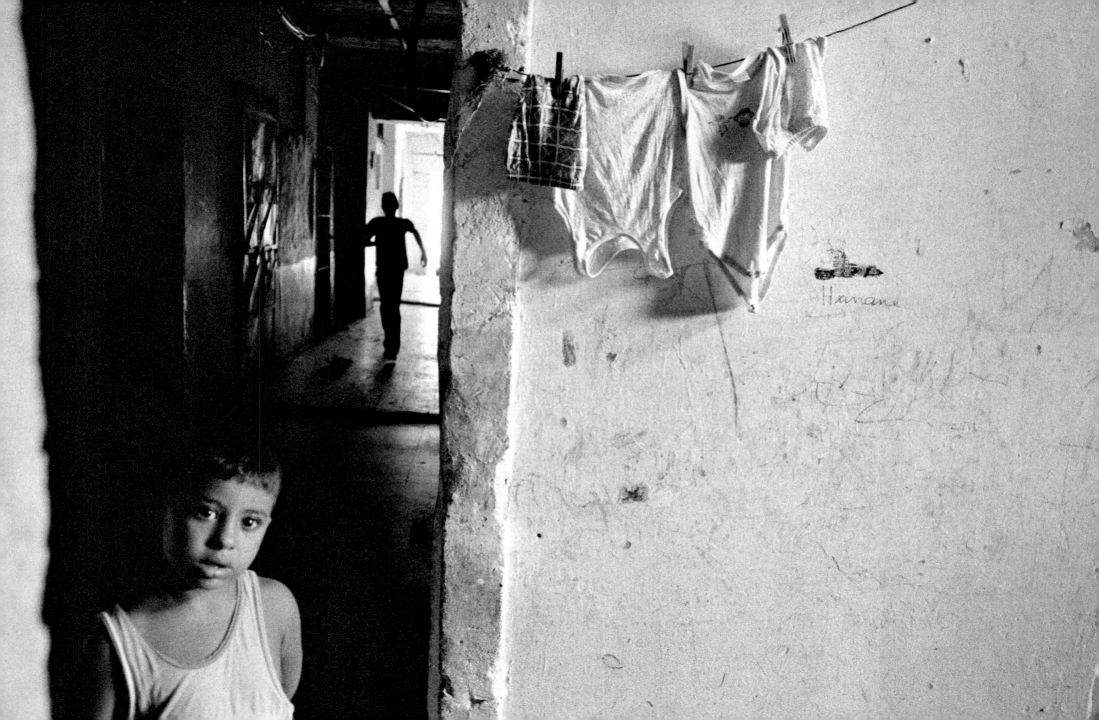

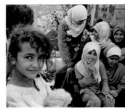

1. Unveiled. Aita El Chaab, Southern Lebanon, 2006.

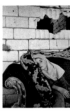

2. Girl and Rocket Hole. Aita El Chaab, Southern Lebanon, 2006.

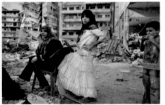

5. Defiant. Haret Hreik, Beirut, 2006. After the 2006 war, people went back to their destroyed homes to survey the damage and look for belongings in the rubble, and also to socialize and keep in touch with neighbors.

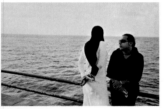

6. Courtship by the Sea. Beirut, 2005.

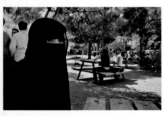

8. Fully Covered. American University of Beirut, 2007. A young woman is wearing the *niqab*, which covers her face, while in the background students are dressed in Western style.

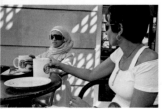

9. Coffee at Starbucks. Beirut, 2005.

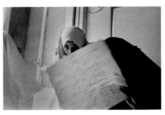

11. A Passage from the Qur'an. Beirut, 2005. In a religious class, a girl is required to read a passage from the Qur'an. Her teacher is covering her head and arms so she can read the text dressed appropriately.

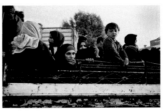

12. On the Truck. Lebanese/Syrian Border, 2006. During the war between Israel and Hezbollah, people were leaving Lebanon by the truckload to cross the border into Syria.

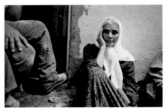

13. Pensive. Shatila Refugee Camp, Beirut, 2005. This lady has been living in the camp for most of her life. The sense of time standing still is overpowering in the camps, as people have nowhere to go.

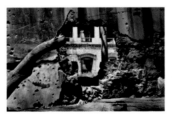

15. Rocket Hole. Beirut, 2003. Downtown Beirut was completely destroyed during the civil war. It has been rebuilt, but one still finds remnants of the old fabric of the city perforated by shrapnel and bullets.

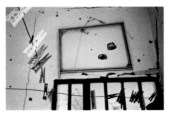

16. Laundry Wire. Aita El Chaab, Southern Lebanon, 2007.

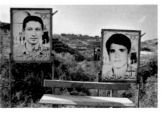

17. Portraits of the Martyrs. Southern Lebanon, 2007. People killed during war are considered martyrs in Middle Eastern cultures. Their images are often made into posters and billboards.

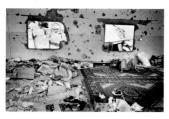

18. Sleeping in the Mosque. Aita El Chaab, Southern Lebanon, 2006. The mosque in this village bordering Israel was demolished during the war. People spread an Oriental rug over the rubble to pray. A man sleeps amidst the destruction.

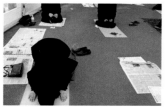

19. Praying in the Tent. Beirut, 2007. Women gather in a tent set up for them. At prayer time, they pray individually using newspapers or cardboard in lieu of prayer rugs.

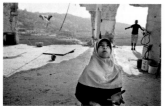

21. Juggling. Aita El Chaab, Southern Lebanon, 2006. After the war, foreign volunteers organized camps for teenagers. The girl is learning to juggle; the man in the background is jumping rope; a Lebanese flag flies on a clothespin.

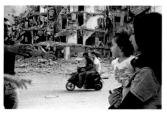

22. Motorcycling through Destruction. Haret Hreik, Beirut, 2006.

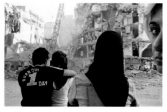

23. Burn-Out Day. Haret Hreik, Beirut, 2006. In the aftermath of war, families and neighbors wait for the wrecking ball to destroy inaccessible buildings, so they can recover belongings from the rubble.

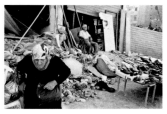

24. The Shoe Merchant. Haret Hreik, Beirut, 2006. Despite the rubble around him, a shoe merchant reopens his store in the same location it used to be.

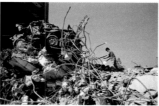

25. Looking for Metal. Haret Hreik, Beirut, 2006. A boy is looking for copper and aluminum wires in the rubble, so he can sell them.

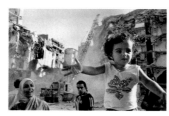

27. Barbie Girl. Haret Hreik, Beirut, 2006. As people wait for the destroyed buildings where their homes once were to collapse under the pounding of the wrecking ball, a toddler, oblivious to the commotion, brings a smile to her mother's face.

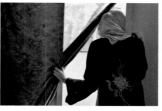

28. Looking Out. Beddawi Refugee Camp, Tripoli, 2007. After the war of Nahr El Bared in 2007, this young lady and her family were made refugees, living in a one-car garage.

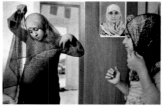

29. Three Generations. Bourj El Shemali Refugee Camp, Tyre, 2005. Families have been living in this southern Lebanon camp for over sixty years.

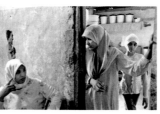

30. The Dead Mother. Bourj El Barajneh Refugee Camp, Beirut, 2005. Two girls are fixing their veil under the watchful portrait of their dead mother.

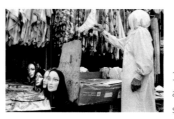

31. Veil Mannequins. Beirut, 2005. A woman shops for a headscarf, as Western-looking veiled mannequin heads fashionably display scarves of different colors and patterns.

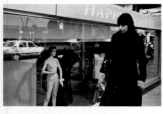

32. Naked Mannequin. Beirut, 2007.

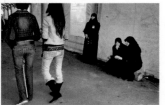

33. Opposites. Beirut, 2007.

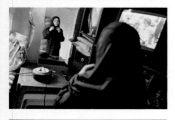

34. Covering Up. Beirut, 2005. A nine-year-old wears the headscarf for the first time.

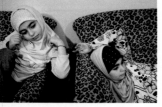

35. Sisters. Beirut, 2007. Rim and Ghida (9 and 11) just started wearing the veil, and switched from a French to a Muslim school. They wear the headscarf fashionably, layering colors and patterns.

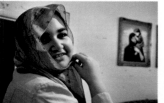

36. Gorgeous. Beirut, 2007. Raya, 12, wearing the veil. Aware of the fashionable aspect of it, she tries on a few headscarves to find the right color and pattern.

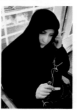

37. iPod. Beirut, 2007.

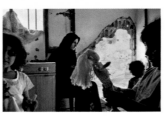

38. Rocket Hole in the Kitchen. Aita El Chaab, Southern Lebanon, 2006. A family hangs out in the kitchen. The wall behind them has been blown up by a rocket.

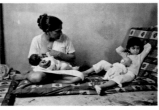

39. Nursing. Bourj El Shemali Refugee Camp, Tyre, 2005.

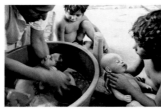

40. Bathtime for Baby. Bourj El Shemali Refugee Camp, Tyre, 2005.

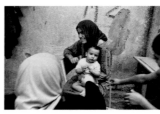

41. Baby. El Beddawi Refugee Camp, Tripoli, 2007. Families displaced from Nahr El Bared refugee camp after the war of 2007 are living in classrooms and socializing in schoolyards.

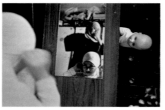

42. The Doll. Shatila Refugee Camp, Beirut, 2005. A nine-year-old girl wears the veil under the perplexed look of her mother who thinks she is too young for it.

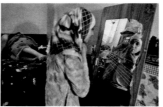

43. Broken Mirror. Beirut, 2005. This young woman, the oldest of five, had to stop her education to help support her family. Her brother, in charge since their father's death, insists she wear the headscarf.

44. Broken Mirror #2. Beirut, 2005.

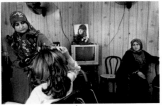

45. Inside the Beauty Salon. Aita El Chaab, Southern Lebanon, 2007. In a society where fashion is a priority, a woman will have her hair fashionably groomed, even if she is veiled and will not appear uncovered in public.

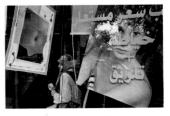

46. Howeida the Beautician. Beirut, 2007. Howeida, a Shiite Muslim from the Southern suburb of Beirut, runs a beauty, tattoo, and piercing parlor in the center of Beirut's upscale shopping district.

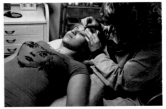

47. Howeida and Tattooed Eyebrows. Beirut, 2007. Howeida, who herself is veiled and dresses modestly, is tattooing eyebrows on her client.

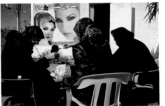

48. Beauty Salon. Aita El Chaab, Southern Lebanon, 2007. Girlfriends have coffee outside a beauty salon, under billboards of Western-looking, heavily made-up veiled women.

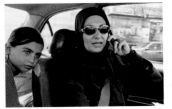

49. Rihab the Plastic Surgeon. Beirut, 2006. Previously trained as a doctor with Doctors Without Borders, Rihab wore the headscarf while on a mission in Iraq in the 1990s. She now works as a plastic surgeon, juggling family and work.

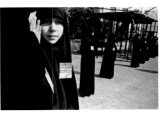

50. Guards of the Rally. Beirut, 2007. Women of the opposition (Hezbollah and allied Christian factions) organized a rally. These women are guarding the periphery of the event.

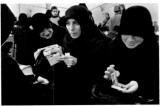

51. Girlfriends. Beirut, 2007. Young college women, covered in black in mourning for Ashura, a Shiite holiday commemorating the death of the prophet Hussein in 680 A.D., giggle as they look at photos of young men.

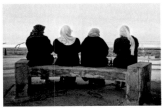

52. Gossiping by the Sea. Beirut, 2004.

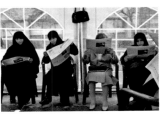

53. Newspapers. Beirut, 2007.

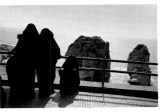

55. Fully Covered in the Heat. Beirut, 2005. Women from Gulf countries, vacationing in Lebanon, often wear the black *abayya*.

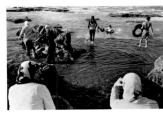

56. Walking on Water. Beirut, 2005. In Beirut one sees women swimming fully dressed alongside women in scant bikinis.

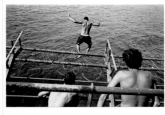

57. Jumping into the Sea. Beirut, 2005. Young men jump over barbed wire to swim in a public fishing area.

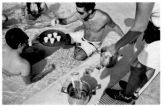

58. Champagne in the Pool. Edde Sands, Byblos, 2005. Affluent young adults have champagne served in the pool at a private beach resort.

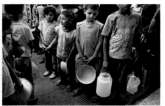

59. In Line for Food. Beddawi Refugee Camp, Tripoli, 2007. Refugees rely of local NGOs for food. Kids wait in line to get a cooked meal during the month of Ramadan.

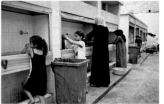

60. Dishes in the Schoolyard. Beddawi Refugee Camp, Tripoli, 2007. Refugees from Nahr El Bared were temporarily relocated in schools, which became makeshift refugee camps. Women and children wash dishes in schoolyard sinks.

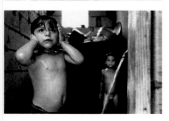

61. Bathtime. Bourj El Shemali Refugee Camp, Tyre, 2005. Water comes into one room of the home, and the same space is used to shower and wash dishes.

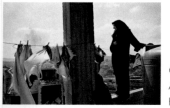

63. Hanging Laundry. Aita El Chaab, Southern Lebanon, 2006. A lady stands on a ledge surveying the destruction in her village, heavily bombed in the 2006 war.

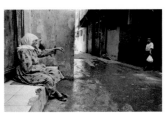

64. Generations Across the Alley. Nahr El Bared Refugee Camp, Tripoli, 2004. This camp, established in 1949, has seen four generations of refugees. It was heavily bombed in 2007.

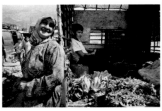

65. Selling Vegetables from the Truck. Khiyam, Southern Lebanon, 2006. After the 2006 war life resumed quickly despite the destruction. At the market, people sell fruits and vegetables from the back of trucks.

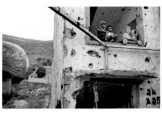

66. Rocking Horse. Aintaroun, Southern Lebanon, 2006. People moved back to their homes following the war of the summer of 2006, often living in badly damaged buildings.

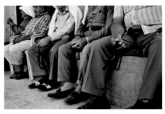

67. Worry Beads. Southern Lebanon, 2006. Older men sit lined up on the edge of a main street observing the resumed activity of cars and people.

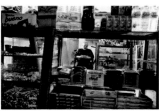

68. Sleeping on the Job. Beirut, 2007. Due to a dire economic situation, businesses were suffering. This seller fell asleep waiting for customers.

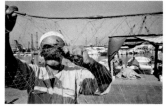

69. Behind the Fishing Net. Sidon, 2007. Fishing is an important and traditional industry in coastal towns and cities. A fisherman is cleaning his fishing net.

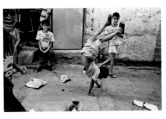

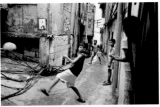

70. Walking on Hands. Shatila Refugee Camp, Beirut, 2005. Children play in narrow and overcrowded alleys, as there are no playgrounds around. Alleys are where camp life occurs.

71. Soccer in the Alley. Bourj El Barajneh Camp, Beirut, 2005.

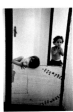

72. Children at the Door. Beirut, 2004. Families who fled Southern Lebanon in earlier years because of Israeli occupation lived in makeshift bombed apartments in Beirut for years, until reconstruction began recently.

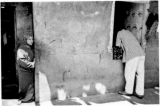

73. Door and Window. Nahr El Bared Refugee Camp, Tripoli, 2004. Bombed in 2007, this camp no longer exists. This family lost their home and became refugees again.

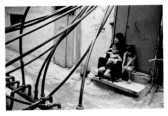

75. Water Pipes. Bourj El Barajneh Refugee Camp, Beirut, 2005. The network of pipes in the foreground brings water into homes from the main water supply outside the camp.

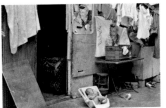

76. Baby and Arafat Posters. Shatila Refugee Camp, Beirut, 2003. Posters and billboards of martyrs and leaders are a common sight in the refugee camps.

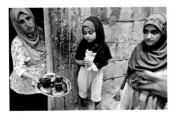

77. Offering Tea. Bourj El Barajneh Refugee Camp, Beirut, 2005. People in the camps are very hospitable, always offering food and drinks. The younger girl, while still in shorts, is wearing a veil pretending to be grown-up.

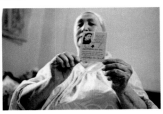

79. Refugee ID Card. Bourj El Barajneh Refugee Camp, Beirut, 2005. A Palestinian refugee in Lebanon since 1948, this lady holds her refugee ID card, her only official valid identification document.

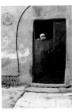

80. Behind the Door. Shatila Refugee Camp, Beirut, 2003.

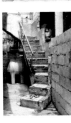

81. Slippers. Mar Elias Refugee Camp, Beirut, 2003.

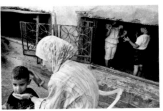

82. Playing on the Roof. Shatila Refugee Camp, Beirut, 2005.

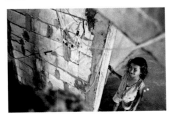

83. Exposed Electrical Wires. Bourj El Shemali Refugee Camp, Tyre, 2005. In an attempt to bring electricity into homes, wires have been roughly brought in and connected. Children play around the exposed wires.

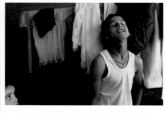

84. Looking Up. Beddawi Refugee Camp, Tripoli, 2007. Families displaced from Nahr El Bared camp after the July 2007 war are living in classrooms. Children are resilient and focus on the novelty of the tragic situation.

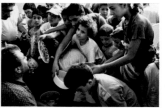

85. Cooking by Candlelight. Beddawi Refugee Camp, Tripoli, 2007. Displaced with her family, this woman cooks in the hallway between classrooms. Electricity is cut off. Little gas cookers were distributed to people by local NGOs.

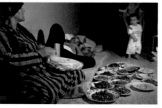

86. Waiting for Iftar. Beddawi Refugee Camp, Tripoli, 2007. During Ramadan, food is laid out on rugs as families wait for the prayer announcing the end of fasting. Temporarily relocated in classrooms, the refugees sleep, cook, and eat in small spaces allocated to them.

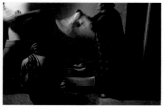

87. Food Distribution. Beddawi Refugee Camp, Tripoli, 2007. After the 2007 war, local NGOs prepared and distributed food to refugee families.

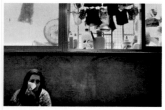

88. Laundry on the Window. Beddawi Refugee Camp, Tripoli, 2007.

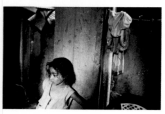

89. Girl in the Light. Bourj El Shemali Refugee Camp, Tyre, 2005.

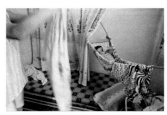

90. Sleeping in the Hammock. Bourj El Shemali Refugee Camp, Tyre, 2005. In a typical one-bedroom home, whole families sleep in one room on futons laid down at night and removed the next day, when the space becomes the living area.

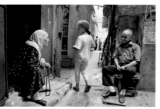

91. Refugee Children. El Beddawi Refugee Camp, Tripoli, 2007. After fleeing Nahr El Bared during the July 2007 war, this extended family shares a space in the UNRWA (United Nations Relief and Works Agency) school. Cardboard, tarp and blankets define individual family spaces.

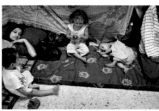

93. Ghost Girl. Bourj El Barajneh Refugee Camp, Beirut, 2004. Alleyways are part of life in the camp. As homes are small and alleys narrow, people socialize sitting on their front steps.

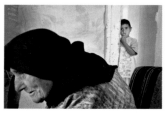

94. Boy and Grandmother. Aita El Chaab, Southern Lebanon, 2007.

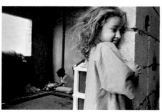

95. Open Window. Bourj El Shemali Refugee Camp, Tyre, 2005. Conditions in this camp are worse than in others. A security wall surrounds the camp, and building materials are not allowed in, preventing families from making homes permanent.

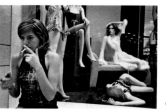

96. Cigarettes and Mannequins. Beirut, 2007.

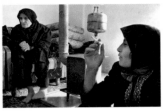

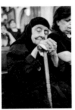

97. Cigarettes. Aita El Chaab, Southern Lebanon, 2007. Smoking is a favorite activity in Lebanon, no matter what background or social class one comes from.

98. Blissful Nun. Beirut, 2008. A Christian Greek Orthodox nun is listening to mass in a Beirut church. Lebanon is home to a very devout Christian community.

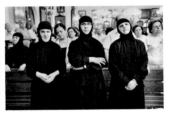

99. Three Nuns. Beirut, 2008. Three Greek Orthodox nuns attend mass, during prayer for Eid El Rab (Celebration of the Father).

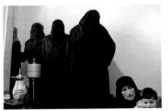

100. Facing Mecca. Aita El Chaab, Southern Lebanon, 2007. In a Muslim home, women are praying facing Mecca, center of the Islamic world and birthplace of the Prophet Muhammad.

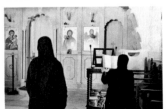

101. Orthodox Nuns. Northern Lebanon, 2005. In a Greek Orthodox Convent nuns pray, facing Christian icons.

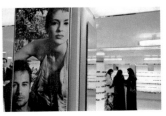

102. Shopping for Sunglasses. Beirut, 2005.

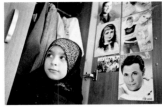

103. Inside the Closet. Beirut, 2005.

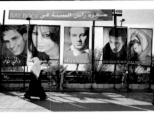

104. Walking under Posters. Beirut, 2005.

105. Edde Sands. Byblos, 2005. Edde Sands is an upscale beach resort.

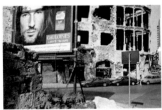

106. Gauloises. Beirut, 2005. A damaged building, untouched since the civil war, its structure barely standing, still towers over a major street intersection.

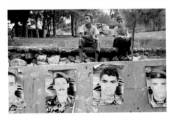

107. Martyred Soldiers. Tripoli, 2007. In Lebanese culture, soldiers killed in battle are martyrs and have their photos hanging in the village. Instead of condolences, one congratulates families on the martyrdom of their sons.

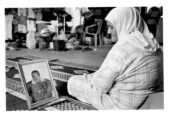

108. The Dead Son. Beddawi Refugee Camp, Tripoli, 2007. A mother mourns her son. He had left the shelter to get food for his kids when he was hit by a rocket and killed. The family had to flee without the body or a proper burial.

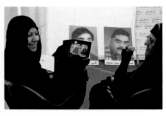

109. Proud Mother of a Martyr. Beirut, 2007.

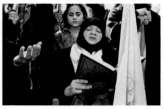

110. Praying for the Martyrs. Beirut, 2007. At a rally they organized, women mourn the sons who recently died during an internal conflict.

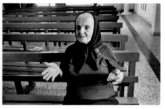

111. Praying at Church. Dbayeh Refugee Camp, Dbayeh, 2008.

112. Greek Orthodox Nun in Prayer. Beirut, 2008.

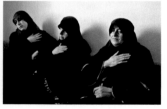

113. In Mourning. Aita El Chaab, Southern Lebanon, 2007. In Lebanese tradition, women dress in black in mourning for forty days. In this village, they also meet everyday for forty days for a collective mourning session.

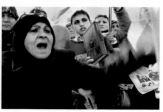

114. Angry Mother of a Martyr. Women's rally, Beirut, 2007.

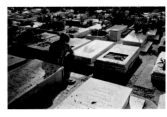

115. At the Cemetery. Beirut, 2005.

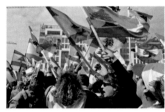

116. Women's Rally. Beirut, 2007. Women of the Opposition parties (Hezbollah and allies) protest the prospect of an imminent civil war by showing images from the Lebanese civil war, reminders of horrors previously endured.

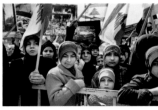

117. Hariri's Anniversary Rally. Beirut, 2007. At a rally commemorating the second anniversary of the killing of Prime Minister Rafic Hariri, over a million people flood the streets of Beirut carrying Lebanese flags. A billboard commemorates Mr. Gebran Tueini from the Al-Nahar newspaper, also recently murdered.

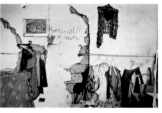

119. Nun with Blowing Veil. Convent of Saydat al Nouriyeh, Chekka, 2008.

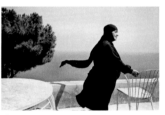

120. The Tailor's Shop. Beirut, 2006.

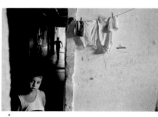

125. Boy and Hanging Laundry. Beirut, 2005.

Acknowledgments

This book would have not been possible without the wonderful people portrayed in it. They welcomed me into their homes, trusted me and treated me like a family member. Their beauty, resilience, hospitality and compassion are an inspiration. My sincere thanks go to every one of them.

My love and my deepest gratitude go to my father, Raja, whose intellect, spirit, integrity, unwavering support and unconditional love have guided me through life every step of the way. I am indebted to him for everything I have accomplished.

I want to thank the people who encouraged me over the years: Costa Manos who taught me to always take the best possible picture; Nick Johnson, for constantly reinforcing my confidence in my work. Anthony Terrana, for going out of his way to help me; Arlette Kayafas for believing in my work; Katherine French and Paula Tognarelli for their behind-the-scenes support; Kelly Bennett and The Massachusetts Cultural Council for supporting my work; and Mary Virginia Swanson for her priceless advice over the years. Thanks to the wonderful team working with me on this book: Jim Mairs for making it a reality. Anthony Shadid, for a beautiful and poetic essay that puts into words what I had hoped to convey through images; Lisa Suhair Majaj for sharing her inspirational poetry with me; and Austin O'Driscoll for taking care of everything.

I would like to thank Maarten Schilt for being the first to believe in this book, and Victor Levie for his time, insight, and sensitivity.

Very special thanks go to Adriana and Michel Elia, to Omar Al-Qattan and the A.M. Qattan Foundation, to Nadine Begdache and Galerie Janine Rubeiz, to the Institute for Women's Studies in the Arab World, Lebanese American University, and to the Center for Arabic Culture in conjunction with Mount Ida College Gallery for their generosity in helping promote this book, and also to Nicholas Baume, Linda Benedict-Jones, Howard Bossen, Leslie K. Brown, Alison Devine Nordstrom, Diana Edkins, D. Clarke Evans, Fouad El Khouri, Jim Fitts, Roy Flukinger, Karen Haas, Elda Harrington, Emily Havens, Randi Hopkins, Peter Howe, Gus Kayafas, Thomas Kellner, Gregory Knight, Russel Joslin, Rachel Rosenfield Lafo, Celina Lunsford, Carol McCusker, Lesley Martin, Jill Medvedow, Carole Anne Meehan, Wim Melis, Kevin Miller, the late Tom Mitchell-Jones, Robert Morton, Laura Moya, Shelley Neill, Brady Nichols Sloane, Ed Osowski, Henry Rasmussen and B&W Magazine, Chris Rauschenberg and the Blue Sky Gallery team, Nancy Rogers, Miriam Romais and Nueva Luz, Rhonda Saad, Amy Schlegel, Rod Slemmons, Barbara Tannenbaum, Anne Wilkes Tucker, Wendy Watriss, Clint Willour, Ricardo Viera, Madeline Yale. This work would not have been possible without their support, feedback and encouragement.

My heartfelt thanks go to James and Audrey Foster for offering me the unique opportunity of exhibiting this work at the Institute of Contemporary Arts, Boston, and to Yukiko Yamagata, Zeina Arida, Sandra Dagher and the Open Society Institute for including my work in "Moving Walls International." I would like to thank my colleagues and dear friends: Karim Fadel for his in-depth critiques and help; Elaine Hagopian for being such an inspiration; Susan Bank and Stella Johnson for being with me every step of the way; Katie Parsons Untalan for her priceless Web talent; Zach Vitale for being my Photoshop consultant at all hours; Emilie Stahl for her daily artistic input; Marc Elliott for the fantastic ICA presentation; Stephan Haley for being much more than a framer. Also, my thanks to Salma Abu Ayyash, Joanne Ciccarello, Jenny Edwards, Cathy England, Carol Khouri, Susan Lewinnek, Firouzeh Mostashari, Rania Naufal, Therese Nasr, Laura Nolden, Mari Seder, Emile Tyan and Kaelen Wilson-Goldie.

My gratitude to the many people in the world of art and photography who have shared their knowledge and expertise: everyone at the Institute of Contemporary Arts, Boston; the Photographic Resource Center; the Griffin Museum of Photography; the Houston Center for Photography; Fotofest; Photolucida; CENTER; Texas Photographic Society; Silver Eye Center for Photography; the Center for Contemporary Arts; and the New England School of Photography.

This work would have not been possible without the precious help of people behind the scenes: Wafaa El Yassir, Ahmad Halimi, Elham Shahrour, Abou Wassim, Kassem Aina, Nahla Ghandour, Leila El Ali, Nawal, Samir El Saade, Mo'taz, Dr. Kamel Mhanna, Elie Sangari, and the NGOs who do a fantastic and relentless job day after day.

My deepest gratitude and love go to my wonderful friends who have been like family to me. I have no words to express how blessed I am to have them around me. My loving thanks especially go to my family in Lebanon, my stepfamily and my in-law family for their love and support.

Last but not least, I would like to thank my loving husband and kids. You are my anchor and my life. My husband Jean—for understanding and encouraging my passion, for constantly getting me out of trouble, for putting up with my trips, my long hours, my laptop as an integral part of our marriage, but mostly for your unwavering patience, support, and love. I could have never done it without you. My wonderful children—Lara, Samer, Maya and Dani—thank you for being the beautiful people you are and for your unconditional love, trust and support. You are the best thing in my life. You taught me how to see beauty in everything. I owe you and love you more than you could ever imagine.

About the Photographer

Rania Matar was born and raised in Lebanon and moved to the U.S. in 1984. Originally trained as an architect at the American University of Beirut and then Cornell University, she worked as an architect for many years before studying photography at the New England School of Photography and the Maine Photographic Workshops in Mexico with Magnum photographer Constantine Manos. She currently works full-time as a freelance photographer while raising her family, and is starting a new project teaching photography to teenage girls in refugee camps with the assistance of non-governmental organizations in Lebanon. In Boston, where she lives, she photographs her four children at all stages of their lives, and is currently working on a new body of work titled "A Girl and Her Room," photographing teenage girls from different countries and backgrounds.

Her work has been published in photography and art magazines, and exhibited widely in solo and group shows in the U.S. and internationally at museums, colleges, galleries and photo festivals. She was recently awarded an artist grant from the Massachusetts Cultural Council, first prize at the New England Photographers Biennial, first prize in Women in Photography International, and honorable mentions at CENTER Santa Fe, Silver Eye Center for Photography, Julia Dean Photo Workshops for the Berenice Abbott Prize, and the Prix de la Photographie Paris Px3 for "The Human Condition." In 2008 she was selected as one of the Top 100 Distinguished Women Photographers by Women in Photography, and was a finalist for the prestigious James and Audrey Foster award at the Institute of Contemporary Art in Boston with an accompanying exhibition.

Her images are part of the permanent collection of many museums, including the Museum of Fine Arts, Houston; the Portland Art Museum, Oregon; the De Cordova Museum and Sculpture Park; the Danforth Museum of Art; the Kresge Art Museum; the Southeast Museum of Photography, and private collections including the Anthony and Beth Terrana Collection, the Ed Oswoski Collection, and the John Cleary Estate.

Ordinary Lives is her first book.

Photographer's Note

The photographs in this book were taken in Lebanon, over numerous trips between 2003 and 2008. I photographed with a Leica M6 and M7, using 28mm and 35mm wide-angle lenses. I do not use flash, so all the lighting was available light. I used Kodak Tri-X 400 ISO film for most of the images, Ilford 3600 if more light was required.

I scan all my negatives and print on 16"x 24" and 24"x 36" archival warm-tone fiber paper.

About the Essayist

Anthony Shadid is the Middle East correspondent for *The Washington Post*. Since September 11, 2001, he has reported from most countries in the Middle East, from Egypt to Syria to Israel and Palestine, where he was wounded in the back while covering fighting in 2002 in the West Bank. In March 2003, weeks before the U.S. invasion, he traveled to Iraq, his third visit there. He remained in Baghdad during the invasion, the fall of Saddam Hussein and the war's aftermath. In 2005, he moved to Beirut, from where he has covered the rest of the Arab world, then returned to Baghdad in 2008.

Before the *Post*, Shadid worked for the *Boston Globe* in Washington, covering diplomacy and the State Department. He began his career at the Associated Press in Milwaukee, New York, Los Angeles, and Cairo, where he worked as a Middle East correspondent from 1995 to 1999. He is a native of Oklahoma City, and a graduate of the University of Wisconsin-Madison.

Shadid was a finalist for the Pulitzer Prize for International Reporting in 2007 for his coverage of the Lebanese-Israeli war a year earlier. In 2004, he won the Pulitzer Prize for his dispatches from Iraq. That year, he was also the recipient of the American Society of Newspaper Editors' award for deadline writing and the Overseas Press Club's Hal Boyle Award for best newspaper or wire service reporting from abroad. In 2003, Shadid was awarded the George Polk Award for foreign reporting for a series of dispatches from the Middle East while at the *Globe*. In 1997, Shadid was awarded a citation by the Overseas Press Club for his work on "Islam's Challenge." The four-part series, published by the AP in December 1996, formed the basis of his book, *Legacy of the Prophet: Despots, Democrats and the New Politics of Islam*, published by Westview Press in December 2000. His second book, *Night Draws Near: Iraq's People in the Shadow of America's War*, was published in September 2005 by Henry Holt.

He is currently at work on a third book, still untitled, set in his family's ancestral village in southern Lebanon.